No Culture,
No Europe
On the
Foundation of
Politics

Pascal Gielen (ed.)

Antennae
Valiz, Amsterdam

No Culture, No Europe
On the Foundation of Politics

Pascal Gielen (ed.)

With contributions by
Rosi Braidotti
Kurt De Boodt
Pascal Gielen
Barend van Heusden
Andreas Kinneging
György Konrád
Thijs Lijster
Isabell Lorey
Jan Masschelein
Anoek Nuyens
Maarten Simons
Naema Tahir

Contents

Introduction
There's a Solution to the Crisis

Pascal Gielen

Over the past decade, the European Union has fallen into a drawn-out crisis, politically as well as economically. Politically, public support for Europe is dropping. A European constitution was rejected by the populations of several member states. European policy is seen as not being democratic enough and Brussels is regarded as being bureaucratic and opaque. Economically, mistrust between member states has been growing since the financial crisis began in 2008. The U.K. is not willing to pay the bill. Trust in the euro is no longer obvious, and feelings of solidarity among states are apparently no longer self-evident. When reading analyses and discussions of these problems, we must conclude that the debate is often being reduced to economic and social arguments, with the traditional political right arguing for more stimulating economic measures while the left demands a more social Europe. Within this debate, a third, neo-nationalistic voice can now be heard, advocating national and sometimes even regional protectionism.

In this book, an interdisciplinary group of theorists, artists and scientists argue that these polemic analyses miss an important element: culture. They identify the European Union's lack of attention for culture as the main cause of both the political and the economic crises. Faith in politics, like faith in a European currency, is first and foremost a cultural issue. Democracy is a matter of political culture, just as good economic relations are a matter of economic culture. In other words, culture as a shared frame of reference and as something that lends meaning to people's lives is not the superstructure but the very foundation or substructure of any society. When we understand politics broadly as 'the configuration of actions that gives form to society', those actions cannot do without interpretation and signification of social reality. So, politics must build on culture, if it is to be politics at all. Therefore, the European Union's lack of structural attention, investment, education and research in the matter of culture is one of the main reasons for the slump it is currently experiencing. Without a solid structural approach to cultural issues on a European level – such as, for instance, the establishment of European cultural and artistic institutes, a sound educational culture, including thorough research and education on economic and political culture – Europe will remain stuck in the current mood of crisis.

No Culture, No Europe not only offers a sharp analysis of the current European situation; many of the authors also present

alternatives. Part 1, 'Artistic and Social Culture', starts out by defining a number of key notions. What exactly is culture, and how does it differ from the concepts with which it is often confused, art and creativity? Philosopher Thijs Lijster and I outline the structure of the entire book, focusing on the relationship between art, creativity and culture on the one hand and describing how institutions of government deal with this relationship in a transforming political landscape on the other. Over the past decade, various European member states have replaced the well-known Rhineland model with a neoliberal approach. What are the effects of this shift on culture in general, but also on the political and economic cultures of communities? In the end, we argue for a new 'meta-ideological' model that goes beyond both the Rhineland model and neoliberalism, and is called 'communism'. Contrary to the communism of days gone by and the more recent neoliberalism, it takes culture and not the economy as the basis of society.

Next, Kurt De Boodt, poet and artistic adviser at BOZAR, relates how artists shared their ideas about Europe under José Manuel Barroso. De Boodt's contribution is not only a case study but also a modest historical sketch of Europe's relationship with the arts. As in the preceding essay, De Boodt sketches a place of dissent and debate as the basis for a dynamic EU. His *agora* is informed by the many singular voices of artists who by the very nature of their idiosyncratic critique and work evoke an involved Europe. This is quite a different image from that of Europe as a bookkeeper, with which European politicians seemed to have been content in the past decade. Wouldn't it be wiser for politicians to have more of an eye for arts and culture, if only to improve upon this image? In any case, art and culture are abundant in Europe, but not much is done about it. Barroso himself hardly got around to it either, in spite of his good intentions as 11th President of the European Commission.

The artist Anoek Nuyens, however, makes us 'feel' how art can contribute. If one can imagine something, she says, it is real. With her contribution '2018: The End of Europe', she makes it clear that artistic culture can lend a much more convincing significance to Europe than any economic or political discourse could ever achieve. EU parliamentarian Guy Verhofstadt was convinced, anyway. Art also makes it possible to imagine and especially really experience the impossible 'dismeasure'

within the 'measure' of a culture. We could not have asked for a more suitable conclusion of this first part about artistic and social culture.

In Part 2, 'European Culture', the European commons is further informed by dissonant voices. The provocative voice of feminist philosopher Rosi Braidotti breaks open the *agora*. If there is to be such a thing as a European identity, the neo-colonial past and Eurocentrism must be dealt with once and for all. Europe can only build a communal culture if it faces its own past. Universalistic claims from days gone by must be replaced by a nomadic Europe that defines itself as a union of minorities.

György Konrád, the Hungarian author who participated in discussions with Barroso (as described by De Boodt), contributes a slightly different voice to the *agora*. He champions a European identity supported by a community of reflexivity, with the studious man as protagonist. However, just as Braidotti envisions a Europe that not only can but *must* learn to live with its problematic past, Konrád posits that 'The studious man is capable of regret and can learn from his mistakes.' Perhaps this attitude contains the building blocks for a European culture as well as a solution to the current crisis.

The capacity for reason is what binds Europe, says cultural theorist Barend van Heusden, which brings us to Part 3, 'Educational Culture'. Van Heusden not only considers 'reason' to be the essence of a European culture, but also sees it as an important quality that can be introduced into the culture of education in a very specific manner, through art. Just as Europe is presently focusing too much on rationality, education nowadays tends towards a rationalization that attempts to quantify just about anything, at the cost of attention to values and experience. Whereas it is art that nurtures this awareness of culture in a very specific way. In Van Heusden's words: 'When we act, we do so upon the basis of this self-image, and the image we have of others. Not in an abstract, conceptual or theoretical way, but through the imaginative recreation of an experience. As such, art is one of the most important forms of cultural awareness we have, and it is the form that affects us most directly, precisely because it comes with and through an experience.' Those who would remove art education from the curriculum also limit

the possibilities for cultural awareness. Reason is coming under pressure from rationality and Europe is in danger of losing its sense of perspective, its awareness of diversity and complexity.

Educators Jan Masschelein and Maarten Simons confirm this view and apply it to the whole of education. The current emphasis on a permanent learning environment, competences and other rationalizations put pressure on European schools and universities. The focus is now on 'fast learning' aimed at direct usability in the labour market. However, this robs schools and universities of their traditional prerogative of remaining slightly aloof from business and politics. After all, such a detached position assumes 'slow learning', a process in which students learn to relate to the world, learn to love the world and learn to take care of it. This is obviously quite different from learning to take care of one's own individual career. It could be argued that schools and universities must be allowed to provide this detachment from business and politics in order that we may address the ongoing European crisis. How can we expect people who only learn to take care of themselves to ever take care of Europe? So, there is a solution to the crisis. It lies primarily within the autonomous or free space that schools and university used to be able to provide. It is there that culture is shaped and it is there that the building of a European cultural commons can begin.

In the fourth and final part, 'Political Culture', we zoom in on culture as the foundation of politics. As with the first essays in this publication, which underline the importance of an agonistic culture of dissent, commons and agora, part 4 almost literally illustrates what such a commons may look like. The views of a political Europe founded on culture could hardly be more diverse than those expressed in the contributions to this section. Writer and human rights lawyer Naema Tahir and philosopher of law Andreas Kinneging position an oligarchically governed Europe as a necessary evil that is only acceptable if those in power are guided by the truths taught by high culture. By contrast, political philosopher Isabell Lorey opens our eyes to a quite different political democracy taking shape within the borders of Europe. Here and now, experiments are being made everywhere with a new form of democracy that is a far cry from the familiar liberal representative model. These democratic practices of a growing, albeit precariatized multitude have dropped the teleological

perspective of their liberal predecessor, which was always promising more democracy or a better or real democracy in the future. By contrast, the democratic practices referred to here are already taking place in the present. In other words, they are not waiting for the empty promises of European or other politicians. Reading Lorey's contribution, there is a completely different Europe coming, a differentiated union of nomads — in Braidotti's words — who are preparing their very own commonism, together with Van Heusden's reason or Konrád's studious man. Because traditional politics in Brussels does not pay enough heed to culture, it risks overlooking this precarious and colourful crowd in its own backyard and in doing so may risk overlooking possible solutions to the ongoing economic and political crisis. Perhaps only a crystal ball may reveal whether the rational oligarchy will be confronted with a new democracy of reason in the near future. One thing can be said with relative certainty, though: history teaches us that historic economic and/or political upheavals tend to come from where you least expect them. What remained unnoticed before and was therefore regarded as impossible suddenly enters the realm of possibilities. Perhaps this is the status of culture in Europe today: culture as a stealth laboratory for new forms of life, an omnipresent incubator, hardly noticed precisely because it is everywhere. What would happen if it were to succeed in a practice in which it is the absolute champion? In short, what would happen if it succeeded in giving the European project a completely different meaning or sense?

No Culture, No Europe: On the Foundation of Politics could not have been realized without the support, both in content and finance, of the European Cultural Foundation (Amsterdam), BOZAR (Brussels), Fontys School for Fine and Performing Arts (Tilburg) and the Arts in Society research centre at Groningen University. I am most grateful to all of them. The article 'Culture: a Substructure for a European Common' is based on the study 'The Value of Culture', which was done in 2014, commissioned by a consortium of cultural centres and the government of Flanders. They graciously allowed me to use and edit it for this publication. I have come to appreciate Pia Pol and Astrid Vorstermans at Valiz Publishers even more for the patience they have shown in realizing this book. Many thanks as well to the authors for their inspiring and sometimes controversial

contributions. I can only hope that they will inform dissent in and about Europe, which may in the end actually make a cultural union feasible.

Part 1

Artistic and Social Culture

Culture: The Substructure for a European Common

Pascal Gielen &
Thijs Lijster

The Measure of Culture

Before addressing the meaning of culture for Europe it seems wise to remind ourselves of what culture actually is. The question about the meaning of culture may sound both extremely heavy and unbearably light. After all, culture is ubiquitous, which sometimes makes us forget that we are dealing with culture. 'Culture is ordinary', as the British sociologist Raymond Williams already stated in his seminal essay of the same title (Williams, 1977). This lightness sometimes obscures the deep and grand values encompassed by the concept. This is why philosophers, sociologists and psychologists have pondered the phenomenon throughout the centuries. In the twentieth century, the psychoanalyst Sigmund Freud, as well as the philosopher Martin Heidegger and the sociologist Zygmunt Bauman reached the same conclusion: culture only emerges in the face of death. Only the awareness of our mortality makes us need culture to give meaning to our own finite lives on this planet. This may sound very profound and heavy, but it is in fact quite logical and obvious. Bauman (Bauman, 2008) at least makes this quite clear in stating that people who are aware that they are mortal will inevitably look for the sense *in* and the meaning *of* their lives. This meaning can only be afforded by others and therefore in relationships with others. Therefore culture always has a social dimension.

In that sense we can still agree with the definition given by the Belgian sociologist Rudi Laermans (Laermans, 2002) who stated that *culture is a socially shared reservoir or repertoire of signs.* In doing so we assume that this 'repertoire of signs' refers not only to a formal semiotic game of similarity and differentiation, but also to as*sign*ing meaning as *sense* that gives direction and reason for existence to both people and societies. Perhaps this is the most fundamental importance of culture for Europe and also the reason why Europe had better not leave culture exclusively to the free market or to the competition between cities and member states. The European project can only gain more meaning and support if it allows citizens to really assign meaning to it. It is primarily the responsibility of the policymakers at the European level to provide enough room for this assigning of meaning and to expressly encourage it.

Let us further elaborate Laermans' definition of culture and take a closer look at its various components. The word 'sign' refers to the meaning we assign to things, at least in the science

of semantics, which distinguishes between signifier, signified and meaning. A further discussion of the insights of semantics is beyond the scope of this book. With regard to Europe, what matters here is that culture is about more than this formal game. Culture is all about *assigning meaning* and it tells us something about what we think is of value in life and how we view the world. Assigning meaning also assumes a *practice*. Culture is not a collection of objects; it is shaped by the actions of people. Culture is kept alive by people – by repetition, adaptation, actualization, interpretation and criticism – and is therefore continuously in development.

Socialization

The words 'socially shared' in the above definition of culture are very relevant to the debate about Europe. They refer to the fact that signs have no meaning at all unless they are supported by a collective. In other words, a number of people have to assign a relatively similar meaning to them. Culture is only viable if it has shared meanings, if it has a 'common' or communality. As Bauman too states, culture always presupposes an 'among/between': interaction among people but also between humans and objects, buildings, et cetera. When culture is understood as giving meaning to a person's life, to a group or to society as a whole, it is not surprising that it touches upon values, normative ideas and fixed customs. Culture touches upon what people think they have in common and therefore upon a community that might be called Europe.

This is why the word 'repertoire' in Laermans' definition seems more apt than 'reservoir'. The former notion expresses much more the temporal and historical nature of cultural interpretations. Within a culture, shared meanings build up in historical layers. They become ingrained as customs, familiar things and heritage, which are therefore always more or less charged with affect. So, people get used to certain customs or cultural traditions and are unwilling to let go of them. Culture is therefore always slightly preservative, even 'conservative' in the a-moral and a-political sense of the word. Within a cultural community, customs and traditions are preserved and it is only because of this that there can be shared meanings and therefore communication and mutual understanding as well. Or, again, only because of this a European common is possible.

The primary role of culture then is a *socializing one: it helps individuals to become integrated in a specific social, political and*

economic order. Culture teaches people existing ways of acting and being within a particular society and in doing so it lends meaning to people's lives in that society. This is exactly why culture enhances social integration or social cohesion. Let there be no doubt about it: it is not so much the family but rather the *culture that is the cornerstone of a society.*

All this doesn't make societies necessarily harmonious. The definition of culture applied here does not preclude the co-existence of many different cultures within a society, that can rub against each other or even come into conflict. According to some philosophers, this tense relationship is in fact typical of the common and of a dynamic culture, which may be to Europe's advantage. In a globalized world, cultures are diversified, complex and in an equally complex manner are interwoven with other cultures, which makes it hard sometimes to define the borders between them (Featherstone and Lash, 1999: 10). Communication is therefore only possible through a shared system of signs. In other words, the notion of society as multicultural or even at conflict is also based on a shared system of signs by which that society can be defined as such in the first place. Culture remains an important binding agent that makes communication possible. This is why Europe should continually invest in such a shared system of signs.

In short, we can understand culture as a *provider of meaning* both in a formal and in a deeply existential sense. It consists of a game by which people, groups and societies give meaning to their existence. That is why culture in this anthropological sense of a 'way of life' is the foundation of societies. That is also why we can speak of an economic, social, political or educational culture. All *are* after all culture and the value of culture is in the first place that it offers people opportunities in all these respects to give *value* to their lives, to lead *valuable* lives.

Perhaps some readers were not actually thinking of culture in this sense when reading the title of this book. Maybe they had club life, or the arts, or at least organized cultural production and distribution in mind. Still, it is useful to reacquaint ourselves with this basic anthropological notion of culture, all the more so because it may provide us with the most important tool for understanding the organized supply of culture in Europe as well. Because primarily in the cultural sector in the broadest sense of the word this anthropological notion of culture is used reflectively.

Here one realizes that culture is not only a social matter, but that it can also shape our living together. It is also in the cultural domain that we see how people assign meaning to their lives on a daily basis and that they can only do so in relationships with other people. In other words, cultural sectors have the tools to help shape the nature of cultures and the direction in which meaning is assigned. However, up till now, very few structural instruments or active policies have been developed at the European level to include its own project in that process of assigning meaning. It is no wonder then that there is so little support for it.

Qualifying

It is important to note that the broad anthropological concept we opt for here differs from another and older understanding of culture as 'civilization'. In that sense, culture (derived from the Latin *colere*, which means to tend, till or cultivate, as in 'agriculture', to 'work' the land) is used in a normative way: people are 'cultured' or not (preferably the first). This older concept of culture not only has a temporal dimension – the notion from the Enlightenment that humanity would become increasingly civilized over time – but also a clear hierarchy. As Norbert Elias wrote in his *The Civilizing Process* (1939), the assumption is that culture 'trickles down' from the higher classes to the lower ones. When people at court started eating with knives and forks, the upper classes would imitate this until finally it would become the norm for the entire society.

This hierarchical notion of culture is of interest because traditional cultural policy in most European countries has always taken a normative notion of culture as its starting point, either implicitly or explicitly. There was 'high' and 'low' culture, and the former deserved to be promoted and subsidized. Mind you: this notion is not necessarily tied to any political colour. While conservative politics wishes to guard the culture of 'the elite', leftist politicians are keen to bring 'the masses' into contact with great art. The point is that this idea of culture as 'civilization' still resounds nowadays in both the legitimization of cultural policy and in various art and cultural reviews. The verdict of the art critic or the decision made by a jury or advisory committee are still based on a value judgement in which a distinction is made between so-called high and low culture, good and bad art, or simply between art and non-art. In the field of cultural heritage one

important professional activity is to distinguish between what is supposed to be historically important and what isn't, what should be preserved, restored and maintained and what should not. Classic processes of canonization also always assume a hierarchy in culture, and over the past few decades the cultural sector especially has become very aware of the fact that this is a work of active construction.

Besides socialization, another important characteristic of culture becomes apparent here. Culture also always assumes *processes of qualification*. In a society, just as in education (Biesta, 2013), there is a continuous process of evaluation of what is deemed important or not, and even of what is of vital necessity or not. Educational programmes, instructions on how to raise children, guidance programmes and even individual coaching projects all originate in this value hierarchy. Within these qualifications it is not only determined more or less objectively what one should know and be capable of in order to be a member of a certain community (e.g., social etiquette, the level of proficiency in the language), but also what one should know and be capable of to be a good dancer, singer, writer, actor, filmmaker or sculptor. Qualification defines in relatively measurable terms the skills, knowledge and competencies that are required to be part of a culture or at least be able to function reasonably well in it. All cultures have a 'curriculum', as it were, that has to be learned in order to 'belong'. Anyone who has anything to do with education or training in Europe probably understands exactly what is meant by this qualification work. Of course this qualification work and what is needed to realize it may be different for each member state and the qualifications will very much depend on their national histories. Any European project will therefore only be successful when it takes a variety of qualification systems into account and actually protects this diversity. One should be very wary of policies that promote uniformization and standardization, as with the 'Bologna reforms' in education.

Subjectification

In contrast to the idea of civilization, *our* anthropological notion of culture is based on diversity and horizontality. This is in line with a shift in cultural theory and cultural policy that took place during the 1970s and 1980s, when the emphasis was no longer exclusively on qualification and promoting 'quality' (whatever that

may mean), but culture was seen as valuable no matter what. Policies became oriented towards not only the material side of culture (the conservation and qualification of cultural goods, although it remained one of the core tasks), but also towards culture as an everyday practice that took place in a domain where people simply meet.

Socio-cultural sectors also consciously develop strategies and methods to bring people together and in doing so they generate, in a modest way, certain forms of living together. Cultural sectors have important instruments to influence society. Keeping in mind the above anthropological definition of culture, this means that they also influence their economic, political or educational cultures and even the mental and physical health of their citizens. These are all after all part of a system of giving meaning, called culture. The cultural sectors have the means to consolidate certain economic, political or educational structures or, by contrast, point to alternative ways of living together. Even more so, they can effectively make these alternatives a reality.

To give a basic example: when a cooking club meets every week in a community centre or cultural centre, doesn't it at the same time teach the participants how to function within an alternative economy? To begin with, they learn recipes without having to buy a cookbook and without having to watch a cook on television. The added joy of tasting dishes together and simply being together is a free bonus. And doesn't a local library also teach that there are much cheaper ways of enjoying literature and of acquiring knowledge? In more abstract terms, is it not so that the cooking club and the local library teach people that financial transactions can be replaced by social interactions? That there can be, besides the culture of the free market, such things as borrowing, exchanging or a mutual gift economy? But even without these local, often face-to-face relationships, Wikipedia demonstrates that we can generate our exchanges of information and our knowledge economy quite differently from how we have organized our economic exchanges up till now.

These modest examples demonstrate that many of the cultural sectors not only engage in socialization and qualification as described earlier, but also in *subjectification*. This last notion, by contrast, does not refer to integrating individuals into an existing or dominant cultural order, but on teaching them to take up a self-reliant, independent or autonomous – sometimes critical

— position within that order. Socio-cultural sectors show both in-dividuals and specific groups that they are not just 'specimen' of a dominant order (Biesta, 2013: 31), but that they can take up an alternative, unique position in it under their own steam. In other words, *socialization, qualification and subjectification belong to the core business of cultural players.*

The Dutch philosopher of education Gert Biesta (Biesta, 2013) sees these qualities as potential tasks for education. We use them here in a broader sense as the essential characteristics of a culture and therefore as the core activities that cultural sectors, in the broadest sense of the word, engage in. Through socialization, qualification and subjectification, these cultural sectors or players are constantly helping to design and shape a social common or community, or: they shape our *living together.*

All these domains in a society, such as the economy, poli-tics or education, shape social interactions, but their final pur-pose is not the social sphere as such. For instance, the economy obviously depends on social interactions such as production re-lations and trade relations (and therefore on a culture) but the final goal of an economy is to produce and distribute goods that we need for living. Besides, the economy provides people who participate in the economic process with an income to buy these goods. Likewise, education naturally engages in socialization to a large extent, but it's goal in the first place is the transfer of know-ledge, and qualification. What greatly worries some pedagogues is that after the Bologna uniformization very little attention is given anymore to socialization and even less to subjectification (Biesta, 2013: 30-36).

This gives cultural sectors an ever increasing social respon-sibility for and in some fields even a monopoly on influencing the social sphere in a reflective manner.

The social sphere is their core business and they increas-ingly have the knowledge and methods to be active in, for instance, integration and citizenship or to initiate processes of social inno-vation. The cultural heritage sector also plays a central role in pro-cesses of socialization, qualification and subjectification. Many museums and other heritage initiatives reflect on existential ques-tions such as: who am I? Why am I here? At the very least they offer information about the cultural order we, or newcomers, find ourselves in. By gaining insight into history and cultural customs these newcomers have a better grip on the social order in which

they are living now. At the same time they can learn in how far their own background differs or even to what extent they intentionally wish to deviate from this background.

In other words, both socio-cultural actors and cultural heritage sectors possess the information, knowledge and methods to either confirm the existing cultural order or undermine it. They have all the means to offer, try out and implement alternatives. All of them are capable of socialization, qualification and subjectification.

The Dismeasure of Culture

If cultural players would confine themselves to socialization and qualification, a culture would come to a halt. Simply put, they would only bring people into the existing order and qualify and quantify them by applying set value hierarchies. However, the socio-cultural and the cultural heritage sector and both professional and amateur arts also have the possibility to subjectify. Among other things, this means encouraging autonomous and alternative voices and make room for them. So often, besides the 'measure' of a culture, a 'dismeasure' is also introduced. When, for instance, the socio-cultural sector reaches out to migrants or newcomers, it makes room for a different measure than the cultural measure that we are accustomed to. Depending on the methods that are developed, this sector can also more or less transform the familiar social order and allow it to mutate. The cultural heritage sector has similar capacities at its disposal, in that it can often uncover unknown histories or provide a fundamentally different look at already known ones. This may change the view that a community has of itself and leads to a 'redirecting' of its social order and culture. Occasionally the uncovered histories can be so shocking that a completely new social order is enforced. In short, just like the socio-cultural sectors, the cultural heritage actors often intentionally introduce a 'dismeasure' into the heart of the common, forcing people to give up their familiar cultural measure and adopt a new one.

Avant-garde

With regard to do this 'dismeasure' that is introduced, an interesting observation is that ever since the modern era it has become, paradoxically, desirable to deviate from the norm. Or, to put it differently, an important role in art is to break with the rule of art.

To the historical avant-garde this was in fact the rule, if something was to be called art at all. Or, in terms of the notions we set out before: avant-garde art applied itself to the process of subjectification by continuously introducing a dismeasure within the measure of a culture. In the words of the Italian philosopher Paolo Virno:

> Great 20th-century avant-garde art from Celan to
> Brecht and Montale, has demonstrated the crisis of
> experiential units of measure. It is as if the platinum
> metre bar kept in Paris to define the standard length of
> a metre suddenly measured 90 or 110 centimetres. This
> emphasis on immoderation, disproportion and the crisis
> in units of measure is to be credited greatly to avant-garde
> art... It is as if the metre, the standard set to measure cog-
> nitive and affective experience, no longer works. (Virno,
> in Gielen and Lavaert, 2009)

This dismeasure is not necessarily only aesthetic or formal in nature. It can also be political or — as Virno implies — cognitive and affective in nature. For instance, if we are made to laugh while watching a scene in a play that would perhaps make us cringe or cry in real life, we can speak of an affective dismeasure that derails the measure of our everyday cultural experience.

Although certainly not everyone in the current art world will still subscribe to the adage of the historical avant-garde, it can hardly be denied that this game with the dominant measure in a culture is an important code that keeps resurfacing. The French philosopher Jacques Rancière calls this code the starting point of modern art or of what he calls the 'aesthetic regime': 'the common factor of dis-measure or chaos now gives art its power' (Rancière, 2009: 52). The German sociologist Niklas Luhmann doesn't limit the rule of deviation to avant-garde either. When he asks himself, within his functionalistic scheme what the true role of art in modern society is — art that is often viewed as 'useless' and therefore without function by society — Luhmann concludes that art creates a *sense of possibility*. 'Nothing is either necessary or impossible', or 'everything that is, can also always be otherwise' (Luhmann, 1997) is the message of art in modern society. Precisely by setting a dismeasure, art shows us that the measure of a culture is only relative. In other words, every dismeasure can become the measure, making all that was the measure before into dismeasure.

According to this view, art and culture relate dialectically, and art often questions or challenges cultural customs and traditions. Art is often disturbing because it may unhinge fixed cultural customs. This is why confrontations with contemporary artistic expressions often lead to debate and dissent, if only about the question whether something is art or not. It is this debate that has become an important aspect of the artistic domain ever since the modern age: to show that there can always be different views, opinions and interpretations and, very rarely, even different ways of living together.

In art the issue is not so much whether the alternative view is more beautiful or more interesting, or nearer to the truth, but rather about the always present possibility of a different perspective. Anyone who reads a book by Javier Marías, visits an exhibition by Michelangelo Pistoletto, attends a production of Romeo Castellucci or a performance by Meg Stuart, goes to a concert by Champ d'Action or Radical Slave or is confronted in the public space by the monuments of Thomas Hirschhorn, can hardly escape the impression that most peculiar worlds are opening up here. Some visitors will be unaffected or forget or suppress the experience as quick as they can, while others will be profoundly moved. Maybe some people will even suddenly see the world they have taken for granted for so long with completely different eyes. Still others will understand that world much better all of a sudden or at least comprehend part of that world in a 'more correct' way than before.

Still, the arts are not engaging exclusively in the subjectification. Socializing and qualifying are just as much part of the cultural practice of the arts. For instance, those who wish to be convincing in the world of dance should at least be able to raise their legs to the right height — at least within a certain dance genre — and those who wish to 'make it' in the world of visual art had better subscribe to the social conventions, views and debates that are topical at any given time. Each little art world has its own social order or, in the words of sociologist Pierre Bourdieu (Bourdieu, 1992), its own 'rules of art', which require socialization. The ticket for entering a specific art world still consists of certain behavioural codes, marked debating skills and desirable opinions, in short: a culture. In this respect art therefore is also socializing and qualifying with regard to artists and other professionals, but it can do the same for an audience.

Although art has to a large extent focussed on subjectification, it can also have a socializing function to both professionals and those who are not connoisseurs of art. Sometimes art participation confirms an identity, at other times it may profoundly influence our existence. Perhaps these are the most essential values that artists have to offer to a society. And it bears mentioning that they often work very hard at it, most of the time for a fee that is inversely proportional to their efforts. This balance is becoming increasingly conspicuous in Europe that claims to champion the core business of artists. After all, it is the artists who primarily engage with the value of creativity that is so highly regarded these days.

Creativity

This is the 'C word' that is quite unavoidable in view of the latest focal points in European policy. 'Creativity' seems to be contributing, slowly but surely, to the already existing confusion about the terms 'art' and 'culture'. Whereas, before the 1970s, the label was reserved for eccentrics, nowadays just about everybody is encouraged to be 'creative'. Isn't there something of an artist in all of us? Or, can't we simply regard the 'noble' arts as just another element of the creative industry?

It looks like nowadays creativity is the mission of every company and policy, and almost the moral obligation of each individual. If we take a closer look at precisely what is meant by 'creativity' (see for instance Florida, 2002 and 2005; Rickards, Runco and Moger, 2009) it appears at first glance to be covering the same ground as contemporary art as described above. After all, creativity is similarly associated with notions such as 'innovative', 'transgression', 'authenticity' and 'uniqueness'. In short, like art, creativity entertains the idea that anything that is, can also always be otherwise. Undoubtedly, creativity is an essential element of art. No wonder then that in everyday communication the borders between creativity and art tends to be vague.

To keep things straight, we will maintain a strict and formal attitude here: not all creativity is art, but all contemporary art is the product of creativity. The most important difference here is the finality. Artists, managers, teachers, scientists and policymakers alike make use of creativity, but their goals are completely different. As we said earlier, modern art is essentially about constantly creating 'dismeasure'. The finality or goal of all works

of art is to always point out alternate possibilities. The goal of creativity within the arts is then to generate new creativity so that new interpretations and therefore new ways of expression become possible. Creativity stimulates the imagination of the public, but not least that of artists themselves as well. Each work of art may trigger a new work of art.

However, within the corporate world, politics or education – to mention but three social domains – it is unthinkable that the only goal of creativity would be creativity itself. The manager who continually introduces a dismeasure in his company will soon lose the loyalty of his workforce. The policymaker or politician who does likewise will generate political instability and juridical insecurity. The teacher who introduces a new educational method each day sends students out to float on an immense ocean of knowledge without a compass. This does not mean that there can be no creativity in the social subfields of the economy, politics or education, but that it becomes dysfunctional if it only serves creativity itself. In the economy, for instance, creativity should lead to better products or more access to markets (and preferably both at the same time). In politics it should lead to the improvement of the community and in education to a better transfer of knowledge. In other words, the goal of creativity here lies outside itself and if it doesn't serve this external goal, it is better not to be creative and to obey the 'measure' for a while.

This last statement immediately clarifies the position of creativity within our triumvirate. It is a concept that continuously negotiates between the tendency of dismeasure of art and the measure of culture. Compared to culture, creativity is revolutionary, which is why the economist Joseph Schumpeter speaks of 'creative destruction': 'that incessantly revolutionizes the economic structure *from within*, incessantly destroying the old one, incessantly creating a new one' (Schumpeter, 2010: 73). Creativity does something similar with the measure imposed by a culture, yet it does so mainly within the measure (or modestly), making it look conformist when juxtaposed with avant-garde art.

Hence our statement: art does not simply coincide with the creative industry. There are two grounds for this. (1) Within the creative industry the economic measure of marketability is taken into consideration in advance, and/or (2) the measure is imposed by the potential for technological or organizational innovation. The dismeasure that is expected from this

out-of-the-box thinking is therefore always coloured by a relatively calculable measure.

Artefacts that are produced in the creative industry are of course always cultural products. Besides having a qualifying character, they also play a role in the game of socialization and subjectification. Furthermore, they can also intervene in an existing cultural order and fundamentally transform it. We need only to think of smartphones or games to see how such creative developments have a profound effect on the design of our living together. However, as stated before, this type of product only does so within the preordained, calculable measure that is often economic or technological in nature. Whereas the impact of such developments on a culture may be much bigger than that of art, they remain within the measure of qualifiability, consumerability and user-friendliness.

In short, the creative industry definitely does transmute a culture, but in a rather restrictive way towards qualifiability and free-market culture. The latter, preconditioned restriction may provide arguments for the European Union to not simply abandon a policy on arts or make it part of, say, and all-encompassing creative industry perspective. Such a decision would narrow culture to economic culture and would impose a certain a priori measure on the arts.

The Core Business of the Cultural Sectors

For now it suffices to draw the conclusion that choices have been made and that our definitions have been made clear. However, not without explicitly stating that these definitions are constructed rather one-sidedly from a European perspective. Keeping this limitation in mind we may state that culture is the all-encompassing 'way of life' and that creativity (in various domains such as economics, politics, education) is capable of making changes to this way of life. It is only within the arts, however, that creativity as such can be a permanent goal in itself. This is why the dominant measure that rules the arts, paradoxically, is that of the dismeasure. Or, an important rule in the arts is that the rule needs to be broken — without any economic, political, or educational restrictions and (as we know from recent art history) even without juridical, ethical, ecological or medical limitations. Even radical physical interventions such as those performed by Orlan or tattooing pigs, as Wim Delvoye does, can be elevated to the status of art in the contemporary art world.

It goes without saying that not everyone has to agree with this, and seasoned art professionals often express doubts about the artistic status of such acts. But, as we stated earlier, this debate about art versus non-art is the very core of the art world ever since the modern age. Art as the domain where a certain dismeasure is still being cultivated, is one of the few places within modern society where just about every measure (be it economic, political, ethical or medical) can be questioned. This is the very openness that the world of fiction allows since the modern age (in democracies, anyway). Or, as the German philosopher Peter Sloterdijk says, since then artists have 'the possibility to spontaneously and triumphantly discuss any subject whatsoever' (Sloterdijk, 2011: 369). Which of course does not mean that all artists do so and that all art lovers accept this, but ever since the historical avant-garde, it has always been a possibility within art.

Art thereby certainly does not have a monopoly on introducing a dismeasure in a culture and most certainly not on the subjectifying practices. As stated, the socio-cultural sector frequently provides forms of living together that fall outside of the familiar measure and the heritage sector sometimes uncovers a history that may cause an existential crisis that touches upon our subjectivity. Although a large part of the art world has made this its central ambition through the historical avant-garde, this does not mean that the arts have the greatest impact on culture. The effects generated by a socio-cultural sector by, for instance, introducing a migrants' culture; the dismeasure of a controversial history introduced by the heritage sector; or the technological innovation that is widely distributed by the creative industry, can all generate a much larger shift within a culture. This is all the more true because (1) a certain degree of playing with dismeasure is more or less expected from the field of art, which makes it inevitable that we get more or less used to this idiosyncratic behaviour, but especially because (2) art is preferably confined to the world of fiction and is therefore seen as largely inconsequential to real life. This applies much less to the 'true story' of a history that is suddenly brought to light, to the communities of migrants that are actually on our doorsteps or to the computer games and smartphones that embellish our work, public and domestic domains (and sometimes thoroughly ruin them).

To round off we may state that the core business of cultural sectors everywhere in Europe is to design and give meaning

to ways of living together. Both cultural professionals and artists, including amateur artists, are involved in society by constantly applying themselves to socializing, qualifying and subjectifying cultural practices. They may guide or accompany people into the social order that is taken for granted; at other times they may establish a hierarchy within that order and assign members of a society their specific place in it; or they may empower those same members, teach them to claim their own place, overturn a hierarchy and, very rarely, even undermine the social order or parts of it.

We could visualize the relationship between culture, creativity and art outlined in this chapter as three concentric circles. Culture is then an all-encompassing human practice, with creative activities forming a substantial part of it in our fast changing society. Art, finally, occupies only a modest territory within this complex of practices. Only now and then, the socio-cultural sector generates a societal model that is rather different from the usual one and only rarely does the heritage sector uncover a history that shakes our cultural foundation or undermines our identity. And although art has made subjectification one of its main social services, we know only too well that the voices of artists often only reach a small circle of the initiated. Within the various kind of activities of a culture, the arts occupy the smallest place, but it is a practice that can be the epicentre from which everything may be set in motion. To phrase it in somewhat poetic terms: art is like a soft song that not everyone can or wishes to hear, but that can on rare occasions make a complete society resonate with it. It is a little bit like Josephine, the little, inconspicuous mouse in Kafka's short story. Her voice is weak, but at times her singing can configure a whole new assemblage of the mouse folk (Kafka, 1924).

The value of a culture is determined by the interplay of socialization, qualification and subjectification and the value of cultural sectors is precisely that they engage in such activities in a reflective manner. Cultural professionals continuously inform the common through these activities and are important in shaping communities. Of course, other social domains such as politics, education, religion, the media and, last but not least, the economy, also determine the shape of a society. Within cultural sectors in the broadest sense of the word this happens more reflectively, however, which means that processes of socialization, qualification and subjectification are often intentionally interfered with in

order to purposely steer society in a certain direction - or rather, attempt to do so. Because of the number and diversity of cultural players, all this pushing and pulling does not result in a very clear direction, let alone a harmonious way of living together. Rather, this varied group of designers produce a common of many divergent types of interaction models and societal forms. In our view, a Europe of diversity, of various cultures, can only find collective support in such a common. Then again, that may be the very essence of what we in our European culture are used to calling 'democracy'. But what exactly is such a common?

Europe Without Common?

Over the last few years, the notion of the 'common' is gaining ground again in political philosophy, cultural theory, and in law. Just think of the discussion of 'creative commons' in connection with copyright issues. But even before the European Union was called a union, it proudly proclaimed the word 'Community', as a political entity. In any case there is a direct link between culture and the notion of the 'common', in Europe too. Where does this concept actually come from and why is it so important within the framework of this book?

At the beginning of the twenty-first century, the concept was reintroduced by both the Dutch philosopher Hans Achterhuis (in 2010) and the American/Italian philosopher duo Michael Hardt and Antonio Negri (in 2009). The common stems from the Latin word *communis,* which has as its Indo-European root mei, meaning 'to swap' and to 'exchange'. *Mei* stands for what people are entitled to by turn. Achterhuis refers to the communal pasture that was freely accessible to a certain community. Cattle could graze there, and people could cut peat for compost and grow crops. The right of use of the common guaranteed its users a chance of survival. Hardt and Negri also posit that the common consists not only of natural resources such as air, water, fuel, et cetera, but also of cultural resources such as language, traditions, knowledge and information, codes, et cetera. After all, no one could claim authorship of a traditional folktale or folk dance.

Although with the advent of the market economy most of the common was privatized and therefore disappeared, there are still 'common grounds' that remain relatively accessible to anyone. There is, for instance, the relatively free access to the Internet nowadays, with especially the Internet encyclopaedia Wikipedia,

which is written and edited by volunteers (and has until now been free of advertising). The safeguarding of the common is crucial for the continuation of a culture or — how could it be otherwise — a *community*. In economic science as well, various researchers point out the importance of so-called 'externalities', the ownership of which can be difficult to ascribe but which are crucial in making a free market economy function as it should. Although the word did not yet exist in his day and age, Adam Smith already mentioned the importance of care and education as externalities. Also, as we know by now from many studies, cultural practices and infrastructures not only play an important role in adding value to economic activities but also contribute to social cohesion, cognitive skills and other mental and physical conditions (see also, among others, Gielen, Elkhuizen, Van den Hoogen, Lijster and Otte, 2014). It is quite obvious that today domains such as mobility and communication play an crucial role in the economy, so it comes as no surprise that many governments try to keep to these domains as easily accessible as possible.

Still, the common does not simply coincide with public facilities or the public domain and neither with what economists call 'externalities'. Hardt and Negri emphasize the fact that the common is fed by both public and private parties that both continuously fling goods, services and images into the ether or speed them through glass fibre cables, and also leave them in the physical public space, to be used by anyone relatively cheaply and sometimes even completely free of charge. As the most divergent social parties and interests confront each other in the common, this frequently results in conflicts. The common is a space of dissent, or, to quote the Belgian philosopher Chantal Mouffe, it is 'agonistic'. (2008). It is often precisely this dissent and tension that produce the creative sparks by which a culture is constantly renewing itself and reconsidering its sources. Communities are anything but harmonious, a fact that we already hinted at before. It is precisely in dissent and not in consensus that a community is shaped. Just as a democracy is maintained by the constant play of criticism and conflict between government and opposition, likewise the community and its culture only display cohesion 'through' internal tensions, conflicts and debates. Whereas consensus leads to homogenization and therefore to a relative standstill of a culture, it is precisely the tensions between tastes, styles, subcultures, political affiliations, religious convictions and social and ethnic groups

that are kept alive in the common. Cohesion then is not defined by consensus, but rather by the will to enter into conflict with each other, albeit without bloodshed. Hence Mouffe's bending of Carl Schmitt's 'antagonism' to 'agonism', from a world of enemies to one of opponents.

Our point is that this common with its free access and all its tensions is indispensable to a dynamic European culture in the broadest sense of the word, so it is also essential to a democratic political, economic, educational and even legal culture. In any case, we find in society various facilities that no longer belong to the common, but whose organization and presentation are still based on the idea of a common. For instance, there is no democratic politics without a parliamentary system in which anyone is basically eligible for election. Likewise, there is no competition (although there are monopolies) within an economy if there is no free market that is, in principle, accessible to everyone. And there is no good, not even an efficient use of knowledge without an educational system that is, in principle, accessible to almost everyone. Finally, there is no honest administration of justice without collective laws and rights and the possibility of free legal aid. All these elements and regulations carry at least traces of the common. By this we mean that they are sometimes no longer completely free and sometimes do not guarantee free accessibility any longer, but that they do rely on the recognition of the importance of a common. However, in what follows we will show how this common has come under increasing pressure over the past few decades, and certainly also within the European Union.

Let us finally remark about this common that it is anything but a so-called 'left-wing' or even neo-Marxist concept. Neither communist nor socialists have a monopoly on the use of the term. Although nowadays quite a few critical theorists, and therefore often leftist thinkers, are hijacking the notion, no one will deny that for instance the Roman Catholic tradition has recognized the importance of the common since way back. After all, the *Communion* is a core element of its liturgy. And those philosophers who call themselves 'communitarianists' (such as Charles Taylor and Alasdair MacIntyre) and stress the importance of the community are by no means leftist thinkers but rather a source of inspiration for conservative or Christian-democratic politicians.

Politics and Culture

Subjectifying and 'autonomizing' activities play a crucial role now, precisely because they are capable of creating new communities or of constantly renewing the common. They can also draw attention to previously invisible/in audible elements of the community (what the French philosopher Jacques Rancière calls *la partage du sensible,* the distribution of what can be perceived by the senses (Rancière, 2007)). As mentioned before, cultural sectors have the instruments, methods and insights to shape the social in a reflective manner. In what follows we will primarily discuss their subjectifying potential. We will do so by demonstrating how culture, creativity and art are related to communities. More concrete: we will primarily discuss the political dimension of communities. After all, the status of the common and what exactly is assumed to be communal and what is not, depends to a large degree on the political climate and the (cultural) policy it produces. Even if that policy, as in the case of the European Union, consists of little interference with culture this reflects a political choice that has an impact on culture. Especially over the past few years this has become quite clear, now that socio-political shifts evidently have consequences for the cultural policies in the various member states. This shift, which is often referred to with the general term 'neoliberalization', will be illustrated here by looking at the differences between the Rhineland and Anglo-Saxon models. We do so especially since within Europe there is quite a lot of debate going on about the advantages and disadvantages of each model.

Looking at the political situation in the various member states, we can already conclude that, in general, there are two different views on which direction to take. Is Europe leaning more towards the United Kingdom and the Netherlands or does Europe opt for innovation and strengthening of the Rhineland model, as we see happening in some of the Scandinavian countries? Perhaps nothing is either black or white and the differences are of a gradual nature. A shift towards either social democracy or neoliberalism can however have important consequences for how one deals with culture and subsequently with cultural sectors. A political-ideological slant also has consequences for how cultural sectors might operate. In what follows we aim to sketch and interpret such a scenario. After all, culture is influenced by socio-political relationships and therefore these also determine how culture and contribute to a common.

Next, we will discuss a recurring notion in the debate about cultural policy, namely 'autonomy'. Although this seems to be a widely shared value, in times of neoliberalism it appears to be very differently interpreted by the opponents in the debate. We will show that autonomy can only exist in and through a common in which subjectifying practices are given space. When autonomous spaces disappear, communities or at least that what they originally were intended to mean, will also evaporate. In conclusion we will return to the common of the culture and see how this notion can add an extra dimension to debates on economy and politics.

The Dismantlement of the Welfare State

All over the world governments are still dealing with the consequences of the financial crisis that erupted in late 2007. Inevitably, the public debate about this crisis has also raised the question of guilt: who is responsible for the crisis? Besides at the 'money-grabbing bankers', the 'negligent supervisors' and the 'lazy politicians', the accusing finger was also often pointed at a more elusive culprit: neoliberalism. The gradual dismantlement of the welfare state, the retreating government and the opening up of the financial markets to multinationals had created the conditions in which the crisis not only could be born, but also strike with a vengeance. Especially in this debate people often referred to the distinction between the so-called 'Rhineland model' and neoliberalism with an Anglo-Saxon flavour. Over the past few years, many politicians, especially Christian-democrats and social-democrats, have argued for the return of the Rhineland model, from Angela Merkel to Yves Leterme and from Wouter Bos to François Hollande. And even conservative and downright classical liberal circles are increasingly voicing criticism of neoliberalism, as in the cases of John Gray (Gray, 2007) and Frank Ankersmit (Ankersmit and Klinkers, 2008), respectively. The latter even posits that neoliberalism is not really liberalism at all, but a form of feudalism, as responsibilities and mandates that belong to the state end up in private hands.

The 'Rhineland model' is a term that was introduced by the French economist and former head of the French bureau of economic policy, Michel Albert, in his book *Capitalisme contre capitalisme* [Capitalism Against Capitalism] (1991). Against the political background of the fall of the Berlin Wall, he describes Rhineland capitalism as an alternative for both communism and the neoliberal capitalism of the post-Reagan United States. The term refers

to the economic model of the countries along the Rhine River: Switzerland, Germany, France and the Netherlands, and related economies such as Belgium, Japan and the Scandinavian countries. As for Europe, we may state that most member states still apply this model. Only the United Kingdom and, more recently, the Netherlands are more outspoken dissidents.

The Rhineland capitalism that is so typical of post-war European welfare states provides a buffer zone against the market, as it were. It could be called 'capitalism with a human face'. It is a culture of consultation, in which the government frequently sits down with both employers and labour organizations (the Dutch even have a special verb for it: 'to polder', until recently a strong tradition in the Netherlands). According to proponents of this model it not only promotes a more just sharing of profits but also enhances the overall stability of the economy. Rhineland economies supposedly also take better care of citizens' well-being (instead of exclusively focussing on prosperity) and also stimulate businesses to act more responsibly with both employees and the environment. They are also supposedly more sustainable than Anglo-Saxon economies, where, by contrast, keeping shareholders happy stimulates short-term thinking and short-term investing (Stiegler, 2011).

All these advantages notwithstanding, especially the Rhineland model came under heavy pressure since the 1990s. It was accused of having created tardiness in decision-making, making it impossible for these economies to function and compete in the global marketplace. Also, the Rhineland economies would have a levelling effect that smothered creativity and 'excellence'. Under the strains of this political criticism and the 'system' pressure of the international markets, a growing number of Rhineland economies in Europe reformed themselves in line with the Anglo-Saxon, i.e. neoliberal model (incidentally, often under the leadership of those same Christian-democrats and social-democrats mentioned earlier.

What neoliberalism exactly is, is not easy to explain in a few words. David Harvey defines it as 'a theory of political economic practices that proposes that human well-being can best be advanced by liberating individual entrepreneurial freedoms and skills within an institutional framework characterized by strong private property rights, free markets, and free trade.' (Harvey 2005: 2). The most important difference between neoliberalism

and the traditional liberalism of thinkers such as Adam Smith and John Stuart Mill is that neoliberalism not only argues against intervening in existing markets but also states that markets should be actively created in areas that were not markets before (for instance in healthcare, education, energy, utilities, et cetera). Harvey also states that we should make a distinction between neoliberalism as a utopian project (the theoretical belief, as with Friedrich Hayek and Milton Friedman, that *laissez-faire* capitalism is a precondition for both a just and well-functioning society and the well-being of the individual) and neoliberalism as a political project (the consolidation of power by an economic elite, Harvey, 2005: 19). The two are hard to reconcile sometimes: the emphasis on individual freedom and the distrust of central government of the former is often at odds with the need for a strong and active state to create markets or save them when the system fails.

Nowadays, in the European context the word 'neoliberalism' is often used in a derogative sense to denote an economic policy that gradually dismantles the post-war welfare state and also corrodes or even completely devours the common we referred to earlier. More developments, effects and concomitant problems are associated with 'neoliberalization'. To name but a few:

— The transition from industrial to financial capitalism in the Western world encourages nation states to make their economies more attractive to multinationals by offering lower taxes and flexible labour policies (Mandel, 1999). A waning influence of labour unions and savings on social benefits are the results.

— The privatization of government and utility services (such as health care, education, social housing, and communication, energy and water companies) and deregulation of markets. The focus on profit instead of service supposedly generates perverse incentives, which leads to 'money-grabbing behaviour' among managers, monopolies, corruption in education, et cetera. Both national and European politics seem increasingly powerless against this, precisely because the politicians have handed over responsibility in these domains to private sectors (Ankersmit and Klinkers, 2008). In other words, even the supervision of the free market is being privatized to a large extent (Gielen, 2013).

— Making the economy more flexible (based on outsourcing and subcontracting) renders the nation state vulnerable: in

their search for lower wages multinationals may suddenly move their activities elsewhere, which results in unemployment; banks may fail, taking savers and pension funds, et cetera, down with them, unless they are bailed out with taxpayers' money.

— In general, the gap between the rich and the poor is getting larger and larger because of the growing inequality in both income and capital (see Harvey, 2005; Stiglitz, 2013 and, recently, Thomas Piketty *Capital in the Twenty-First Century* (2014), which caused quite a stir).

These are all economic developments and effects, whereas our subject here is culture. Nevertheless we mustn't underestimate the cultural effects generated by neoliberalism. Some of these are:

— By making the labour market more flexible or by upscaling organizations (mergers) people feel less appreciated for the experience they have or for their 'craft' as a teacher, nurse, scientist, et cetera, for which they studied hard to become specialists (Sennett, 2006 and 2008). This also makes it harder for people to keep identifying themselves with the work they do.

— A culture emerges in which people are primarily addressed as *consumers*, instead of as producers, workers or citizens (Bauman, 1998); even in domains where a consumer identity seems less obvious, for instance in care, education or government services in general (see, for instance, Masschelein and Simons, 2006; Biesta, 2013). Patients, students or citizens who see themselves primarily as consumers who buy care, education or government services adopt a radically different attitude towards these classic institutions. This need not be only negative – it can lead to a degree of empowerment – but in practice there are definitely negative consequences: for instance, politicians who play up to citizens, or universities that aim to please students (instead of challenging them).

— Paradoxically, privatization goes hand-in-hand with an increasing *inspection* of activities, leading to feelings of distrust between employers and employees, teachers and students, government and citizens, et cetera (De Bruyne and Gielen, 2012; Gielen, 2013d). In this way the 'marketization' indirectly leads to *de-professionalization*, because the professionals (the teachers, the doctors, the judges) always have people breathing down their

necks. Besides, a growing number of tools and resources that originally were controlled by professionals are ending up in the hands of a top layer of managers (Lorenz, 2012).

— In a neoliberal culture people are encouraged to always regard each other as competitors. This competition is the engine of a 'social acceleration' (Rosa, 2013), which causes feelings of uncertainty and alienation among large parts of the population. In other words, people have the feeling of being less and less able to exert any influence on either their own lives or on society. Paradoxically, (neo)liberalization leads to a growing feeling of lack of freedom, and confusion.

— In the cultural domain the creative industry is gaining ground. Cultural goods that used to be freely accessible to everyone, are now sometimes only offered at a steep price. Within the Marxist tradition this is called the 'commodification' of culture. Harvey mentions it is an example of neoliberal 'accumulation by dispossession' (Harvey, 2005: 159).

These are examples of how political-economic developments influence the *meaning* that people assign to their own lives and to living in the community. One may think initially that this only concerns our working life, our life as a nurse, a teacher, a scientist or an artist. However, it is obvious that these developments affect the lives of those who receive these services just as much: the students, the patients in hospitals, the visitors of a museum. Even family life is affected by them. Closer inspection reveals that almost all aspects of life, of the entire culture, are influenced by these political-economic developments. And this culture has an important influence on our so-called Gross National Happiness. Starting at a certain level, the accumulation of wealth and economic growth have an inversely proportional effect on this Gross National Happiness. Or, as the saying goes: 'you can't buy happiness'. This common knowledge does raise some doubts about the persistence call by European policymakers and corporations for — still more — economic growth.

There is no doubt that these problems are on the agenda as of parties across the entire political spectrum, but the kind of solutions that they propose are radically different. Over the past few decades, one notable aspect is that refuge has been sought in social measures (usually by left-wingers) or in economic measures

(usually by right-wingers), but that no one seems to be looking at culture. Nevertheless, we know from quite a lot of research with relative empirical certainty that cultural and arts participation definitely contribute positively to both the mental and physical condition of populations. The more so because health is always party defined by subjective elements too. People who are culturally integrated and are based on a firm common are able to function autonomously and have a better chance of giving real sense and meaning to their lives. So perhaps there are still unexplored possibilities hidden in the field of culture that politicians and other policymakers may use: opportunities that don't even have to be very expensive.

Culture, Creativity and Art in Times of Neoliberalism

As a result of the financial crisis, various economy measures were taken in many European countries and these measures also affected many cultural sectors. In several countries, including Great Britain, Hungary, Italy and the Netherlands, heated debates and sometimes even protests about the pros and cons of cultural subsidies followed. The tone of these debates sometimes bordered on the hysterical (at a protest action in the Netherlands people literally 'screamed' for culture) and the reproach of 'cultural barbarism' was met head on with the qualification of art and culture as 'left-wing hobbies'.

Without immediately taking sides in this debate – whether or not to cut back on culture – let us begin by observing two things about this debate. Things that catch the eye because of the historic relationship between art and culture on the one hand and between art and politics on the other. First, it is striking that the distrust is primarily aimed at the arts. In the debate this distrust comes primarily from the political right (as evidenced by the qualification 'left-wing hobbies'). This is peculiar, since traditionally it was the liberal citizen who fought alongside the arts in the fight against traditionalism. Since the nineteenth century, artists were often regarded as prototypes of the liberal autonomous individual (Seigel, 1986) and the arts, again, as the engine of subjectification. To give a striking example: during the Cold War, Abstract Expressionism was even secretly financially supported by the CIA because it supposedly was proof of the creativity and intellectual freedom in western capitalist democracies.[1]

Observation two: in the discussions about cutbacks on culture both sides played the 'autonomy card', as in making an appeal to autonomy as a value. Those who defended the cutbacks argued that artists and cultural institutes should learn to stand on their own feet and become less dependent upon subsidies, in other words: be more autonomous. Those who were against cutbacks argued that art and culture should be able to operate independent of the markets and that taking away subsidies would jeopardize their autonomy.

Two things are clear. First, liberalism has some link with autonomy. This is not strange, as this political ideology starts from the idea of the free, independent (autonomous) individual. However, as Immanuel Kant said, autonomy is not doing whatever you want to do, but living by your own laws (the literal meaning of *auto-nomos*). Even if, as stated earlier, the rule of art is to break the rules, this does not mean that artists can do whatever they feel like. The whole discourse around arts, the institutions and the critics also impose rules on them, albeit sometimes implicitly. Secondly, in the debate about cutbacks on culture the term 'autonomy' is used rather carelessly, as often it is not made explicit exactly what is defined as autonomous (art, the artist, the art institute, the aesthetic experience, social or broader cultural practices) and *in relation to what* these things are autonomous or not (the state, the market, let alone tradition, religion, et cetera; Lijster, 2012).

It therefore seems worthwhile to take a closer and longer look at the concept of autonomy and explore what it means in the three domains mentioned above: culture, creativity and art. We will also look at the effects that the neoliberalization of these domains has for their autonomy.

Autonomy of Culture

In light of the broad definition of culture as a 'socially shared repertoire of signs' that we introduced above, it may seem strange to speak of the autonomy of culture. After all, if culture is this broadly defined as the customs and ways of doing things of a community, then everything is 'culture' and it becomes hard to see it as a separate domain.

Nevertheless it does make sense to speak of the autonomy of culture, insofar as it consists of multiple cultures that each have their own dynamics and are self-producing (*autopoetic,* in Luhmann's terms). So we are not talking here in the first

place about individual autonomy, but rather about the collective autonomy of communities. All the same, these are closely related, since individual autonomy cannot be achieved without structurally guaranteed systems of solidarity, or, more concrete, without a basis in education, health care and culture. Culture provides us with answers to existential questions. My self-image and individual autonomy depend on how I define myself as part of and in relation to a certain shared culture. The Belgian psychoanalyst Paul Verhaeghe calls this process of identification and separation (Verhaeghe, 2012). Putting too much emphasis on either of the two carries a risk: it could lead to a culture of sameness (resulting in exclusion) or to a culture of isolated and lonely individuals, respectively. Through the process of identifying with and separating from certain cultures, these cultures maintain themselves and continue to develop.

By contrast, the heteronomy of culture would mean that it is unilaterally defined by an external factor, such as the market or the state. In this respect we can invoke Jürgen Habermas' by now classic distinction between 'lifeworld' and system (Habermas, 1981). While according to the German philosopher the lifeworld consists of the whole of shared meanings by which people interact and communicate with each other, the system is a domain where people, by contrast, are primarily directed by power (the state) or money (the market). Whereas, according to Habermas, the 'project' of modernity consisted of separating the lifeworld from the system, he recognizes the danger of a colonization of the lifeworld by the system (in both communism and laissez-faire capitalism) in the twentieth and twenty-first century. This colonization occurs when the free exchange of arguments about, for instance, science, morality or art is endangered by a dominance of the logic of one of the systems.

We can also observe this danger in the criticism of neoliberalization. It is said that the meaning of 'good care', 'good science', 'good education' and 'good art' is changed under the influence of the market. What was good care, for instance, was traditionally determined in the interaction between doctor/nurse/therapist and patient/client. One could also say that it was (autopoietically) determined by the medical community, just as scientists defined what was good science among themselves, artists (and other professionals in the fields, such as critics, curators, et cetera) decided what was good art, and teachers (and educators) decided what was good education. They all had their own culture, which was

an acknowledged right, in which most of the problems were dealt with autonomously in each community.

An often-heard complaint is that nowadays external factors such as efficiency, targets, measurability and evidence-base become increasingly important, making the actors in the communities concerned feel that they are losing control (for science see Boomkens 2008, Lorenz 2013 and Halfman and Radder 2013; for education see Masschelein and Simons 2006, Biesta 2013 and De Bruyne and Gielen, 2012; for care see Desmet, 2009; and for art institutes see De Bruyne and Gielen, 2013a and b). Finally, this not only concerns these individual communities but also entire cultures. A *heteronomous* culture then is a culture that no longer makes its own rules but is governed by a logic that is not its own. The 'own' culture, such as that of behavioural and assessment codes of medical practitioners among themselves, scientists among themselves, politicians among themselves, lawyers among themselves and also artists among themselves, is in jeopardy. This means that the values of their culture are also ignored or simply replaced by values that originally were not part of their 'lifeworld'. Surgeons who perform operations based on ethical and medical codes may perhaps act relatively differently than surgeons who think about the number of patients he needs to deal with. Likewise, judges may perhaps look at a case file differently, depending on whether they focus on justice or on the number of cases to close. Politicians who are freely electable may advance somewhat different ideals than those who depend on a number of wealthy sponsors for their election. And someone working in the cultural heritage sector who focuses on pulling in big crowds may well dig up other histories and label them as 'relevant' than would be the case if they would operate exclusively from their historical expertise. In any case, many professionals end up facing such unsolvable dilemmas these days and this is because they can no longer determine their own culture. The shared repertoire of signs that was created and decided upon by professionals among themselves, but also by family members or, for instance, theatre enthusiasts among themselves, is generated by other 'alien' mechanisms when autonomy is lost. This is what gives people the feeling that they are losing their grip on their own culture. It should come as no surprise that in such cases many professionals, individuals, but also families and other communities lose the meaning and

the satisfaction of their existence, as that satisfaction came from their autonomy in managing their own culture.

Autonomy of Creativity

We have already looked at the various ways in which creativity functions in the arts on the one hand and in the corporate world, politics and education on the other. We noted that the difference is in the finality: whereas creativity in art only produces creativity again, creativity in the corporate world, politics and education must yield other results. At first glance, it would seem obvious that we can only speak of the autonomy of creativity within the domain of the arts.

Still, creativity has its own autonomous space. Especially when creativity is embraced by the whole of society as a value and particularly when the economy itself is increasingly concerned with cultural values rather than with immediate practical value (Žižek, 2010), the common sources of creativity must be watched over. As Hardt and Negri stated in their *Commonwealth* (2009), the economy nowadays increasingly depends on creativity, but at the same time it constitutes a danger to creativity. Every instrumentalization of creativity also ties it down, because it privatizes what belongs to the common and precisely this common is what nourishes creativity. This is why, according to Hardt and Negri, cultural capitalism is inevitably steering towards a crisis. We will return to this aspect when discussing the notion of the common or communal and what it means for a European community.

But also in other domains than the market, politics or education the ever louder sounding call for creativity is often accompanied by a narrowing of the concept. New initiatives must immediately yield, preferably measurable, results. Competition, which is rampant in a growing number of social fields, also draws heavily on creativity. After all, competing parties prefer to keep their ideas to themselves, whereas creativity benefits from the exchange of ideas and the accessibility of other people's creative output. It has been noted more than once that the battle of patterns in science (especially in physics and medical science) and technology has negative effects on developments in those areas.[2]

Truly scientific and technological innovations, but also social or economic ones, are arrived at precisely in autonomous creative spaces. Or, as Masschelein and Simons say, students at a

technical school only start thinking seriously about what else a car engine could do when it is regarded separately from the car in the autonomous space of education (Masschelein and Simons, 2006). And wasn't it the Philips corporation that gave its engineers every Friday afternoon off to 'just do anything' in the company labs? Gilles Holst, a former director of the Philips NatLab, had the following guidelines for his research policy: 'do not become bogged down in details; give lots of freedom; cherish idiosyncratic individualism; in case of doubt, choose anarchy; stop detailed budgeting; do not be guided exclusively by the possibility of sales; do not let the production departments dictate the budgets for research.'

Holst was very much aware of the 'externalities' that were needed to keep a company going, but he also knew that the company needed a space for experiments and even for 'loss' if it wanted to arrive and more innovative insights. Tinkering and messing about, endless discussions with colleagues and even boredom are often the basic ingredients for creative thinking. Those who begrudge creativity this autonomous time-space and smother it in over-meticulous efficiency calculations and other accountability regulations will seldom sail high into the creative firmament. Or, in our jargon: creativity is then reduced to working off a neat checklist within the measure. This may be a high measure, but it is only mediocre when compared to the dismeasure that allows for the risk of an autonomous space.

Autonomy of Art

Volumes have been written about the autonomy of art and we certainly do not intend to give an exhaustive analysis of the subject within the scope of this essay, but we do feel that it is important to mention it here. The more so because we have noticed that although the autonomy of art has long since been discarded as a myth by the historical avant-gardes (Bürger, 1974), it still remains a value that is appealed to time and again, not in the least in debates about art and cultural policies, as mentioned earlier.

Let it be clear right away that in our view autonomy should not be contrasted with 'being part of society' or even with 'social relevance', as is so often the case in the public debate. The contrast between artistic autonomy and social relevance is a false one. On the contrary, the social relevance of the arts consists of their 'dismeasure', in other words of their capacity to show that everything that is can also always be different. This means there

is a close relationship between this dismeasure and the autonomy of art. Or, in the words of Rancière, quoted earlier:

> This absence of common measurement, this registration of the disjunction between registers of expression and therefore between the arts, formulated by Lessing's Laocoon, is the common core of the 'modernist' theorization of the aesthetic regime in the arts - a theorization that conceives the break with the representative regime in terms of the autonomy of art and separation between the arts. (Rancière, 2007)

The conditions for this capacity of dismeasure are set by a domain in which creativity is not expected to yield immediate results but where it can exist for its own sake, i.e. autonomously.

Such a domain cannot be taken for granted; it has to be generated and supported by a social process. We could also say that the autonomy of art is safeguarded by society. As the German philosopher Theodor Adorno already observed, art is both autonomous and a 'social fact': it has itself 'become' social in a lengthy process of emancipation from church and court. The autonomy of art is the product of the differentiation of value regimes in modern society, which means that we can no longer judge art by criteria of truth (trueness to nature) or of morality, as was the case before the modern era. That this is a relatively recent development is illustrated by, for instance, Baudelaire and Flaubert, who both had to stand trial for corrupting morality with a literary work as late as 1857. We have since grown accustomed to the arts having their own institutions in the form of museums, academies, publishers, societies and critics, who all produce their own rules and criteria (Gielen, 2013b). That in itself is more evidence that the 'autopoietic' nature of art is rooted in the community. The doctrine of *l'art pour l'art* [art for art's sake], which is traditionally associated with the autonomy of art, can therefore justly be called a myth, if only because the autonomy of art is itself *heteronomous*, i.e. is always conditioned by society (Lijster, 2012; Gielen, 2013a).

The above analysis of the ways in which autonomy can be understood in culture, creativity and art brings us to the following tentative conclusions. First, autonomy in these fields should not be regarded as the opposite of community; on the contrary they presuppose and influence each other. Just as a community cannot

exist without the autonomy of culture (in our broad definition), autonomy in these respective fields cannot exist without the support of the community. This means, secondly that this is precisely what the task and responsibility of cultural policy could be: safeguarding that autonomy, and thereby the community. We will now further investigate this concept of community.

The Community of Culture – The Culture of Community

It is hardly a secret that neoliberals are not very enthusiastic about the notion of community. Just think of Margaret Thatcher's famous statement: 'There is no such thing as society.' The starting point of neoliberalism is the atomistic individual, the *homo economicus,* detached and cut off from his cultural, ethnic or religious background. It should come as no surprise then that neoliberal policies, which are aimed at efficiency, standardization and measurability, are a threat to various forms of community. The logic of the market, which is imposed upon the whole of society, leads to hyper-individualization, undermining of solidarity (by dismantling the welfare state), weakening of citizenship and, rather obviously, of community spirit. When citizens are increasingly approached as consumers – and therefore start to regard themselves as such – or are encouraged to see their fellow citizens as competitors, it is no wonder that they no longer feel responsible for the community. This is also true, by the way, of countries where the state has traditionally played a smaller part, such as the United States and the United Kingdom. These countries have always had a close-knit and active local community life, although this has been increasingly corroded by the growing inequality in income, by unemployment (partly caused by moving production elsewhere) and by the shrinking role of local entrepreneurship over the past few decades. Remarkably, though, community art is quite popular there (cf. De Bruyne and Gielen, 2011). Such initiatives are often started to fill in or compensate for the holes that neoliberal policies make in these communities. Community art then functions as an opiate to the grief caused by neoliberalism.

In the introduction to this chapter we already mentioned that, unlike communitarians, we do not regard community as a harmonious entity. On the contrary, the community is the place where confrontations and conflicts between its members occur, but also the place where these can be articulated through subjectification and be democratically resolved. Culture – taken in the

broader sense of the word to include creativity, cultural heritage and art – is the place where both subjectification and socialization take place. The community offers safety, solidarity and thereby security – all basic conditions for freedom – but at the same time it is something to react against in order to shape one's own life in freedom. In short, there is no individual freedom without collective structures of solidarity, institutions and constitutions to fall back on.

Traditionally, the community controlled the commons or 'commonness' and, as mentioned above, members of the community could appeal to and make free use of these commons for their livelihoods, on the condition that they did not use them to make a profit. We know that these actual commons were shrinking on the eve of the modern era and were converted into private property, a process that is called 'the enclosure of the commons'. This enclosure is by no means a historical phenomenon or a completed process, as it is still going on today. By this we are not only referring to the increasing privatization – meaning expropriation of the community – of communal ownership of, for instance, fossil fuels, land, water supplies or even genetic codes. Hardt and Negri extend the notion of the commons to include immaterial matters such as communication (think of Facebook), information and cultural practices. The enclosure of the commons means, for instance, that publicly performing the traditional song 'Happy birthday to you' now constitutes a violation of copyright, which has fallen into the hands of Warner/Chapell Music.

By referring to culture as a 'commons' we do not only wish to state that art and cultural heritage should remain easily accessible to all, as that would still imply a limited vision of culture as something that we 'consume'. The communality of culture does not simply mean that everyone has access to culture but also that culture is a shared practice that is the result of interaction. This obviously makes it important that all members of the community possess the necessary knowledge and skills (qualification), can successfully connect to the culture (socialization) and create an authentic role for themselves (subjectification). In this respect we can say that both the Rhineland model and neoliberalism focus especially on managing socialization and qualification. The first model does so through (over)regulating and bureaucratic processes, the second through quantification

and by introducing management processes such as audits, accreditations and individual assessments. Both systems restrict the possibilities for subjectification.

Of relevance here is the distinction made by the American Professor of Law and philosopher Lawrence Lessig. He distinguishes between a *Read Only* (RO) and a *Read/Write* (R/W) culture (Lessig, 2008). A Read Only culture has a vertical division between producers and consumers. In other words, there is a clear distinction between the producers of cultural goods and the public that consumes these goods. A *Read/Write* culture, by contrast, is based on the 'commonness' of a culture that is not only accessible to all but to which all also actively contribute (again, Wikipedia comes to mind). In the words of Lessig:

> One emphasizes learning. The other emphasizes learning by speaking. One preserves its integrity. The other teaches integrity. One emphasizes hierarchy. The other hides the hierarchy. No one would argue we need less of the first, RO culture. But anyone who has really seen it believes we need much more of the second. (Lessig, 2008: 87-88)

As the quote shows, Lessig stresses the importance of both, but at the same time he states that in our contemporary culture, which is oriented towards consumption and commodification, the emphasis is on the first. Because we have increasingly begun to see culture as a commodity – a commodity that is also increasingly subjected to ever more strict copyrights – the communality of culture is at stake. This in spite of the fact that the commonness of culture is an important element of a democratic society, according to Lessig. This is why he stresses that the word 'Free' in the title of his book *Free Culture* (2004) should not be read as in 'free beer', i.e. that all culture should be available at no charge, but as in 'free speech'. In other words as something that supports, facilitates and protects everyone who wishes to make use of it.

Both Lessig and Hardt & Negri believe that the exploitation of communal cultural property is not only disastrous for culture in the long run, but also for the (creative) economy, which has made itself increasingly dependent upon the creative force that emanates from culture. A sustainable economy, in other words, is only possible when it is based on a solid community.

To further clarify the relations which we discussed between the three pillars of culture (taken here in the broadest sense of the word, including creativity and art), politics and economy, we can present them in the following, admittedly rather simplistic, scheme:

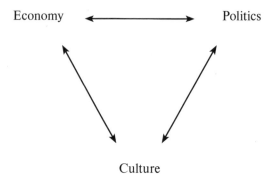

Economy ←————————→ Politics

Culture

In all its simplicity, the above scheme does clarify the various connections. Traditionally, the most attention by far went out to the upper relationship, that between the economy and politics. The way in which politics and the market interact and could or should mutually influence each other is of course the central theme of **political economy,** the science that we associate with names such as Smith, Ricardo and Marx, and later Keynes and Hayek. Culture was often seen as secondary to this relationship – the 'superstructure', as Marx called it.

However, it is clear that other connections have become increasingly important. In the first place, as we discussed, the present-day economy is running more and more on culture and creativity. The notion of **cultural economy** not only refers to the domain of the creative and cultural industries. Within traditional economies too, 'cultural' values are taking central stage. The dominant post-Fordist labour regime embraces art, creativity and culture in almost all branches and sectors of industry (see also Gielen, 2009) and political philosophers have been emphasizing the cultural dimension of politics ever since the 1990s. Political justice is much

more than a fair distribution of goods (redistribution). It is also important to recognize, in both a legal and socio-cultural sense, the diversity of people, groups and their life projects and values in a community (recognition). The German philosopher Axel Honneth even states that only when we recognize others and empower them to express their identity (cultural, sexual, religious or otherwise) we open up the way to a more just redistribution (Fraser and Honneth, 2003). The classic Marxist distinction between base and super-structure is inverted here: a 'politics of culture' or **cultural policy** becomes the base of social life.

By the same token we can speak of an **economic culture** or a **political culture**. With regard to the first, we have already mentioned how the word 'money-grabbing culture' (which is indeed a culture too) is often used since the financial crisis broke out. More generally speaking, one could say that economic behaviour and economic relationships partly depend on the type of cultural values that we share.[3] After all, an exclusive focus on profit maximization is also part of a certain cultural conviction: the conviction of what is important in the lives of human beings.[4] Different views on or within a culture automatically lead to different views on, for instance, the importance we attach to economic growth, a sustainable economy, differences in income, et cetera. The commons of culture is at the basis of our convictions, either implicit or explicit, about the economy. It is no coincidence that cultural projects are often places of refuge to experiment with alternative economic and business models.

Democracy too is dependent upon the communal space of culture. Democracy is not just a political system where our votes are counted once every so many years; that much is clear from just the laborious attempts of the West to 'bring' democracy to countries that lack a democratic culture. Democracy presupposes the ability and possibility of citizens to inform themselves (and therefore an independent press), to reflect on values, to hold different opinions about them and to discuss them and negotiate about them. Culture is *the* place where we think about what we find important and meaningful and where we are also confronted with how other people think about these issues.[5]

It is no coincidence that we put culture at the base of the triangle in our illustrative scheme. It certainly is not intended to mean that culture is like 'raw material' for the economy and politics. As we have tried to argue here, culture is rather the foundation

of communal life. To invest in culture is therefore much more than financing 'hobbies', either left-wing or other. Together with education, the cultural sector has traditionally been in charge of the socialization, qualification and subjectification of citizens and that is why it is the foundation of the community. Without that foundation Thatcher's statement that 'there is no such thing as society' might very well be too close to the truth for comfort. In that case we had better speak of the European Market instead of the European Union. And, just to be clear, in that new entity there would be no task for politics either, except that of managing and controlling. Politics as 'the designing force of society' would be rather pointless then, as politicians would only serve to balance the budget, manage things well and look after consumer interests. In a society without an autonomous management of culture, citizens would be no more than consumers of goods and services which the government may or may not provide (probably mostly not).

The autonomy of the social sphere is also the reason why mass consumption cannot be entirely manipulated, precisely because this 'mass' is rather active than passive and, indeed, possesses a subjective cultural power. At the same time it explains why the state or the government has difficulty in the total (or totalitarian) control and rational organization of its political entity, precisely because the social sphere has its own rationality, or, rather, its own rationalities. The social swarming constantly escapes structures of state and market cycles, precisely because it has its own culture, or, rather, multiple cultures. As we know, both advertising and political propaganda try to anticipate that culture, but always seem to come up against its (autonomous) logic and resistance. The misjudgement of culture as an independent social practice is the very reason why political programmes as well as market strategies often fail or run aground because of their wrong assessments time and again.

The continuous political crisis in Europe might be instructive here. At one time, the European Union grew out of political as well as economic motives: after two devastating world wars, lasting peace would be safeguarded by European collaboration and institutionalized political consultations. At the same time, economic collaboration would enhance prosperity and guarantee that Europe could hold its own in competing with the economic superpowers. However, now that Europe is in stormy economic weather and we are taking peace on the continent for granted

(at least in most parts of it), the Union is steadily losing popular support. In northern Europe it can't explain, for instance, why Germans would have to declare their solidarity with Greeks, whereas in southern Europe people feel exploited by the harsh economic measures that the North is imposing on them. According to the philosopher and Europarliamentarian Gianni Vattimo, this is typically a *cultural* problem: while Europe evolved into an economic union in a unilateral and technocratic manner, the idea of a European culture retreated into the background. Politicians lack a shared narrative and common values to appeal to in pointing out the importance of European collaboration (Gabriëls and Lijster, 2013).

Both the political crisis in Europe and the current financial crisis are partly due to a lack of knowledge of culture but also to a lack of investment in it. The debate about an economic or social Europe is lacking a third dimension, the cultural one. Without cultural citizenship there can be no political trust and therefore no political support for Europe. However, as we already noted, a lack of interest in culture also generates mistrust of an economic and monetary union. And, as we also noted before, 'trust' is one of the most important intersubjective values that can typically only come from culture. Everyone knows that a competitive market as well as purely bureaucratic politics or power politics are anything but conducive to relationships based on trust. Technocratically good administration and economically efficient management are not enough to make Europe into a living community. That would indeed take a solid cultural embedding.

Commonism

Various European member states do still have a strong tradition in cultural policy, but the example of the United Kingdom and the Netherlands clearly demonstrates that this is not to be taken for granted and nothing guarantees that it will remain so in the future. The common is constantly threatened by the market and by politics, and that in turn, strangely enough, threatens the functioning of that same market and politics. A sustainable social biotope (we consciously do not address ecological issues here, not because we fail to recognize them, but because it would take us beyond the scope of this book) requires a good balance within the triumvirate culture-economy-politics as outlined before. Both the Rhineland model and neoliberalism can disturb this balance.

A Rhineland model may do so because of too much bureaucracy, slow decision-making or too big a role for politics, leading to over-regulation and smothering of the common. Neoliberalism may do so by overemphasizing the economy, or rather the free market, by competition and a compulsory focus on purely economic growth, thereby delivering the common completely into private hands and making it vanish.

This is why a third option is perhaps worth considering. It is a model which we propose to call, not without risk and loosely inspired on Laermans (2011), 'commonism'. It differs only in one letter from a political system that has been widely vilified in Europe. By choosing it we run the risk of being misunderstood. Still, as we understand it, commonism is not a narrow-minded one-party ideology. Just as the Rhineland and neoliberal model it could shape society though and in that respect it is political-ideological in nature, or perhaps we could say it is 'meta-ideological', as it accommodates multiple party political ideas. For instance, liberalism may reconcile itself with a commonist organization of society if it realizes that both individuals and the market can only be free when this freedom is guaranteed by a collective. Individual freedom can only be optimized when individuals are both stimulated by and can fall back on collective and structurally embedded mechanisms of solidarity. A free market that completely sucks dry the common in a frenzy of competitive accumulation will eventually run itself into the ground. It will absorb its own source, as it were. This is why the free market will always have to be regulated to such an extent that enough flows back into the common. Then again, political parties that are traditionally religiously inspired, such as the Christian-democrats, have always realized that they need a common to make a society, including their own politics, function. We already pointed out the central meaning of Holy Communion in the Roman Catholic tradition. However, it is important that they regard the common in a broader sense than just that of community, the family or their own parish, to meet the globalized conditions of today. The same can be said of nationalistic parties. If they don't recognize that national cultures must deal with globalization trends in which other cultures are constantly transforming their 'own' culture, they will have a hard time maintaining a culturalistic perspective. Reality will soon catch up with them. As to their neo-nationalistic successors, we see how they are strategically

abandoning the controversial blood-and-soil narrative in favour of more technocratic or administrative-technical variations. By accusing other nations or member states of 'bad government' they mainly hope to gain political power and votes, but they don't pay much attention to their 'own' cultural traditions. Any respect from them for commonism as proposed by us could only come from a true re-evaluation of what cultures have in common. Paradoxically, this culture-driven policy appears to be mainly absent in current nationalistic tendencies. Besides, if it surfaces at all, their political convictions make them use it against rather than in favour of Europe. Nevertheless neo-nationalistic parties could gain some advantage from a commonism that indeed embraces dissent and thereby cultural diversity within Europe. At first glance, socialism seems to have a lot of affinity with a commonalistic model, but historically it has focussed too much on the social and too little on the cultural aspect of solidarity mechanisms and equality ideals. Nevertheless culture, as we've argued before, is the foundation from which values such as solidarity and equality are introduced into society. It would in the first place mean a cultural reorientation for socialism if it were to align itself with a commonalistic model. The same may be said of ecologically inspired parties such as the Green parties. Ecological problems and imbalances can only be addressed structurally if a large-scale change of mentality takes place in people, governments and the business world, which means first and foremost a profound change in their culture. The Green parties need to be convinced of the impact they could generate through cultural policy. Finally, communist regimes may be the furthest removed from what we call 'commonism' here. Especially if we look at dictatorial, undemocratic relics such as North Korea or China or at technocratic variations such as the former USSR. After all, such systems frenetically fight, or have fought, the common as we described the concept above. A model of dissent doesn't stand a chance under such regimes. All dissonant voices, on which the common thrives, are expressly placed outside the political order there and labelled as dissidents. This is why a communism could only survive within a commonism if it were to accept the possibility of many singularities. Both the philosophers Negri & Hardt (2009) and Alain Badiou (2009) seem to be looking to re-define communism in that vein, although their efforts have been mostly limited to theoretical exercises so far.

Anyway, our point is that both the Rhineland and the neo-liberal model may have had their day. A new model announces itself, one that claims the interest of the common as the fundamental structure for possible ways of living together. Of course we are aware that this idea is highly speculative, and we do not know enough of political science to provide any concrete administrative advice for this model. However, we are convinced — and no more than that — that a future European constitution will have to include and embrace the common if it is to be founded on anything.

Whichever direction Europe chooses, by negating culture and thereby the social sphere's own logic, the Rhineland model and neoliberalism will in any case run aground sooner or later. Whichever path one chooses, it is relatively certain that one will encounter social barricades, actions and sometimes even blind violence. When the common becomes choked, it can turn really mean. Its internal agonism will then sour into antagonism. Social eruptions as we have witnessed in both the *banlieus* of Paris and the suburbs of London over the past few years, or more moderately in the Molenbeek quarter of Brussels, are painful evidence of that. Of course socio-economic inequalities play a part in these conflicts, but also a lack of recognition of culture. Politicians and journalists sometimes gratuitously call such violence 'meaningless' or 'senseless'. Based on our analysis above we could say that they are right, except for the fact that policy and opinion makers may mean something different by it. In our view, meaningless violence erupts when people are robbed of every meaning. And, as we argued before, culture is an important carrier of meaning. Even more so, it is the only thing that gives meaning to people's lives. Therefore, if the autonomy of culture is threatened, this blocks the possibilities to give meaning to our own existence — through socialization, qualification and especially subjectification. This may sound dramatic, but it is precisely the drama that is inherent in culture. Or, to rephrase it in semiotic terms: nothing is as dramatic as not being able to *signify* oneself or that one's meaning is denied or simply not even noticed by other people. Whether you are a migrant or an illegal (*without papers - without signification*), a single mother or a 'hard-working' freelancer or business manager, if you can't signify yourself you cannot obtain a place within the symbolic order, which within a culture is always also a social order. Depression up to the point of suicidal desperation at the individual level as well as collective manifestations of vandalism

and violence take place at the very edge of the cultural sphere. Both individuals and collectives who feel marginalized will try to regain meaning through physical aggression against themselves or their social environment. They try to become part of a symbolic universe again the hard way, as it were; in short, to want to be recognized or 'signified'. And only culture can provide this right to meaning. Culture is the ultimate signifier, as we have argued several times. It is therefore the most important reason why policymakers at the European level really should fundamentally rethink the ways in which they plan to feed this culture and keep it alive. To put it even more strongly: without a solid cultural policy, European politics will eventually dig its own grave.

Notes

1 www.independent.co.uk/news/world/modern-art-was-cia-weapon-1578808.html

2 See this interview (in Dutch) with science philosopher Trudy Dehue (Rijksuniversiteit Groningen): www.kennislink.nl/publicaties/medicijntests-moeten-onafhankelijk-zijn-van-medicijnbedrijven.

3 Companies are very much aware of this, as witnessed by the growing interest of corporations for 'business narratives' or 'corporate storytelling', meaning the transfer of the meaning and values of the company and its products through narratives, directed at both the employees and business relations.

4 The *locus classicus* of this relationship between economics and culture is of course Max Weber's *The Protestant Ethic and the Spirit of Capitalism* [1904-1905].

5 It is precisely for that reason that Martha Nussbaum stresses the importance of art and culture (and of education in these areas) in her pamphlet *Not For Profit* (2010). For instance, she states: 'Today we still maintain that we like democracy and selfgovernance, and we also think that we like freedom of speech, respect for difference, and understanding of others. We give these values lip service, but we think far too little about what we need to do in order to transmit them to the next generation and ensure their survival. Distracted by the pursuit of wealth, we increasingly ask our schools to turn out useful profit-makers rather than thoughtful citizens. Under pressure to cut costs, we prune away just those parts of the educational endeavor that are crucial to preserving a healthy society.' (Nussbaum, 2010: 141-142).

Bibliography

– Achterhuis, H. (2010) *De utopie van de vrije markt,* Amsterdam: Lemniscaat.

– Adorno, T. and Horkheimer, M. (2009) *Dialectiek van de Verlichting,* transl. by M. Van Nieuwstadt, Amsterdam: Boom [1944].

– Albert, M. (1991) *Capitalisme contre capitalisme,* Paris: Édition du Seuil.

– Ankersmit, F. and Klinkers, L. (2008) *De 10 plagen van de staat,* Amsterdam: Van Gennep.

– Baudet, T. (2012) *De aanval op de natiestaat,* Amsterdam: Bert Bakker.

– Bauman, Z. (1998) *Globalization: The Human Consequences,* New York: Columbia University Press.

– Bauman, Z. (2008) *The Art of Life,* Cambridge: Polity Press.

– Biesta, G. (2013) *Goed onderwijs en de cultuur van het meten,* The Hague: Boom/Lemma.

– Boomkens, R. (2008) *Topkitsch en slow science: Kritiek van de academische rede,* Amsterdam: Van Gennep.

– Bourdieu, P. (1980) 'Le capital social', in: *Actes de la Recherche en Sciences Sociales,* vol. 31, 2-3.

– Bourdieu, P. (1992) *Les règles de l'art: Genèse et structure du champ littéraire,* Paris: Édition du Seuil.

– Bürger, P. (1974) *Theorie der avant-garde,* Frankfurt am Main: Suhrkamp.

– Coleman, J.S. (1990) *Foundations of Social Theory,* Cambridge MA: The Belknap Press of Harvard University Press.

– Corsani, A. and Lazzarato, M. (2009) 'Travailler dans le secteur du spectacle: les intermittents', in: Bureau, M.-C., Perrenoud, M. and Shapiro, R. (eds.) *L'artiste pluriel: Démultiplier l'activité pour vivre de son art',* Villeneuve d'Ascq: Septentrion Presses Universitaires, 35-50.

– De Bruyne, P. and Gielen, P. (eds. – 2011) *Community Art: The Politics of Trespassing,* Amsterdam: Valiz.

– Desmet, M. (2009) *Liefde voor het werk in tijden van management: Open brief van een arts,* Tielt: Lannoo.

– Elias, N. (1994) *The Civilizing Process,* transl. by E. Jephcott, Oxford: Blackwell [1939].

– Featherstone, M. and Lash, S. (1999) *Spaces of Culture: City-Nation-World,* London and Thousand Oaks CA: Sage.

– Florida, R. (2002) *The Rise of the Creative Class... and how it's Transforming Work, Leisure, Community and Everyday Life,* New York: Basic Books.

– Florida, R. (2005) *The Flight of the Creative*

Class: The New Global Competition for Talent, New York: HarperCollins.
- Fraser, N. and Honneth, A. (2003) Redistribution or Recognition? A Political-philosophical exchange, London: Verso Books.
- Gabriëls, R. and Lijster, T. (2013) 'Beyond Metaphysical Realism. An Interview with Gianni Vattimo', in: Krisis: Journal for Contemporary Philosophy, 2013(3), 52-57.
- Gielen, P. (2000) Kleine dramaturgie voor een artefactenstoet, Gent: Dienst Culturele Zaken.
- Gielen, P. (2009) The Murmuring of the Artistic Multitude: Global Art, Memory and Post-Fordism, Amsterdam: Valiz.
- Gielen, P. and De Bruyne, P. (eds. - 2009) Being an Artist in Post-Fordist Times, Rotterdam: NAi Publishers.
- Gielen, P. and Lavaert, S. (2009) 'The Dismeasure of Art. An interview with Paulo Virno', in: De Bruyne, P. and Gielen, P. (eds.) Being an Artist in Post-Fordist Times, Rotterdam: NAi Publishers, 17-44.
- Gielen, P. (2011) 'Mapping Community Art' in: De Bruyne, P. and Gielen, P. (eds.) Community Art: The Politics of Trespassing, Amsterdam: Valiz, 15-34.
- Gielen, P. and De Bruyne, P. (2011) Teaching Art in the Neoliberal Realm: Realism versus Cynicism, Amsterdam: Valiz.
- Gielen, P. (2013a) 'Autonomie als heteronomie', in; Corsten, M.-J. et al. (eds.) Autonomie als waarde, Amsterdam: Valiz.
- Gielen, P. (ed. - 2013b) Institutional Attitudes: Instituting Art in a Flat World, Amsterdam: Valiz.
- Gielen, P. (2013c) Creativiteit en andere fundamentalismen, Amsterdam: Mondriaan Fund.
- Gielen, P. (2013d) Repressief liberalisme: Opstellen over creatieve arbeid, politiek en kunst, Amsterdam: Valiz.
- Gielen, P., Elkhuizen, S., Van den Hoogen, Q., Lijster, T. and Otte, H. (2014) De waarde van cultuur, www.vlaanderen.be/nl/publicaties/detail/de-waarde-van-cultuur.
- Grossi, E. et al. (2012) 'The interaction between culture, health, and psychological well-being: data mining from the Italian Culture and Well-being project', in: Journal of Happiness Studies, 13 (1), 129-148.
- Habermas, J. (1981) Theorie des kommunikativen Handelns, Frankfurt am Main: Suhrkamp.
- Halfmann, W. and Radder, H. (2013) 'Het academisch manifest', in: Krisis: Tijdschrift voor actuele filosofie, 2013(3), 2-18.— Grossi
- Hardt, M. and Negri, A. (2009)

Commonwealth, Cambridge MA: The Belknap Press of Harvard University Press.
- Holden, J. and Jones, S. (2006) Knowledge and Inspiration: The Democratic Face of Culture, London: Demos/MLA.
- Laermans, R. (2002) Het Cultureel Regiem: Cultuur en beleid in Vlaanderen, Tielt: Lannoo.
- Laermans, R. (2011) 'The Attention Regime – On Mass Media and the Information Society', in: Schinkel, W. & Noordegraaf-Eelens, L. (eds.) In Medias Res: Peter Sloterdijk's Spherological Poetics Of Being, Amsterdam: Amsterdam University Press, 115-132.
- Laermans, R. (2011), 'The Promises of Commonalism', in: De Cauter, L., De Roo, R., and Vanhaesebrouck, K. (eds.) Art and Activism in the Age of Globalization, Rotterdam: NAi Publishers, 240-249.
- Lessig, L. (2004) Free Culture: How Big Media Uses Technology and the Law to Lock Down Culture and Control Creativity, New York: Penguin.
- Lessig, L. (2008) Remix: Making Art and Commerce Thrive in the Hybrid Economy, New York: Penguin.
- Lijster, T. (2012) Critique of Art: Walter Benjamin and Theodor W. Adorno on Art and Art Criticism, (doctoral thesis Rijksuniversiteit Groningen).
- Lorenz, C. (2012) 'If You're So Smart, Why Are You under Surveillance? Universities, Neoliberalism, and New Public Management', in: Critical Inquiry, Vol. 38, 3 (Spring 2012), 599-629.
- Luhmann, N. (1997) Die Kunst der Gesellschaft, Frankfurt am Main: Suhrkamp.
- Masschelein, J. and Simons, M. (2006) Globale immuniteit: Een kleine cartografie van de Europese ruimte voor onderwijs, Leuven: ACCO.
- Mandel, E. (1999) Late Capitalism, transl. by J. de Bres, London: Verso Books [1978].
- Mouffe, C. (2008) Over het politieke, Kampen: Klement/Pelckmans.
- Nussbaum, M. (2011) Niet voor de winst: Waarom de democratie de geesteswetenschappen nodig heeft, transl. by R. van Kappel, Amsterdam: Ambo [2010].
- Piketty, T. (2014) Capital in the Twenty-First Century, transl. by A. Goldhammer, Cambridge MA: The Belknap Press of Harvard University Press.
- Rancière, J. (2007) Het esthetische denken, transl. by W. van der Star, Amsterdam: Valiz.
- Rancière, J. (2009) The Future of the Image, Brooklyn NY and London: Verso.

- Rickards, T., Runco, M.A. and Moger, S. (2009) *The Routledge Companion to Creativity,* London and New York: Routledge.
- Rosa, H. (2013) *Beschleunigung und Entfremdung ,* transl. by R. Celikates, Frankfurt am Main: Suhrkamp.
- Savage, M., Bagnall, G. and Longhurst, B. (2005) *Globalization & Belonging,* London and Thousand Oaks CA: Sage.
- Scott, A.J. (2000) *The Cultural Economy of Cities,* London and Thousand Oaks CA: Sage.
- Seigel, J. (1986) *Bohemian Paris: Culture, Politics and the Boundaries of Bourgeois Life,* 1830-1930, London: Penguin.
- Sennett, R. (1998) *The Corrosion of Character: The Personal Consequences of Work in the New Capitalism,* New York and London: W.W. Norton & Company.
- Sennett, R. (2006) *The Culture of the New Capitalism,* New Haven CT: Yale University Press.
- Sennett, R. (2008) *De ambachtsman: De mens als maker,* transl. by W. van Paassen, Amsterdam: Meulenhoff.
- Sloterdijk, P. (2011) *Je moet je leven veranderen,* transl. by H. Driessen, Amsterdam: Boom.
- Stiegler, B. (2011) *For a New Critique of Political Economy,* London: Polity.
- Stiglitz, J. (2013) *The Price of Inequality: How Today's Divived Society Endangers our Future,* New York: W.W. Norton & Company.
- Throsby, D. (2001) *Economics and Culture,* Cambridge: Cambridge University Press.
- Turner, B.S. (2001) 'Outline of a General Theory of Cultural Citizenship', in: Stevenson, N. (ed.) *Culture & Citizenship,* London and Thousand Oaks CA: Sage, 11-32.
- Verhaeghe, P. (2012) *Identiteit,* Amsterdam: De Bezige Bij.
- Williams, R. (1977) 'Culture is ordinary' in: Gray, A. and McGuigan, J. (eds.) *Studying Culture: An Introductory Reader,* London: Arnold, 5-14. Winner, E., Goldstein, Th.R and Vincent-Lancrin, V. (2013) *Art for Art's Sake? Overview,* OECD Publishing.
- Žižek, S. (2010) 'How to begin from the beginning', in: Douzinas, C. and Žižek, S. (eds.) *The Idea of Communism,* London: Verso Books.

An Agora Where Artists and EU Politicians Meet
The Barroso Case

Kurt De Boodt

Rather paradoxically, whenever former European Commission chairman José Manuel Barroso engaged in discussions with artists, he would invariably paraphrase an American president: 'Ask not what Europe can do for you, ask what you can do for Europe.' During the two terms of Barroso's chairmanship, politicians and artists found each other. Agonizingly slowly, the awareness is growing that the European Union, if it is to survive, must not be an exclusively economic and political project but a cultural one as well. European artists and politicians can enhance each other's aspirations. Only, as architect Rem Koolhaas knows from ten years of experience, it is difficult to help the EU. 'In many cases,' says Koolhaas, 'my experience has been that, for all the intelligent people inside the EU, there is a surprisingly large reluctance to do anything. I understand that, of course: politics is extremely complex and coloured and difficult to address at this particular moment. But a certain raw honesty could work wonders in terms of creating an urgency for Europe other than as something that is in permanent crisis and slouched on a couch.'

The European Cultural Community
One of the most frequently quoted one-liners about European collaboration and culture is mostly wishful thinking: *'Si c'était à refaire, j'aurais commencé par la culture'* [If it could be done all over again, I would have started with culture]. The quote is ascribed to Jean Monnet, who, together with Robert Schuman, was one of the main architects of the European Economic Community, but he never spoke these words. Still, it is a nice thought, good for a daydream about a European Community founded on culture, an 'ECC'. José Manuel Barroso referred to this apocryphal term in one of the first speeches he gave as Chairman of the European Commission at the *Berliner Konferenz für europäische Kulturpolitik,* on 26 November 2004. In his first week in office, the Portuguese EU 'President', who would chair the European Commission for ten years, spoke extensively about 'Europe and culture'. He brought his audience firmly down to earth by stating that Jean Monnet knew only too well that European integration would have failed if economy and markets had not been its starting point. The process of European unification started as economic integration. Europe should now consider to what degree it would also integrate politically and, as far as he was concerned, we had reached a point where the European project could also take great

steps forward with regard to cultural integration. He concluded with a one-liner about European unification and culture of which we can always remind him: 'The EU has reached a stage of its history where its cultural dimension can no longer be ignored.'

But then, what was so different from the times of pioneer Jean Monnet? Why could the EU no longer ignore its cultural dimension in 2004? First of all, the largest single expansion of the Union had taken place. On 1 May 2004, almost 15 years since the fall of the Berlin Wall, ten new member states were welcomed, including three Baltic states (Estonia, Latvia and Lithuania), four more countries from behind the now-raised Iron Curtain (Hungary, Poland, Slovakia and the Czech Republic) and two islands in the Mediterranean (Malta and Southern Cyprus). The internal rupture between West and East could finally be mended. During the Cold War, the old continent had taken a step back, licking its wounds in the comfort zone of the power vacuum between the United States and the Soviet Union. The German philosopher Peter Sloterdijk, in his book *Falls Europa erwacht. Gedanken zum Programm einer Weltmacht am Ende des Zeitalters ihrer politischen Absence* (1994) [If Europe Awakes: Thoughts on the Programme of a World Power at the End of the Era of its Political Absence], calls the European institutions that were founded after the Second World War the crutches on which Europe learned to walk again. By 2004, those crutches had evolved into fully developed prostheses and Europe was once more ready to claim its role on the world stage, full steam ahead. The other world players and the citizens of Europe certainly had high hopes, and there was even a draft for a real European constitution that spoke of a 'common destiny'. The European member states had chosen each other and would now move forward together as a branched-out conglomeration of families and in-laws. And so, in Berlin, Barroso openly spoke of a 'cultural identity [that] is made of its different heritages, of its multiplicity of histories and of languages, of its diverse literary, artistic and popular traditions'. Identity – always a tricky theme for politicians who stand up for culture...

A few months earlier, Bernard Foccroulle, then the director of the Belgian Opera De Munt/La Monnaie, had presented Barroso's predecessor Romano Prodi with a petition that was signed by illustrious figures[1] from the artistic scene in Europe: 'For a Europe founded on its culture'. The petition also mentioned the ten new member states, the European constitution and globalization.

Its tone was a lot sharper, however. The artists spoke of a huge crisis on a global scale (the growing gap between poor countries and rich ones), the inequality in developed countries, the rise of nationalism in Europe, the ecological future of our planet, terrorism, insecurity, fundamentalism, and war. The verdict was harsh: 'Europe does not play a central role in the world order... it meets with almost total indifference from European citizens. It is as if Europe was unable to understand the sense of itself, or to prove itself as something more than a supranational bureaucracy.' And so the artists called for (1) a European constitution as a true civilization project; (2) an ambitious European project that was capable of cementing a European cultural identity that reflects both unity and diversity; and (3) new, daring and federation-building initiatives that would serve the European cause, especially its cultural dimension. What is remarkable is that the petition did not address the European Commission as such (which is still more or less the 'government' of the EU) but the heads of state and government leaders of the then 25 member states. With regard to item three, the petitioners expressly addressed the countries that were the most supportive of the unification process. After all, the artists were well aware that not all member states were enthusiastic about a stronger Europe, let alone a Europe that builds on its cultural foundation. Because, well, political jurisdiction over culture is first and foremost the prerogative of individual nations or cultural communities...

What Can Europe Do for Culture?

The best-known cultural activity initiated by the EU is 'European Capital of Europe', which started with Athens back in 1985. The EU also presents several awards: for cultural heritage, architecture, literature, film, and pop music. Nice, but such tried-and-true recipes that rely heavily on visibility do not really make a difference in terms of content. Since 2000, the European Commission provides seven-year subsidy programmes for culture to stimulate international collaboration and support the European film industry.

We mustn't forget that culture has only relatively recently made it onto the European political agenda. The Treaty of Rome (1957) contains not a single paragraph on culture, although its preamble does refer to culture 'as a factor *capable* of uniting people and promoting social and economic development'. The door

towards a European cultural policy remained ajar for 35 years. It wasn't until the Maastricht Treaty (1992) that the Union laid the legal foundation. In the article in the treaty on culture, four sentences delineated the playing field:

> The Community shall contribute to the flowering of the cultures of the Member States, while respecting their national and regional diversity and at the same time bringing the common cultural heritage to the fore.
> Action by the Community shall be aimed at encouraging cooperation between Member States and, if necessary, supporting and supplementing their action...
> The Community and the Member States shall foster cooperation with third countries and the competent international organizations in the sphere of culture...
> The Community shall take cultural aspects into account in its action under provisions of this Treaty, in particular in order to respect and to promote the diversity of its cultures.

The rather tentative phrasing – 'bring to the fore', 'encourage', 'foster', 'take into account' and especially the almost apologetic 'if necessary' – leaves little doubt: the ball remains in the member states' court. Culture is a *complementary* authority of the EU and this should be taken literally: the EU, if necessary, does only what member states can't or won't do. Which applies in the first place to encouraging international collaboration, both within and outside the borders of the Union and the European continent. Harmonizing the cultural policies of the member states is simply not an option. Culture may play a part in other domains of EU policy. Where there is a political will, there's a way...

However, there is little room for manoeuvring: decisions about culture must be ratified, unanimously, by the European Parliament and the European Council. In 2005, the European constitution met with a resounding njet in both France and the Netherlands. The big 'European civilization project', for which the European artists had urgently pleaded in their petition, didn't get off the ground. The Treaty of Lisbon (2007) offered a consolation prize: it literally adopted the article on culture (which is now article number 167). The preamble emphasized the European heritage and common values more strongly by stating that the Treaty draws 'inspiration from the cultural, religious

and humanist inheritance of Europe, from which have developed the universal values of the inviolable an inalienable rights of the human person, freedom, democracy, equality and the rule of law'. Instead of unanimity, 'Lisbon' introduced the notion of Qualified Majority Voting in the European Council. The national veto on culture was softened somewhat, at least concerning decisions about the range of subsidy programmes. In 2007, the Commission formulated a European cultural strategy for the first time: 'The European Agenda for Culture in a Globalizing World'. There were three priorities:

1 Cultural diversity and international dialogue
2 Culture as a catalyst of creativity in the framework of
 the Lisbon Strategy for Growth and Jobs
3 Culture as a vital element of the Union's
 international relations

This agenda also aimed to initiate a structured dialogue with the cultural sector and stated its belief in a transversal principle known as 'mainstreaming culture in all relevant policies'. Politically, the document constituted an extended hand to the cultural sector. It at least confirmed that the European Commission meant to take culture seriously, or more so. In relation to the Treaty, there was nothing new under the sun, as its legal provisions restrict what the Agenda for Culture may contain. Note the emphasis on the economic aspect (priority 2): growth and jobs. It seems to me a mainly pragmatic approach: as an economic union, on behalf of a complementary authority such as culture, by all means do the things in which we are competent (or should be competent). The seven-year funding programme was given a telling new name: 'Creative Europe'. True, in Eurospeak the broad cultural field is labelled 'Cultural and Creative Industries' (CCI). Targets such as 'smart, sustainable and inclusive economic growth' and opening 'new markets' have become buzzwords in the communication of 'Creative Europe'. However, when artists from the so-called 'core arts' criticize the EU for reducing culture to the creative economy and artists to producers of merchandise, they seem to be shooting from the hip. In my opinion, such criticism demonstrates a lack of knowledge of the complementary competence at various administrative levels, ranging from municipalities and cities to federal states, nation states and the European level.

As for the third priority, culture in international contacts, the previous Commission and Council didn't really do their homework. For example, the European External Action Service, under the High Representative of the Union for Foreign Affairs and Security Policy, did not take any cultural initiatives.[2] There was no European cultural representation in countries outside the EU, although it is exactly there that the EU can really shine in its complementary role in cultural policy. Within the context of a globalizing world with many competitive countries, regions and transnational conglomerations, the EU should take the lead and do more than just support its member states. The conclusion of the Executive Summary of the Preparatory Action 'Culture in EU External Relations' is quite clear: 'In a nutshell, the report reveals considerable potential of culture in the rapidly changing and multi-polar world of the twenty-first century. The failure to maximise on this potential now would be a huge missed opportunity for Europe.'

What Can Artists Do for Europe?

Over the past few years, many artists have risked their necks for the European cause. Thematic years such as the 'European Year of Intercultural Dialogue 2008' and the 'European Year of Creativity and Innovation 2009' brought together a fine group of cultural ambassadors. There was no shortage of advice and manifestoes. Think tanks came up with ideas for the long term. For example, a group of intellectuals led by Lebanese writer Amin Maalouf advised the European Commission on 'the contribution of multilingualism to Intercultural Dialogue'. Two other initiatives outlined what artists could do (and were willing to do) for Europe. Artists can contribute content to the debate and they can do what they are experts at: create images and tell stories.

As early as the pre-Barroso years, the European Cultural Foundation invited a number of historians and artists to reflect on the same broad subject: *Europe as a Cultural Project (2002-2004).* An extensive report was produced with recommendations for the member states and the European institutions as well as for international cultural networks, foundations and cultural operators. In his personal contribution, Dutch historian Geert Mak argued for a European 'agora': 'In our Reflection Group, we kept coming back to the same point: that without meeting places and coffee houses, any further political process will be left hanging in the

air. Without such debate, Europe will continue to be just a flow of catchphrases, a democracy in name only, but in reality a *grand ennui*, with no stories to tell, no discussion, and no public drama. The lack of shared attitudes to life creates an intellectual inertia which ultimately could bring down the entire European Union. This makes democratic and cultural dialogue within Europe – I intentionally avoid the word 'unification' – a matter of the greatest urgency. In the current situation, European 'culture' is no longer the icing on the cake, but rather a vital condition for survival.'

The European Film Academy brought together a group of more than twenty filmmakers in the think tank 'The Image of Europe', under the auspices of President Barroso. It was time to 'consider another lingua franca, the language of the images', said Volker Schlöndorff, the German director best-known for his adaptation of Günter Grass' novel *The Tin Drum*. The group called for member states to include film and visual language in the curricula of primary and secondary schools, on the same footing as literature and the written word. The filmmakers also offered the European Commission their help 'in shaping the future of European cinema as part of European identity'. Wim Wenders, President of the European Film Academy, exclaiming 'He is only too right!', wholeheartedly endorsed José Manuel Barroso's call: 'We have to concentrate more on the emotional side of Europe. Cinema can help us to create an emotional relation. Through cinema we can indeed speak about the European dream and we can develop it together.'[3] Europe has an image problem, says Wenders. The multifaceted images of Europe evoked by filmmakers do not correspond with what Europe is supposed to represent. The utopian dream that Europe was synonymous with fifty years ago and that briefly seemed to gain momentum again with the fall of the Berlin Wall, was gradually giving way to lethargy and scepticism. The think tank of filmmakers refused to give in to such pessimism: 'These filmmakers were dedicated Europeans, we seemed to know exactly how much Europe meant to us. Europe was present, alive, wanted and needed in our midst. Why was it, why *is* it that the Directorate General which is responsible for Communication isn't counting *more* on us, isn't using *us*, the specialists, if you want, when it comes to European imagery and storytelling? Why did we have to impose us, lift our fingers and say: "Hey, we're here, we're good at this! Emotional communication is our business!" As freethinking artists, these filmmakers did not shy away at all

from being 'instrumentalized', a knee-jerk reflex that can often be observed in the cultural sector whenever policymakers come too close. The European Dream is out there! Moreover, says Wenders, who has lived and worked in the USA for many years, the American dream is founded mainly on the hopes and projections of European migrants. He adds, 'Why then was there never a European equivalent of this "American Dream"? Wouldn't the time have come to start dreaming it, at least when the Americans had stopped doing so? (When was that? After the Great Depression? The Vietnam War? Watergate?) But no, there has never been talk of the "European Dream". The subject was already covered – by the cinema, by the world of moving pictures. Right from the start.'[4] Whereas American filmmakers unitedly flaunted the collective dream, the 'European cinema' that developed in parallel with it remained the sum of small national film industries. At the same time, however, this diversity and specificity is its strong point. 'European cinema,' says Wim Wenders, 'is luckily not just one but it is composed of many voices and these voices have something in common that we proudly call European cinema. A lot of people over the years have asked the question "does it exist or isn't it just the sum of all the national cinemas?" – It is more than the sum. The sum is already quite a lot but European cinema is much more with its language of its own with its own rules and its own history. A very distinct language... that Hollywood learned a lot from over the years... European films have a tradition of being very specific, you find few European films that take place nowhere or anywhere. They take place in a certain location, they have a certain language. They are located in a specific place.'[5]

Cultural Policy Advisors

President Barroso's experience with the model of 'The Image of Europe' encouraged him to launch a broader cultural initiative. The economic crisis had made this even more urgent. If Europe had an image problem, it could not ignore the cultural dimension. And so it came to be that I, being a policy adviser to the Brussels Paleis voor Schone Kunsten (The Fine Arts Palace) accompanied my boss Paul Dujardin – CEO & Artistic Director of same and administrator of numerous cultural organizations and networks – to a meeting in the President's office, in late January 2010. The European President does not wear a crown; you are not sworn to secrecy about anything discussed with him. It is an open secret,

by the way, that Barroso is a keen concertgoer, opera lover and exhibition visitor. Culture to him means more than just relaxing after hours and he sincerely values inspiring late-night discussions with, for example, Daniel Barenboim, after a concert by the West-Eastern Divan Orchestra. Many artists can testify to this: Barroso knows what he's talking about. Culture to him is no obligatory political thing. His message that afternoon essentially was that he felt the time had come to emphasize and publicize Europe's added value: modernity, diversity, Europe as a space that is not an island. He was not pessimistic about this. Cultural consumption in the EU was going well; the only thing that was missing, or was at least not visible enough, was the European dimension of culture. He therefore envisioned that during his second mandate as Chairman of the Commission there would be an initiative to mobilize networks of artists in such a way that it would appeal to European citizens. Something along the lines of 'The Image of Europe', but broader in scope, with artists from various disciplines.

However, all this must go through the proper administrative channels and the Directorate General for Education and Culture must be involved. The Chairman of the Commission may ask for official advice through the Bureau of European Policy Advisors (BEPA). This advisory agency, which is interdisciplinary in nature and is staffed by EU officials, was founded in 1989 by Jacques Delors as the Forward Studies Unit. Under Romano Prodi, this group, now called Group of Policy Advisors (GOPA), concerned itself with four domains: economy, social affairs, foreign policy, and, more surprisingly, dialogue with religions. At the start of his second mandate, Barroso reorganized BEPA to become an interdisciplinary agency, so that he could also seek external advice on 'developments and trends that are relevant to policy-making in the medium and long term'. It is to Barroso's credit that he did not only, for instance, commission Professor Mario Monti to write a report 'containing options and recommendations for an initiative to relaunch the single market as a key strategic objective of the new Commission', but that he also put culture on BEPA's agenda. He could easily have left the matter to his Cypriote Commissioner of Culture and her department. The European mill grinds slowly and many practical difficulties and scheduling problems had to be overcome, but eventually two meetings took place on the top floor of the Berlaymont Building, attended by artists and representatives of the cultural world

and presided over by Barroso and European Commissioner Androulla Vassiliou.[6] The European *agora* Geert Mak had dreamt of was gradually forming, albeit in private company and behind closed doors.

The first meeting's agenda featured four themes: The Image of Europe, Cultural Actions in the World, Digital Shift & New Technologies, and Patronage. Quite a lot for what was a relatively short meeting. I remember specifically Luc Tuymans' statement that culture is not only inclusive, which is primarily a concern of cultural mediators, but that art — his art anyway — wants to be exclusive. Exclusivity means quality, excellence, relevance, anticipation. Besides, the art market is founded on the idea of the exclusive, if nothing else. Or, flippantly: 'I live from the 1% of Americans who have the money.' Apart from market value, Europe should learn to be exclusive again and speak of itself decidedly and with strong images. Which is not achieved by printing Euro notes that feature fictional bridges so as not to offend any individual member states. Otherwise, we would have seven different notes for 12/18/... Euro countries. Rem Koolhaas likes looking at Europe from the outside, for instance from the perspective of China. In China, people do have 'a very defined perception of European culture'. Over there they are convinced that European culture has a lot to offer (to them). It's just that 'The EU is unbelievably difficult to help'. It's structures are too cumbersome, its procedures too slow. Artists quickly feel 'disarmed' and find their own way regardless, across borders, both inside and outside Europe.

At the second meeting, Bernard Foccroulle countered this by stating that artists also often had difficulty finding the right balance between their personal artistic approach and their position in the world, for example when it came to taking part in political debates. Not all artists are drawn to societal discourse or have a talent for it. According to Foccroulle, culture may lend both a realistic and a symbolic (through projects and actions) dimension to Europe. Artists are often conspicuously absent at cultural debates at the EU level, added Birgitta Englin. Apparently, someone completely forgot to invite them... The fact that these roundtables with artists took place at a high level at all, and that the extended hand was that of the Chairman of the Commission, was part of the initiative's success. At the second meeting, now that more of the participants had had the opportunity to voice their opinions, there was a growing need to decide on a

concrete and structured plan. As Luc Tuymans stated, 'Culture must be given back its authority through and within the project. Something structural needs to be done.' Barroso understood. In concluding the meeting, he announced that he would take decisive steps in 2013, the Year of the European Citizen: 'Let's do something formidable. Let's create a platform, an Agora — which means "square" in Greek but also "now"' in Portuguese — to communicate, where women and men from culture debate Europe and where we all engage with citizens in a serious conversation about the future of Europe.' Geert Mak nodded affably.

Then there was a fortunate instance of serendipity. It turned out that Euro-parliamentarian Morten Løkkegaard had similar plans. He felt that Europeans were ready for a revamped narrative of who they were, where they were coming from and in which direction they were going. It was not up to politicians and bureaucrats to articulate this new European chapter, but to artists and scientists: 'Those in the world of culture have to speak up and take their part of the responsibility for Europe.' Løkkegaard presented his 'A New Narrative for Europe' during the 2012 budget negotiations in the European Parliament. Forces were united. Said Løkkegaard, 'It was then that President Barroso's office called and asked if the President could join us. It is the first time in modern European history that a political leader at the very highest level has become personally involved in a "soft policy" area such as this.'[7]

A New Narrative for Europe

Why a new narrative? Not because the 'old' post-WWII European narrative is no longer valid, but because it is no longer self-evident to the youngest generation and because the world has completely changed, sixty years on. That 'old' narrative, 'peace through economic integration', was awarded the Nobel Peace Prize, as a reminder from Sweden.[8]

It is a stressful narrative at that. Total peace remains elusive. The war in Yugoslavia in the 1990s and a sizeable European arms trade partly contradict the story. At the edges of the European continent, there is war in Syria and Ukraine, and the Israeli-Palestinian conflict festers on. The island of Cyprus is literally divided into South (the EU member) and North (the Turkish territory). Its capital, Nicosia, is intersected with a buffer zone of barbed wire. The EU and globalization do not automatically bring

prosperity, at least not in equal measure everywhere. Europe as a union of values remains an ideal. Barroso: 'So we have to give a telos, a renewed sense of purpose, to European integration in the age of globalization, and to reflect on how we can move towards it. In this process, European citizens should be inspired by the great achievements of European culture and history and also be stimulated by new ideas and new projects that can help us rise to the challenges of the 21st century.'[9]

The vicissitudes and process of the entire New Narrative pilot project have now been extensively documented in the book *The Mind and Body of Europe: A New Narrative* (2014).[10] The Commission set up a cultural committee of some twenty cultural personalities[11] who kept the pilot project on track and signed a joint declaration, 'The Mind and Body of Europe'. The backbone of the project consisted of three General Assemblies with a broad spectrum of participants, together consisting of 600 people, at which President Barroso was always present, sometimes accompanied by highly-placed politicians. Among these were, in Warsaw, Donald Tusk (then Prime Minister of Poland, now President of the European Council, succeeding Herman Van Rompuy); in Milan, Prime Minister Enrico Letta; and in Berlin, Chancellor of Germany Angela Merkel. Both Warsaw and Berlin are symbolically charged locations in recent European history. It is striking how politicians approach the need for a European narrative from their own experience. Donald Tusk, who took his first steps in politics with Solidarity, no longer has faith in grand narratives: 'Today, we live on the ruins of all those great ideas of the 20th century... We, the people of Solidarity and the then democratic opposition, did not strive to deliver a new world on the debris of the past, nor did we want a new order, understood as an ideological project. Instead, we strove towards ideas we were ready to accept, even though they were in fact old-fashioned. Maybe they were not as old as the world itself, but they were at least as old as modern Europe: freedom under a constitutional government, equality before the law and pluralism.' Being Portuguese, Barroso knows only too well what a dictatorship is like. This has certainly influenced his European thinking and actions. At these Assemblies, not only politicians spoke but artists, philosophers, scientists, and cultural opinion leaders as well. Personalities such as György Konrád, Elif Shafak, Jürgen Habermas, Alicja Gescinska, Jean-Marc Ferry, Stefano Boeri, Rem Koolhaas, Olafur Eliasson,

Michelangelo Pistoletto, Jimmie Durham, Luc Tuymans, Okwui Enwezor, and Placido Domingo. The New Narrative Project was a fine exercise in listening and debating among people from various backgrounds who did not always speak the same language. By which I particularly mean the political discourse versus a more cultural or philosophical way of expressing oneself. Not that the gap is unbridgeable; it just takes time and willingness to listen if we are to understand each other better. It requires getting closer.

True, the Berlin declaration is mainly written in the language of the Eurocracy. Rhetorically, the text alternately speaks of Europe as a 'state of mind' and as a 'political body'.[12] The text brings to the fore two cultural ideals — renaissance and cosmopolitanism — as 'vital parts of the Europe of today and tomorrow' but otherwise hardly resembles a manifesto drawn up by artists. Or, as the architect Pier Paolo Tamburelli phrased it during a discussion in Brussels at the Palace for Fine Arts on 21 May 2014: 'It looks and sounds very much like the European Union. It's very institutional. As if the one thing the European Union didn't want was conflict.' He argued for a sharper discourse that dared to incorporate more conflictual issues: 'What is missing, and what could perhaps be introduced, is a certain nastiness.'

But that, obviously, was not the idea. The point of the exercise was to present a positive narrative of values worth striving for, a narrative of a rich cultural heritage and of a revitalized 'meaning'. The narrative was supposed to be a response to the populist form of Euroscepticism — invariably aimed *against* Europe — that advertised its message through emotions. What mattered most of all was mobilizing the pro-European voices which, for a variety of reasons, remained silent. Barroso appealed to them in his 2012 State of the Union: 'I expect all those who call themselves Europeans to stand up and to take the initiative in the debate. Because even more dangerous than the scepticism of anti-Europeans, is the indifference or the pessimism of the pro-Europeans.' The think tank of the European Film Academy had already demonstrated that many artists were pro-European, at least when it came to the underlying European dream and spirit of openness. At the same debate in Brussels, Sneška Quaedvlieg, Secretary General of Europa Nostra, revealed a little about the ideas behind 'A New Narrative': 'I think all of us who are here don't want the European story to end, and in fact this whole process, I mean the New Narrative project, is reacting to the nastiness around us that is

destroying all the achievements of the integration process. It is about communicating about the European integration in positive terms, in terms that celebrate its achievements, and attack its failures and the causes of these failures. That nuanced approach is key to bridging the gap between politicians and citizens.'

But then, aren't artists and intellectuals contrary and free spirits by nature? Shouldn't we be wary of the danger of instrumentalization or even a mild form of propaganda? Critical spirits are not that easily enlisted. It sends out a strong signal when a writer such as György Konrád, who has had first-hand experience of dictatorship in Hungary, clearly speaks out in favour of constitutional limitations imposed by the EU on national sovereignty: 'Behind a proud façade of national sovereignty the state under Hitler and Stalin did what it liked with the population. I would welcome it if being a part of Europe meant that the power of national political leaders was curbed from above and from below. I would like to know that for many years to come the history of my homeland would not bear the stamp of approval of just a single person. I think it would be a good thing to limit the national local political class, because I do not trust them too much.'[13] In 'Warum Europa', Konrád too mentions the crucial role of the intelligentsia in the debate. We still need counterbalances, voices that speak with authority without aspiring to be part of the ascendant political power. Such independent individuals do not have to pay lip service to, for example, a political party. Advisers are people who are invited for discussions. They have an opinion on matters of public interest, but they don't owe their position to elections or appointments. According to Konrád, 'We need outstanding thinkers, scientists and artists whose opinions, unanimously agreed around the table, are of interest to public opinion. We need points of view whose importance is determined not by how many people support them, but by the argument itself and the spiritual and moral authority of those expressing it.'[14] In her contribution, 'Intellectuals, Populist Rhetoric and Democracy', the philosopher Alicja Gescinska calls intellectuals 'the watchdogs of democracy'. Of course, artists and intellectuals are only too human and have not always used their position in the most admirable way. Art, philosophy and totalitarianism, modernism and fascism[15] have proven not to be irreconcilable. On the other hand, freethinkers are often the early targets of both left- and right-wing totalitarian regimes. Today, the EU countries are sufficiently adequate liberal democracies, otherwise

they would not have been accepted as members. What is most needed is a firm counterweight against rising extremist and populist tendencies. Alicja Gescinska summed up the situation by saying, 'As political positions, extremism and populism lack three things that are part of a real intellectual debate, and part of what is required to make democracies work: the capacity to develop nuanced views, the capacity to reach compromises through dialogue and the capacity to be modest.'[16]

The New Narrative project's value lies primarily in the fact that it is taking place at all, that the hand was extended, said Alicja Gescinska at the launch of the accompanying book in Brussels. The importance of the Declaration and of the book with its multitude of voices is that they exist at all and that others may build upon them. Criticism has already been partly added to the book, in addenda and the many individual contributions. Says Stefano Boeri, 'That insistence on what it means to be "European" is for me one of the weak points of the Declaration. If you want to strengthen European identity, nothing is more useless than to focus on European identity! What appeals to me, conversely, about the New Narrative and about President Barroso's idea is that it seems to be a new version of the Republic of Ideas. Francesco Cavalli suggested that the Declaration could function as a sort of virus, and in a similar vein I would say that it can function as a catalyst, a platform of cultural exchanges across languages, disciplines, practices, etc.'

How to proceed? Luc Tuymans keeps urging for a tangible and 'visual' response to Barroso's question. The visual arts throw light on the same complex and multi-layered subjects that politics has to deal with. One idea, he says, would be a 'Documenta for Brussels', to be held every five years: 'Rather than lay out an artistic agenda, we invite the EU to create the physical and logistical framework within which artistic debate can thrive and be celebrated on its terms. Were the EU to translate this right to freedom of expression into a large-scale, recurrent exhibition of contemporary art in Brussels, the fields of art and of politics would both benefit.'[17]

Unlike Luc Tuymans, Olafur Eliasson emphasizes the inclusive element of the cultural model in his 'New Narrative' contribution 'Your Inner We'. He believes in the power of culture to bring quite diverse people together without polarizing or ignoring individual differences. In his view, culture may become a 'reality

producing machine' that strengthens inter-European ties. Eliasson practices what he preaches. In the build-up to the European elections of 2014 he expressed his ideas with a work of art that took up the entire front page of the Danish newspaper *Politiken*. The front page had the Danish words *Dit* (Your) and *vi* (we), while on its opposite side, written in reverse right between those words, was the word *indre* (inner). You had to hold the page up against the light to be able to read the full phrase. Eliasson opened up a whole field of meaning of small and big 'we's', of individual and collective identities, between the unfolded newspaper and the readers. In his own words, Eliasson produces an abstract meeting between individuals and Europe: 'There are large "we's" and small "we's", static and transformative "we's". A major challenge for the EU is its lack of "we" feeling. We can't take a European "we" for granted. The sad truth is that the European "we" is not doing well at all. I think it has been assumed, implicitly, that the economic advantages of having a common market would convince everyone of the EU's *raison d'être*. The quantifiable aspects were mistakenly pushed to the forefront of the European project as the main reasons for identification. But bonds are not created through economic incentives alone. Identity does not simply grow from shared prosperity. Feelings of identity and identification with others require culture, history and trust. If we are to create a European "we" for the future, we have to include culture and historical awareness – not as the only valid "we", not as an exclusive "we", but as one that includes many other "we's" that we are also part of – in nation states, cities, work, families. The European "we" cannot operate at the expense of the other "we's"; it has to embrace them and, paradoxically, use them as a stepping stone.'[18]

Michelangelo Pistoletto, too, translates his ideas on European citizenship into an image. In the hall of the architecturally nondescript Justus Lipsius building that houses the European Council is his symbol for 'the third paradise'. Between the two loops of the mathematical symbol for infinity, which in his view represent the natural and artificial orders, Pistoletto has placed a larger, third circle, representing the finite world in which we somehow have to realize our future: the third paradise. According to Pistoletto, 'The two external circles of the *Third Paradise* signify, alternately, nature and artifice: one is the natural paradise where human beings were fully integrated into nature; the second is the artificial paradise that has brought us to the achievements

of the modern era, but also to the social and environmental degradation we are sinking into... Paradise comes from an ancient Persian word meaning "protected garden". Europe is our garden. We gardeners must take care of its landscape, of the natural biodiversity as well as of the environment developed by humans — different languages and traditions, and scientific discoveries and new technologies — in an effort to develop the sense of creative balance between nature and artifice that promotes sustainability in all areas of life.'[19]

'We Europeans... A European garden... A new Renaissance... Cosmopolitanism...The mind and body of Europe...' At the interface between thinking and acting, between telling and imagining, artists contribute to shaping the new chapter that European citizens should be writing together. A strong collective narrative can only benefit from critical and, yes, even Eurosceptic voices. Indifference, lethargy and an excruciatingly slow bureaucracy are much more damaging to a communal drive.

Notes

1 Among the first 100 signatories were Claudio Abbado, Cecilia Bartoli, Maurice Béjart, Pierre Boulez, Peter Brook, Patrice Chéreau, Hugo Claus, Alain de Botton, William Forsythe, Ken Loach, Amin Maalouf, Antonio Muñoz Molina, Cees Nooteboom, Wolfgang Rihm, Esa-Pekka Salonen, Wislawa Szymborska, Toots Tielemans, Jordi Savall and Sasha Waltz.

2 On behalf of the European Commission, The Preparatory Action 'Culture in EU External Relations' conducted an extensive study in 54 countries. The report formulates 12 operational recommendations and 8 key messages, pointing to such issues as the great potential of culture in international relations, a greater demand for more and better European cultural relations in the world and the need for a coherent strategy founded on 'listening, sharing, imagining and creating together, rather than individual national cultures in a purely representational logic'. www.cultureinexternalrelations.eu

3 Wim Wenders (2009) European Culture Forum, Brussels, 29/30 September 2009, closing speech.

4 Wim Wenders (2007) 'The Image of Europe. Identification and Representation', at the conference *A Soul for Europe,* Discourse on Europe, Brussels, 11 June 2007.

5 Filmmaker Wim Wenders ' Film is a language that can be taught', European Parliament, 28 October 2010.

6 On 8 November 2011, with Paul Dujardin, Vasco Graça Moura, Rem Koolhaas, Frédéric Martel, Radu Mihaileanu, Pere Portabella, Jordi Savall, Malgorzata Szczesniak, Luc Tuymans, Emilio Rui Vilar, Krzystof Warlikowski and Patrick Zelnik. On 17 September 2012, with Jorge Barreto Xavier, Dulce Maria Cardoso, Joana Carneiro, Emmanuel Demarcy-Mota, Paul Dujardin, Birgitta Englin, Jan Fabre, Rose Fenton, Bernard Foccroulle, Rosie Goldsmith, Vasco Graça Moura, Claudie Haigneré, Péter Inkei, Rem Koolhaas, György Konrád, Geert Mak, Mary McCarthy, Radu Mihaileanu, Michelangelo Pistoletto, Pere Portabella, Jordi Savall, Luc Tuymans and Björn Ulvaeus (one of the B's in Abba).

7 Morten Løkkegaard (2014) 'The Need for a New Narrative', in: *The Mind and Body of Europe: a New Narrative,* Brussels: European Commisssion.

8 In its press release, the Nobel Prize Committee mentioned the financial crisis in one and the same breath with the process of economic and political unification: 'The EU is currently undergoing grave economic difficulties and considerable social unrest. The Norwegian Nobel Committee wishes to focus on what it sees as the EU's most important result: the successful struggle for peace and reconciliation and for democracy and human rights. The stabilizing part played by the EU has helped to transform most of Europe from a continent of war to a continent of peace.' In his acceptance speech, delivered together with the President of the European Council, Barroso stressed the international force of art and science: 'As a successful example of peaceful reconciliation based on economic integration, we contribute to developing new forms of cooperation built on exchange of ideas, innovation and research. Science and culture are at the very core of the European openness: they enrich us as individuals and they create bonds beyond borders.'

9 José Manuel Barroso (2014) 'Interweaving Narratives', in: *The Mind and Body of Europe: a New Narrative,* Brussels: European Commission.

10 http://issuu.com/europanostra/docs/ the-mind-and-body-of-europe (The book also contains some visual interventions)

11 Kathrin Deventer, Paul Dujardin (chair), Olafur Eliasson, Rose Fenton, Cristina Iglesias, Michal Kleiber, Gÿorgy Konrád, Rem Koolhaas, Morten Løkkegaard (observer), Yorgos Loukos, Peter Matjasic, Sir Jonathan Mills, Michelangelo Pistoletto, Plantu, Sneška Quaedvlieg-Mihailovic, Tomas Šedlacek and Luisa Taveira.

12 In other words, Europe is equated here with the European Union of 28 member states, while the European continent has 51 countries and the Council of Europe has 53 members, including Russia and Turkey. In my opinion, this ambiguity of the notion of Europe should be more strongly expressed in the narrative.

13 György Konrád (2013) 'Warum Europa? ', in: *Debate on the future of Europe,* Brussels: European Commission, 11-07-2013. http://ec.europa.eu/debate-future-europe/new-narrative/contributions-comments/articles/gyorgy_Konrád_en.htm

14 Ibid.

15 Roger Griffin (2007) *Modernism and Fascism: The Sense of a Beginning under*

Mussolini and Hitler, London: Palgrave
Macmillan.

16 Alicja Gescinska (2014), 'Intellectuals,
Populist Rhetoric and Democracy', in: *The
Mind and Body of Europe: a New Narrative,*
Brussels: European Commission.

17 Luc Tuymans and Tommy Simoens (2014)
'Healing symbolic trauma: what the EU
can do about its identity with the help of
the visual arts', in: *The Mind and Body of
Europe: a New Narrative,* Brussels:
European Commission.

18 Olafur Eliasson (2014) 'Your Inner We', in:
*The Mind and Body of Europe: a New
Narrative,* Brussels: European
Commission.

19 Michelangelo Pistoletto (2014) *'The Third
Paradise', The Mind and Body of Europe: a
New Narrative,* Brussels: European
Commission.

2018:
The End of Europe

Anoek Nuyens

Here I go again. I'm in Brussels, and I'm lost. What else is new? I've put my iPhone back in my coat pocket, since it tells me the location I am looking for doesn't exist. Fortunately, there are also some real people about who know their way around and the second one I ask for directions is only too happy to help out. Over there, behind that door, that's where it is. I go to the door, open it and take a seat in a waiting room. After a few minutes, it is my turn. I get up, walk through a hallway and find myself in a maze of small and large rooms, some empty, some filled with all kinds of stuff, manuscripts and objects. The building I have entered is like a museum, but different. It is a museum from another era. I am a visitor from the year 2060, looking back on the rise and fall of the European Union.

Paying attention to every detail, I go through this history, which began in 1958, when the European Union was founded as a peace project by six nations. I look at photographs, I read descriptions and move closer and closer to our own time. 2014, 2015, 2016... up till 2018. That's when things went wrong and the European Union was blown to smithereens. Finished, done. The euro went bankrupt. Framed euro coins and euro notes hang on the wall, next to photographs taken at the European Parliament in Brussels that look like nostalgic portraits. The consequences of '2018' are painstakingly described: rising food prices and, eventually, a massive wave of suicides all over Europe. Everything is presented here very precisely and with great imagination, on the edge between fact and fiction, without becoming implausible.

The exhibition *Domo de Europa Historio en Ekzilo* was made by the Flemish theatre-maker Thomas Bellinck. Besides drawing a general audience in Brussels, the exhibition was also visited by some prominent members of the EU Parliament, including Guy Verhofstadt, leader of the Liberal Fraction and freshly named candidate for the Presidency of the European Commission. From what I hear, Verhofstadt left the exhibition gesticulating in excitement. What he had seen here was what he had been trying to say for years now. And he had always failed. 'This', he said, 'is so much better than how politicians can say it.' But what was that 'it'? What did this work of art about Europe show, that he, ex-prime minister of Belgium and died-in-the-wool EU parliamentarian, was unable to express?

Actually, what Bellinck does here is quite simple: he shows Europe in transition. He does so by presenting Europe's genesis.

He starts in the past, arrives in the present and ends with a not unthinkable future scenario. He shows us what will happen if we do not fight for Europe, while at the same time making us think about the inhumanity of the current European migration policies, to name but one example. He shows us old ideals, but also how these ideals have evolved into realities with devastating consequences, such as our consumer behaviour. This is not propaganda, not for or against something. What Bellinck does is to show how Europe is at a crossroads at this point in history. He presents Europe to his audience and asks the crucial question: What are we going to do about it? Are you going to fight for it or are we going to let it go bankrupt?

Europe is only one of many subjects and issues that are currently at a tipping point. Ever since the current economic crisis began in 2008, our faith and trust in the present economic system have been profoundly shaken. Things that used to provide us with security and stability, such as jobs, houses and money in the bank, suddenly turn out to be unstable and a source of anxiety. This anxiety is expressed in various ways. A part of society has started looking for alternative certainties and appears to be moving in a mostly inward direction: to what is known, what is safe and familiar. Others see the crisis — and the imaginary open spaces created by large-scale cutbacks — as an opportunity for new initiatives. Many of these initiatives are characterized by being small-scale, local and sustainable. This may sound insignificant, but combined, these initiatives most definitely influence the relationships between citizens and companies and between citizens and government.

New initiatives are not only born from practical necessity. They also have an idealistic side: a longing for transparency — to know where something came from, to understand the production process and in that way make sure that something like the housing bubble, which started the economic crisis, cannot occur again. Personally, I kind of like these small-scale initiatives, if only because of the messages I receive on Peerby. *Dear Anoek, your neighbour Elien, who lives three blocks away from you, needs a chainsaw.* Still, I cannot imagine a society that is completely fragmented into small-scale networks, as there are also big stories, all-encompassing themes, transitions and upheavals that we need to discuss as a community at large. Our future is about finding the right balance between the big and the small, between humans and systems, between dreams and reality.

And this is where artists come in. In these times of transition, artists are the wheel greasers who move about everywhere. For a while, I thought that artists were the binding agents between the big and the small, between the inwardly and outwardly directed movements. Lately, however, I have become increasingly convinced that artists are not making links but are building imagination. Artists can provide insight into grand and complex future scenarios and transitions. Modern theatre-makers can provide the community with tools by imagining worlds, and in doing so bring Europe as a theme closer to the people again. Not by shouting propagandistic slogans, not by putting forward their own opinions, but by calling Europe into existence by imagining it. Imagination is crucial. If you can imagine something, then it exists.

Another big story that challenges our imagination and could definitely do with a theatrical adaptation is privacy. Why is it, many a journalist wonders, that so many people shrug their shoulders about illegal monitoring, invasion of privacy and related issues? I think I know the answer: because it isn't treated theatrically. Just imagine. You buy a ticket at a theatre. As soon as you enter, I scan your credit card without you being aware of this. The performance starts deceptively calmly, as I welcome you and explain a few things. Then a group of people comes on stage, introduced by me as hackers. A video screen lights up, divided into a lot of little boxes. Each box now fills up with a name, photographs and information. The screen represents the audience: all of its members have their own little box.

You are being hacked, live. We know your name, your bank balance, whether you are divorced or not, if you argue a lot with your children. Everything out in the open, for the entire community to see. And we would go on and on until you feel a shiver running down your spine. Until it becomes physical. Until you are so caught up in it that you can imagine just what it's like, invasion of privacy. Only when it becomes theatre, when it becomes physical and we are caught up in it, can imagine it, will we make the connection.

It takes time to make this type of theatre. Time to fail, to do proper research, to encounter things that are perfectly useless. But time has become increasingly scarce since the cutbacks in art and culture in the Netherlands in 2013. Everyone in the field seems to feel the need to prove themselves; to themselves, to the audience, to society. Among other things, this need is expressed by an urge

to produce. As soon as one production is ready for opening night, the next one is already announced. Everything needs to be good right away, and preferably earn many nominations and awards. Scoring is what counts, and winning. In that respect, it is no coincidence that Thomas Bellinck is from Flanders. He worked on his production full-time for nine months. The question is how long this will remain possible in Belgium, now that severe cutbacks in the budgets for art and culture have been announced there as well.

The most devastating effect of the urge to produce is that it makes one inclined to stay indoors, inside the rehearsal space where one can quickly and effectively sketch what is going on outside. But the kind of theatre I am speaking of, the kind of theatre that is desperately needed now, demands that theatre-makers go out, mingle in the stream, searching, taking stock. You can't do that from behind a desk or from within a rehearsal space. You need to go outside, through the doors of the building. Check out the streets, the neighbourhood, the city, the country; cross the border to the rest of Europe; cross an ocean, explore the world and everything surrounding it. Get involved with the space around you, ask questions, and above all do not be afraid of not knowing something. Remind yourself that none of us knows. Doubt. Fail. As Samuel Beckett once said: 'Ever tried. Ever failed. No matter. Try again. Fail again. Fail better.' Infiltrate like a Trojan horse, make a note of what you see, cross it out on second thought and when you are done, come back. Bring the world with you, through the doors, through the hallway, to the theatre, imagine it. Then together we can reflect about where we come from, how we got here and which path we would like to take.

Part 2

European Culture

Nomadic
European Identity

Rosi Braidotti

Over and beyond its legal and economic scaffolding, the project of constructing a 'new' European identity as a multicultural democratic space within the framework of the European Union is an on-going process of cultural and political transformation. Culture is both its intrinsic motor and in some ways its biggest challenge.

Like many democratically-minded academics working in Europe today (Balibar, 2001; Habermas, 2001; Passerini, 1998) I believe in the transformative potential of this project and have defined it in terms of the 'becoming-nomadic' of European transcultural identity (Braidotti, 1994; 2002; 2011b). Let me first explain and later expand this thesis.

The European Union as a progressive project opens up a site of possible re-elaboration of the negative traits of European culture that caused so much turmoil and human suffering in the past. That is to say that Europe is historically condemned to revisit and redeem its own history (Foucault, 1966). Foremost among the bad old habits is nationalism, linked to xenophobia and racism. Like all old habits they are never truly over, but rather seem to recur with distressing regularity. They express a double and doubly misguided assumption: the first is the arrogant assumption that Europe is the centre of the world and the second is the construction of non-Europeans as pejorative 'others'. The European Union as a transformative project constitutes a rupture from this traditional vision of sovereign European identity and as a consequence it also recasts Europe's relationship with its others.

As I see it — and hope for — both historically and politically the project of the European Union involves a process of critique of the former self-appointed role of Europe as the alleged centre of civilization. Following Foucault (1966), Deleuze and Guattari (1972; 1980), Derrida (1991) and Irigaray (1977), this self-aggrandizing view has the further unfortunate implication of appointing the standard European citizen as the prototype of a civilized human being. The distinctive traits of this quintessential European human are supposed to be the self-reflexive and self-correcting universal powers of 'reason', which allegedly find their highest expression in European culture and notably in European humanism. Built into this rational vision are a number of sub-clauses which come with the humanist legacy, notably: secularism, faith in scientific progress and a project of universal human emancipation.

'Europe' in this frame of reference is therefore not a specific geo-political location with a situated political history, but rather a universal and abstract concept. Europe as the symbol of universal self-consciousness posits itself as the site of origin of reason and designates itself as the motor of the world-historical unfolding of rationality, reducing difference to a structural position of pejoration. The epistemic and world-historical violence engendered by the claim to universalism and by the oppositional view of consciousness, lies at the heart of what Ulrich Beck has lucidly labelled 'methodological nationalism' (1999), which I call conceptual Eurocentrism (Braidotti, 2011b). My critique of this vision and its Eurocentric assumptions is grounded in feminist theory. The grounded nature of this approach also makes it easier to provide ethical accountability for feminist knowledge claims. As the work of feminist philosophers such as Genevieve Lloyd (1985) has pointed out, universalistic claims are actually highly particular and partial. Feminist epistemologists, notably Sandra Harding (1991) and Donna Haraway (1990a), have produced some of the most significant critiques of the false universalism of the European subject of knowledge, which also sets the standards for the model citizen. They also offered alternative accounts of both political and epistemic subjectivity and explored their concrete applications to social as well as scientific practices. This process of epistemological revision affects both new theorizations of the subject and the Eurocentrism implicit in the universalistic posture. The double critical charge forces a revision of the idea of Europe as the 'home' of the rational citizen and the knowing subject, which translates into the notion of science as democracy in the classrooms and democracy as the white European man's burden (Harding, 1993).

A critical reappraisal of this double assertion of European superiority amounts to a re-grounding of Europe, no longer as the centre, but as one of the many peripheries in the world today. This process of consciousness-raising is a sober awakening to the specific historicity of the European situation, in the light of the contemporary globalized context. One of the most strident contradictions of our world is in fact the co-existence of dynamic and productive transnational spaces on the one hand, and on the other the resurgence of hyper-regionalisms. The global city and Fortress Europe stand both face-to-face and as two sides of the same coin (Sassen, 1995). In what follows I will first outline this

rather schizoid phenomenon (Deleuze and Guattari, 1980), and then defend a process of 'becoming-minoritarian' of Europe as a way of both bypassing the binary global-local and of redefining European cultural identity in a culturally hybrid globalized context (Braidotti, 2002).

Global Diasporas

The globalized world is defined by multiple flows of mobility and diasporas of people, information, cultures, commodities and capital. Avtar Brah argues that diasporic space is made of relationality and that it inscribes 'a homing desire while simultaneously critiquing discourses of fixed origins' (Brah, 1996: 193). It is a transnational space of mobility, borders, transitions and flows which expresses 'the overlapping and non-linear contact zones between natures and cultures: border, travel, creolization, transculturation, hybridity and diaspora' (Clifford, 1994: 303).

The diaspora affects a broad range of spaces from the roots of indigenous people to the routes of the itinerant subjects in the postcolonial world order. Jewish in origin, the term 'diaspora' describes the uprooting and dispersion of many populations: the Armenian, Turkish, Palestinian, Cuban, Greek, Chinese, Hungarian Yugoslav and Chilean, to name but a few. Clifford comments: 'In the late twentieth century, all or most communities have diasporic dimensions (moments, tactics, practices, articulations). Some are more diasporic than others' (Clifford, 1994: 310).

The global diaspora has enormous implications for a world economy linked by a thick web of transnational flows of capital and labour. Such a system is marked by internal — as well as external — processes of migration implying mobility, flexibility or precariousness of work conditions, transience and impermanent settlements. Furthermore, globalization is about the deterritorialization of social identity, which challenges the hegemony of nation states and their claim to exclusive citizenship. This proliferation of ethnic and racialized differences within the political economy of global mobility produces the stratification of multiple layers of control in a system known as 'scattered hegemonies' (Grewal and Kaplan, 1994). This is a system of a centre-less and continuous flow of data, information and capital that defies binary oppositions between the centre and the many peripheries and implements a complex multi-directional

circulation, not only between the geo-political blocks but also within them.

As a result, massive concentrations of infrastructures exist alongside complex, worldwide dissemination of goods. The technologically-driven advanced culture that prides itself on being called the 'information society' is in reality a concrete, material infrastructure that is concentrated on the sedentary global city. Sassen defines global economies as: 'the location of transnational spaces within national territories' (Sassen, 1994: xiii). Migration is the inner core of this system of differentiated mobility. The global city and the refugee camps (Agamben, 1998) are not dialectical or moral opposites: they are two sides of the same global coin. They express the schizoid political economy of our times. The methodological but also moral challenge is to neither dismiss nor to glorify the status of marginal, alien others, but to find a more accurate, complex location for a transformation of the terms of their political interaction.

If differentiated mobility and worldwide migrations are the defining features of our times, then rootlessness and constant displacement need to be brought into sharper focus. Precisely because of this, social critics need to be very careful in their approach to any analysis of the new subject positions that have emerged in post-industrial times. The differences in degrees, types, kinds and modes of mobility and – even more significantly – of non-mobility need to be mapped out with precision and sensitivity. I argue that cartographic accuracy is made necessary by the fact that travelling, mobile and hence non-unitary subject positions – such as migrants, hybrids, nomads and cyborgs – are key elements of our historicity, but they are quite different in location and social implication (Braidotti, 1994; 2011a). Subjects situated in one of the many poly-located centres that weave together the global economy experience different degrees of social access and entitlement. We require adequate, politically-invested cartographies to account for them and for their internally contradictory power relations.

James Clifford (1994), for instance, makes careful distinctions between different kinds and metaphors of travel: from the colonial exploration or bourgeois 'tour', to the itineraries of immigrant or indentured labourers. Zygmunt Bauman (1993), in his analysis of postmodern ethics, juxtaposes the figuration of the pilgrim to that of the tourist and the nomad, and gives them diametrically opposed ethical codings.

A range of new, alternative subjectivities have indeed emerged in the shifting landscapes of advanced capitalism and its global diasporas. They are contested, multi-layered and internally contradictory subject positions, which however does not make them any less riddled with power-relations. They are hybrid and in between social categories for whom traditional descriptions in terms of sociological categories such as 'marginals', 'migrants', or 'minorities' are inadequate, as Saskia Sassen (1995) astutely suggests. The proliferation of new social subjects on the margins of the global circulation economy, simultaneously expresses the enduring power of classical systems of exploitation, but also the changing powers of the emerging new subjects. As Deleuze taught us (1968), it is important to resist the temptation of casting these new subject positions in a dialectical mould as it would result in the uncritical reproduction of Sameness on a planetary scale. These different subjects must therefore be approached in a complex multi-directional manner that stresses their novelty and their creative potential.

These different locations need to be accounted for in such a way as to make the power differences explicit. The different narratives, however, have to be embedded in specific histories and geographies, thus preventing superficial metaphorizations (Braidotti, 2011a). The work on power, difference and the politics of location offered by postcolonial and anti-racist feminist thinkers who are familiar with the European situation — among them notably Spivak (1987), Hall (1992), Brah (1993) and Gilroy (1987) — can support this project methodologically and strategically.

Feminist cartographic and materialist philosophies of the subject also provide new methods to avoid universalistic generalizations and thus ground critical practice so as to make it accountable. We need more complexities, at both the micro and the macro levels of the constitution of subjectivity, in terms of genders and across ethnicities, class and age. These axes set the parameters for a nomadic cultural agenda that needs to be addressed in the framework of the new European Union.

I therefore propose an alliance between, on the one hand, the deconstruction of the unitary idea of Europe as the 'cradle' of civilization — with its corollary implications of rational citizenship, liberal individualism and cognitive and moral universalism, and on the other, the construction of non-unitary identities, I see the new European Union as a framework for the

transformation of European identity in the sense of multiple, hybrid, diasporic and nomadic vision of the subject-in-process. This is the process of becoming-minoritarian of Europe.

From Eurocentrism to the Becoming-Minoritarian of Europe
I have argued so far that we now live in a world that is organized along multiple axes of mobility, circulation, flows of people and commodities, which amounts to saying that we live in ethnically mixed worlds. Europe is caught in this dynamic, but the phenomenon of a pluri-ethnic or multicultural European social space is controversial to say the least. European culture seems ill-equipped to confront the phenomenon of mass migration. Worldwide migration — a huge movement of populations from periphery to centre — has challenged the claim to an alleged cultural homogeneity of European nation states and of the European Union. This challenge goes quite deep into Europeans' self-representation and it cannot therefore be solved by a mere pluralistic proliferation of minorities and minority rights, to paraphrase Kymlicka's idea of multicultural citizenship (1995). A qualitative shift of perspective in our collective sense of identity is required instead, in the direction of the becoming-nomadic or minoritarian of European citizenship in the sense of a post-nationalist European space.

Politically, as Stuart Hall put it (Hall, 1987; 1990), resistance against the European Union can be seen as a defensive response to overcoming the idea of European nation states. The backlash against this process takes the form of a nationalistic wave of paranoia and xenophobic fears that is simultaneously anti-European and racist or anti-immigrants. Thus, the expansion of European boundaries coincides with the resurgence of micro-nationalist borders at all levels in Europe today. Unification coexists with the closing down of borders; the common European citizenship and the common currency coexist with increasing internal fragmentation and regionalism; a new, allegedly post-nationalist identity coexists with the return of xenophobia, racism and anti-Semitism (Benhabib, 1999). The collapse of the Soviet empire simultaneously marks the triumph of the advanced market economy and the return of tribal ethnic wars of the most archaic kind. Globalization means both homogenization and an exacerbation of power differences (Appadurai, 1994; Eisenstein, 1999; Shiva 1997).

My proposal for a nomadic practice of identity argues that if it is the case that a socio-cultural mutation is taking place in the direction of a multi-ethnic, multi-media society, then the transformation cannot affect only the pole of 'the others'. It must equally dislocate the position and the prerogative of 'the same', the former centre. In other words, what is changing is not merely the terminology or metaphorical representation of the subjects, but the very structure of subjectivity, the social relations, and the social imaginary that support it. The very syntax of social relations, as well as their symbolic representation, is in upheaval. The traditional standard-bearers of Eurocentric presumptions no longer hold in a civil society that is, among other things, aware of gender differences, is multicultural and not only Christian or secular, but multi-denominational. More than ever, the question of social transformation begs that of representation: what can the traditional vision of the rational, European/white subject do for emerging subjects-in-process? The challenges, as well as the anxieties evoked by these new developments require new forms of expression and representation, that is to say transformative social practices which need to be implemented critically.

To sum up: the European Union as a nomadic project has to do with the sobering experience of relinquishing universalistic claims and taking stock of our specific location, adopting embedded and embodied perspectives. This is the opposite of the grandiose and aggressive universalism of the past: it is a situated and accountable perspective. It's about turning our collective memory to the service of a new political and ethical project, which is forward-looking and not nostalgic. The reactive tendency towards a sovereign sense of the Union is also known as the 'Fortress Europe' syndrome, and has been extensively criticized by feminists and antiracists. They warn us against the danger of replacing the former Eurocentrism with a new 'Europ-ism' (Essed, 1991), i.e. the belief in an ethnically pure, exclusively Christian Europe. The claim to ethnic purity is, of course, the core of fascism.

Next then, the European Union is faced with the issue of cultural hybridity: can one be European and Black or Muslim? Paul Gilroy's work on Black British subjectivity (1987) is indicative of the problem of how European citizenship and racial identity emerge as contested issues. One of the radical implications of the project of the European Union is the possibility of giving

a specific location, and consequently historical embeddedness or memory to anti-racist whites. In order to accomplish this transformative shift, Europeans need to look at themselves through the eyes of others, however painful it may be to discover that white is perceived by non-whites as the colour of death (Morrison, 1992) and of terror (Hooks, 1994).

The biggest drawback of inhabiting a sovereign or dominant identity is in fact the lack of self-awareness about how this looks to others: hence the structured invisibility of whiteness, its non-racialized value and its claim to be a 'colourless multicolouredness' (Dyer, 1993). Michel Foucault argues along similar lines in defining the Panopticon (Foucault, 1975) as the void that lies at the heart of the system and — being itself invisible — defines the contour of both social and symbolic visibility (Young, 1990). Deleuze and Guattari (1972; 1980) also comment on the fact that any dominant notion — such as European-ness or masculinity — is defined by dialectical opposition to its 'others' and thus has no positive self-definition. The prerogative of being a dominant subject consists in this peculiar form of entitlement: to be able and be allowed to cast outwards upon others the burden of structural marginalization, which confirms the dominant subject by spelling out what he is not. Virginia Woolf (1938) had already commented on this aspect of the logic of patriarchal domination when she asserted that what matters is not so much that He, the male, should be superior, as long as She, the Other, is clearly defined as inferior. There is no dominant concept other than that which acts as a term to index and police access and participation to entitlements and powers. Thus, the invisibility of the dominant concepts is also the expression of their insubstantiality: the centre is void. This, however, makes it all the more effective in marginalizing the many others on whose structural exclusion their powers rest.

The immediate consequence of the process of re-grounding European identity is that this hegemonic dialectical mode is undone in favour of multi-situated or 'nomadic' perspectives. The centre has to undergo a process of becoming-other, becoming-minoritarian: being a nomadic European subject means to be in transit between different identity formations, but, at the same time, being sufficiently anchored to a historical position to accept responsibility for it. The 'becoming-minoritarian of Europe' also dispels the privilege of invisibility that was conferred on Europe as the alleged centre of the world. By assuming full responsibility

for the partial perspective of its own location, a minoritarian European space opens up a possible political strategy – and thus attributes a positive role – to those who inhabit this particular centre of power in a globalized world marked by scattered hegemonies, and hence no longer dominated by European power alone.

Flexible Citizenship

In this last section I want to argue that the project of becoming-nomadic of European transcultural identity can be strengthened by and in turn support a new practice of flexible citizenship. In other words, the nomadic and transcultural definition of European identity can be concretely translated into a set of 'flexible' forms of citizenship that would allow for migrants and temporary non-European residents – in fact, all kinds of hybrid citizens – to acquire legal status in what would otherwise deserve the label of 'Fortress Europe'.

The starting point for this part of my argument is that the classical model that linked citizenship to belonging to a territory, an ethnicity and a nation state, and opposed it to a condition of statelessness, is no longer adequate in the light of the multiplicity of global diasporas and states of mobility I highlighted above. The phenomenon globally known as flexible citizenship describes the de-linking of the three basic units that used to compose citizenship: one's ethnic origin or place of birth; the nationality or bond to a nation state and the legal structure of actual citizenship rights and obligations. These three factors are disaggregated and disarticulated from each other and become rearranged in a number of interesting ways. Most of us today have some direct experience of this kind of deterritorialization, including in higher education in Europe, marked by the international students flow and colleagues.

A radical restructuring of European identity as post-nationalistic can be pragmatically implemented in a nomadic variation of flexible citizenship in the framework of the 'new' European Union (Ferreira et al., 1998). A disaggregated idea of citizenship emerges in fact from the current EU situation – as a bundle of rights and benefits that can accommodate both native citizens and migrants. This would entitle even temporary migrant citizens to partake of the rights and duties of active socio-political participation and grant them a legal status. It is an attempt to accommodate cultural diversity without

undermining European liberal democracies and the universal idea of individual human rights.

For instance Habermas has repeatedly defended the calls for a European constitution, that is to say Europe as a political project that would involve the consolidation of a European public sphere. This might strengthen the shared political culture of European democracies and welfare states. Likewise, in her recent work on European citizenship, Benhabib (2002) critically questions the disjunction between the concepts of nation, the state and cultural identity. Solidly grounded in Kantian cosmopolitanism, Benhabib argues forcefully that 'democratic citizenship can be exercised across national boundaries and in transnational contexts' (Benhabib, 2002: 183). She is especially keen to demonstrate that the distinction between a national minority and ethnic group does very little to determine whether an identity/difference-driven movement is 'democratic, liberal, inclusive and universalist' (Benhabib, 2002: 65). Benhabib also examines the extent to which the medieval charts of rights of cities can be activated against the nation state, especially in the case of asylum laws.

The model of nomadic flexible citizenship would involve dismantling the us/them binary in such a way as to account for the undoing of a strong and fixed notion of European citizenship in favour of a functionally-differentiated network of affiliations and loyalties. For the citizens of the Member States of the European Union, the new EU citizenship rests on the disconnection of the three elements discussed above: nationality, citizenship, national identity. According to Ulrich Preuss, such a European notion of citizenship, disengaged from national foundations, lays the ground for a new kind of civil society, beyond the boundaries of any single nation state. Because such a notion of 'alienage' (Preuss, 1996: 551) would become an integral part of citizenship in the European Union, Preuss argues that all European citizens would end up being 'privileged foreigners'. In other words, they would function together without reference to a centralized and homogeneous sphere of political power (Preuss, 1995: 280). Potentially, this notion of citizenship could therefore lead to a new concept of politics that would no longer be bound to the nation-state. This notion of European citizenship is a pragmatic way of developing the progressive potential of the European Union, and also of accounting for the effects of globalization upon us all. These effects boil down to one central idea: the end of pure

and steady identities, and a consequent emphasis on creolization, hybridization, a multicultural Europe, within which 'new' nomadic European subjects can take their place alongside others (Bhavnani, 1992).

Collective Imagining

What this project now lacks is a social imaginary that adequately reflects the social realities, which we are already experiencing, of a post-nationalist sense of nomadic European identity. We have collectively failed to develop adequate, positive representations of the new trans-European condition that we inhabit in this Continent. This deficit in the creativity of our social imaginary both feeds upon and supports the political timidity and the resistances that are being mobilized against the European political project. More work is needed on the role of contemporary media and the cultural sector in stimulating the social imaginary of global nomadic cultures (Hall, 1992; Shohat and Stam, 1994; Gilroy, 2000; Braidotti, 2002).

At least some of the difficulty involved is due to the lack of a specifically European – in the sense of European Union – public debate, as Habermas (1992) put it in his critique of the absence of a European public sphere. This is reflected in the rather staggering absence of what I would call a European social imaginary. Thinkers as varied as Passerini (1998), Mény (2000) and Morin (1987) all signal this problem, in different ways. Passerini laments the lack of an emotional attachment to the European dimension on the part of the citizens of the social space that is Europe. Elsewhere she has developed hypotheses on a possible critical innovation of what a 'love for Europe' could mean (Passerini, 2003). For Mény the problem is rather the lack of imagination and of visionary force on the part of those who are in charge of propelling the European Union politically. For Edgar Morin, Europe is ill-loved and somewhat unwanted, 'une pauvre vieille petite chose' (Morin, 1987: 23).

My question therefore becomes: how do you develop such a new European social imaginary? I think that such a notion is a project and not a given, which however does not make it utopian in the sense of being overly idealistic. On the contrary: it is a virtual social reality that can be actualized by a joint endeavour on the part of active, conscious and desiring citizens. It entails the necessary dose of dream-like vision without which no social project can take off and gather support.

Something along these lines is expressed with great passion by Edgar Morin, when he describes his becoming-European as the awakening of his consciousness about the new peripheral role of Europe in the post-World War II era, after his years of indifference to Europe, in the tradition of Marxist cosmopolitanism and international proletarian solidarity. By his own admission, Edgar Morin overcame his mistrust for the European dimension of both thinking and political activity in the late 1970s, when, like most of his generation, he distanced himself from the unfulfilled promises of the Marxist utopia. This sobering experience made him see to which extent the new worldwide binary opposition USSR/USA had dramatically dislocated the sources of planetary power away from Europe (Morin, 1987). The concrete result of this new consciousness-raising was that Morin started taking seriously the scholarly work associated with the research of European roots as both a cultural and political specificity. This is the paradox that lies at the heart of the quest for a new, post-nationalist redefinition of European identity: it becomes thinkable as an entity at the exact historical time when it has ceased to be operational as a social or symbolic reality. This confirms my insight that the process of becoming-Europeans entails the end of fixed Eurocentric identities and it thus parallels the becoming-nomadic of subjectivity.

New images and self-representations of Europe, do not readily appear out of thin air. Producing a new imaginary requires the means of revisiting it, acknowledging it and understanding the complicity between 'difference' and 'exclusion' in the European mind-set. Repetitions are the road to creating positive redefinitions, in a progress of creative deconstruction. Communities are also imaginary institutions made of affects and desires (Anderson, 1983). Homi Bhabha, for instance, (1990; 1994) stresses the fact that common ideas of 'nation' are, to a large extent, imaginary tales that project a re-assuring but nonetheless illusory sense of unity over the disjointed, fragmented and often incoherent range of internal regional and cultural differences that make up a national identity. We have also become painfully aware of the extent to which the legitimating tales of nationhood in the West have been constructed over the bodies of women, as well as in the crucible of imperial and colonial masculinity.

The liberating potential of this process is equally proportional to the imaginary and political efforts it requires of us all. The

recognition of the new multi-layered, transcultural and post-nationalist idea of Europe in this case would only be the premise for the collective development of a new sense of accountability for the specific slice of world periphery that we happen to inhabit. Through the pain of a certain degree of de-familiarization, 'post-Eurocentric Europeans' may be able to find enough creativity and moral stamina to grab this historical chance to become 'just' Europeans in the post-nationalist sense of the term. This becoming-minoritarian would be a gesture towards in-depth transformation.

The project of developing a new kind of post-nationalist identity is related to the process of dis-identification from established, nation-bound identities. There is no denying that the quest for an adequate European social imaginary requires inner dislocations of entrenched habits and as such it involves some sense of loss. No process of consciousness-raising can ever be painless. Migrants know this very well. Home is lived both at the material and at the imaginary level, where it might be a destination, or something which is repeatedly deferred to. 'Home' is not necessarily a place of 'origin', but can indicate multiple belongings. A post-nationalist sense of European identity and of flexible citizenship requires leaving 'home', which entails an extra effort in order to change deeply embedded habits, also in terms of imaginary self-representation.

This sobering experience — the humble and productive recognition of loss, limitations and shortcomings — has to do with self-representations. Established mental habits, images and terminology, railroad us back towards established ways of thinking about ourselves. Traditional modes of representation are reassuring and slightly addictive. To change them is not unlike undertaking a detoxification cure. A great deal of courage and creativity is needed to develop forms of representation that do justice to the complexities of the kind of subjects we have already become. Cultural action for transformation is the key to the fulfilment of this project.

The project of changing the social imaginary requires intense collective and personal cultural investments, which I situate in the direction of becoming-minoritarian. The assemblage formed by a body of individuals devoted to this process is both historically grounded and socially embedded: it is community that decides, in a gesture of affirmation that engenders the constitution of new forms of self-representation for what was till then a

'missing people'. This project mobilizes the collective imaginings as well as other cognitive and rational resources.

Collectively, we can empower alternative patterns of becoming nomadic European post-nationalist subjects. This project needs to explore new cultural formations of hybrid identities at the very centre of Europe. It is a labour-intensive cultural effort on the part of all and it also requires active participation and shared desire. The cultural motor of becoming nomadic Europeans is the desire for what we are capable of becoming. This liberating potential is directly proportional to the collective affects it mobilizes in us all. The recognition of Europe as a post-nationalist entity is the premise to the creation of a sense of accountability for the specific margin of the planet that Europeans occupy. The becoming-minoritarian of Europe enacts this reconfiguration as an active experiment with different ways of inhabiting this social space.

I want to describe the project of a post-nationalist understanding of European identity as a great historical chance for Europeans to become more knowledgeable about our own history and more self-critical in a productive sense. Nietzsche argued in the early twentieth century that many Europeans no longer felt at home in Europe (Nietzsche, 1966). At the start of the third millennium, many would argue that those who do not identify with Europe in the sense of the centre – the dominant and heroic reading of Europe – are ideally suited to the task of reframing Europe, by making it accountable for a history in which fascism, imperialism and domination have played a central role. In nomadic European subjects lie the post-nationalist foundations for a multi-layered and flexible practice of European culture and citizenship in the frame of the new European Union.

Bibliography

- Agamben, G. (1998) *Homo Sacer: Sovereign Power and Bare Life,* Stanford CA: Stanford University Press.
- Anderson, B. (1983) *Imagined Communities,* New York: Verso Books.
- Appadurai, A. (1994) 'Disjuncture and Difference in the Global Cultural Economy', in: *Theory, Culture, and Society* (7), 295-310.
- Balibar, E. (2001) *Nous, Citoyens de l'Europe? Les Frontiers, l'Etat, le People,* Paris: Decouverte.
- Bauman, Z. (1993) *Postmodern Ethics,* Oxford: Blackwell.
- Beck, U. (1999) *World Risk Society,* Cambridge: Polity.
- Benhabib, S. (1999) 'Citizen, Resident, and Alien in a Changing World: Political Membership in a Global Era', in: *Social Research* 66, (3) (September 1999), 709-744.
- —. (1999) 'Sexual Difference and Collective Identities: The New Global Constellation', in: *Signs* 24, no. 2 (winter 1999), 335-361.
- —. (2002) *The Claims of Culture: Equality and Diversity in the Global Era,* Princeton NJ: Princeton University Press.
- Bhabha, H.K. (ed. - 1990) *Nation and Narration,* New York: Routledge.
- —. (1994) *The Location of Culture,* New York: Routledge.
- Bhavnani, K-K. (1992) *Towards a Multi-Cultural Europe?,* Amsterdam: Bernardijn ten Zeldam Stichting.
- Brah, A. (1993) 'Re-Framing Europe: En-Gendered Racisms, Ethnicities, and Nationalisms in Contemporary Western Europe', in: *Feminist Review,* (45) (September 1993), 9-29.
- —. (1996) *Cartographies of Diaspora: Contesting Identities,* New York: Routledge.
- Braidotti, R. (1994) *Nomadic Subjects: Embodiment and Sexual Difference in Contemporary Feminist Theory,* New York: Columbia University Press.
- —. (2002) *Metamorphoses: Toward a Materialist Theory of Becoming,* Malden MA: Blackwell.
- —. (2011a – 2nd ed.) *Nomadic Subjects: Embodiment and Sexual Difference in Contemporary Feminist Theory,* New York: Columbia University Press.
- —. (2011b) *Nomadic Theory: The Portable Rosi Braidotti,* New York: Columbia University Press.
- Clifford, J. (1994) 'Diasporas', in: *Cultural Anthropology 9,* (3) (August 1994), 302-338.
- Deleuze, G. (1968) *Différence et Répétition,* Paris : Presses Universitaires de France.
- Deleuze, G. and Guattari, F. (1972) *L'anti-Oedipe: Capitalisme et schizophrénie I,* transl. by R. Hurley, M. Seem and H.R. Lane, Paris: Minuit, *Anti-Oedipus: Capitalism and Schizophrenia.* New York: Viking Press/ Richard Seaver, 1977.
- —. (1980) *Mille plateaux: Capitalisme et schizophrénie II,* transl. by B. Massumi, Paris: Minuit, 1980. *A Thousand Plateaus: Capitalism and Schizophrenia,* Minneapolis MN: University of Minnesota Press, [1987].
- Derrida, J. (1991) *L'Autre Cap,* Paris: Minuit.
- Dyer, R. (1993) *The Matter of Images: Essays on Representations,* New York: Routledge.
- Eisenstein, Z. (1999) *Global Obscenities: Patriarchy, Capitalism and the Lure of Cyberfantasy,* New York: New York University Press.
- Essed, P. (1991) *Understanding Everyday Racism: An Interdisciplinary Theory,* London and Thousand Oaks CA: Sage.
- Ferreira, V., Tavares, T., and Portugal, S. (eds. - 1998) *Shifting Bonds, Shifting Bounds: Women, Mobility, and Citizenship in Europe,* Oeiras: Celta.
- Foucault, M. (1966) *Les Mots et les choses,* Paris : Gallimard.
- —. (1975) *Surveiller et punir,* Paris: Gallimard.
- Gilroy, P. (1987) *There Ain't no Black in the Union Jack: The Cultural Politics of Race and Nation,* London: Hutchinson.
- —. (2000) *Against Race: Imaging Political Culture Beyond the Color Line,* Cambridge MA: Harvard University Press.
- Grewal, I. and Kaplan, C. (eds. - 1994) *Scattered Hegemonies: Postmodernity and Transnational Feminist Practices,* Minneapolis MN: University of Minnesota Press.
- Habermas, J. (1992) 'Citizenship and National Identity: Some Reflections on the Future of Europe', in: *Praxis International 12,* (1), 1-34.
- —. (2001) *The Post-National Constellation,* Cambridge: Polity.
- Hall, S. (1990) 'Cultural Identity and

Diaspora', in: Rutherford, J. (ed.) *Identity: Community, Culture, Difference,* London: Lawrence and Wishart.

— —. (1992) 'What Is This Black in Black Popular Culture?', in: Dent, G. (ed.) *Black Popular Culture,* Seattle: Bay Press.

— —. (1987) 'Minimal Selves', in: Bhabha, H.K., and Appignanesi, L. (eds.) *Identity – The Real Me: Post-Modernism and the Question of Identity,* London: Institute of Contemporary Arts Documents (6).

— Haraway, D. (1990) *Simians, Cyborgs and Women,* London: Free Association Press.

— Harding, S. (1991) *Whose Science? Whose Knowledge?,* Ithaca NY: Cornell University Press.

— —. (1993) *The "Racial" Economy of Science,* Bloomington IN: Indiana University Press.

— Hooks, B. (1994) *Outlaw Culture: Resisting Representations,* New York: Routledge.

— Irigaray, L. (1985) *Ce sexe qui n'en est pas un,* transl. by C. Porter, Paris: Minuit, 1977. *This Sex Which Is Not One.* Ithaca NY: Cornel University Press, 1985.

— Kymlicka, W. (1995) *Multicultural Citizenship,* Oxford: Clarendon.

— Lloyd, G. (1985) *The Man of Reason: 'Male' and 'Female' in Western Philosophy,* London: Methuen.

— Mény, Y. (2000) *Tra Utopia e Realtà. Una Costituzione per l'Europa,* Florence: Possigli Editore.

— Morin, E. (1987) *Penser l'Europe,* Paris : Gallimard.

— Morrison, T. (1992) *Playing in the Dark : Whiteness and the Literary Imagination,* Cambridge MA: Harvard University Press.

— Nietzsche, F. (1966) *Beyond Good and Evil,* transl. by W. Kaufmann, London: Vintage, [1886].

— Passerini, L. (ed. - 1998) *Identità Culturale Europea: Idee, Sentimenti, Relazioni,* Florence: La Nuova Italia Editrice.

— Preuss, U. K. (1996) 'Two Challenges to European Citizenship', in: *Political Studies* (44), 534-552.

— Sassen, S. (1994) *Cities in a World Economy,* London and Thousand Oaks CA: Pine Forge Press.

— —. (1995) Losing Control: *Sovereignty in an Age of Globalization,* New York: Columbia University Press.

— Shiva, V. (1997) *Biopiracy: The Plunder of Nature and Knowledge,* Boston: South End Press.

— Shohat, E. and Stam, R. (1994) *Unthinking Eurocentrism: Multiculturalism and the Media,* New York: Routledge.

— Spivak, G.C. (1987) *In Other Worlds: Essays in Cultural Politics,* London: Methuen.

— Woolf, V. (1938) *Three Guineas,* London: Hogarth Press.

— Young, R. (1990) *White Mythologies: Writing History and the West,* New York: Routledge.

A Land of
Studious Peoples

György Konrád

What is the role of culture in European integration? It is lasting and decisive. A unitary European culture existed before an economic or political community in Europe. This is because the first is derived from relationships between people, the second between states; and people find common ground more easily than states.

Europe's great innovation is cultural pluralism, a tendency that runs parallel to the spread of the philosophy of human rights, based on an obligation to respect the individual.

Europe is notable not for its intentions, but for what already exists here today: the delicate attraction to diversity encapsulated by European humanism. This pluralist sensitivity extends to the level of the tiniest details; into the personality itself and its manifold transitory states, but does not abandon the common tenets the Judeo-Christian and ancient humanist traditions and — since the Enlightenment — European secular thinking have defined. What makes Europe special is its balance between the universal and the particular, the general and the unique, the common and the individual.

What unites Europe? Is it merely a community of economic interests? Ideologies could not unite it — neither the National Socialist, nor the Communist-Socialist vision provided a suitable basis for the unification of this continent. Both were destructive illusions that served to subjugate Europeans to their particular centres of power.

Europe has its respect for pluralism to thank for what it has achieved, something that recognizes the fundamentally unitary nature of mankind and can humble itself before a child. Different as they are, European pluralism learns to accept people and like them. We can call this outlook European humanism.

Europe is really a community of values. Our greatest treasure, 'our magic weapon' is European humanism, which acknowledges the variety and sovereign nature of the realities of people's lives and personalities. European pluralism has weathered thousands of years and asserted itself irrepressibly as a tendency in the progress of society. It means the separation of moral and physical force and the separation of religion from the state; it means social cohesion to ensure that the individual is protected by the law against the powers that be; and it means the dynamic independence of citizens.

The trustworthiness of the civilized citizen lies in an internal set of values, for the maintenance of which a fear of punishment is not in itself sufficient.

Europe is held together by a community of reflection. The classics are all one family. There were no national borders in art; borders are for the men in power. Creative works do not cry out for borders, on the contrary — the more insubstantial, the more virtual the borders, the better such works can spread. There can be no borders for cultural values, for words and symbols. Cultural exchange has grown global, too.

Europeans think with the entirety of their collective and individual pasts and their experience informs their instinctive sympathies and antipathies. Thinking is an activity influenced by values, and by the hierarchy of those values. What is the ideal, and what are our highest values; to what views are our other reflections subjugated?

We are more than merely functional mechanisms. People do not only speak one language; a banker is not just made of money, an engineer of technical parts or a musician of music; nor is a cook only about cooking and a mother of raising children. Each person is a universe and every leaf an irreproducible whole. Softly feeling out the secrets of the personality — that is the real challenge of the spirit.

The relativization of values casts doubt not only on European integration, but on the whole system of international agreements. The constructive approach is an empathy that can be flexible and understanding towards relativities, and a dialogue, tension, even drama between universal values. We cannot renounce either of the opposite poles.

The core of Europe comes down to *more brains than brawn*. After the vulgar accumulation of plenty, we are on a voyage of discovery towards the light, the immaterial, the virtual. We are moving from a world of quantities to a world of quality. This requires a more complex intelligence, more inspired relationships and a higher level of culture, and needs philosophy to penetrate out into the material environment. This process goes along with the strengthening of the sovereignty of culture.

Being European is an obligation to learn, think, love, work, and practice self-restraint.

There are certain minimum standards of quality that retail goods have to meet. These standards could exist for cultural goods as well; the profits from low-quality products could be offset with taxes. In the long run, quality wins, because cheap goods are soon driven out of the market. We do not have to accept that

democracy is pandering to the lowest common denominator. The pollution of the information network is just as serious as the pollution of the rivers and the air. It is simply not true that freedom and the convenience of primitivism are one and the same thing.

The intelligentsia have, out of a sense of guilt, cast into doubt the value of knowledge in the face of ignorance. The engaged and proactive role of the intelligentsia is proper in a democracy too. The intelligentsia can allow itself to be strict if necessary, even in a democracy.

Cultural and artistic activity have been a part of European history all along; art has always existed, and will probably continue always to exist. Life has arranged it so that artists make up a community. Their mediums already unite European culture; a more intimate familiarity with creative works across borders already exists. The circulation of books has never been so vibrant and is starting to break out of the bounds of national markets. The literature of small nations is beginning to break onto the European stage, if only thanks to trends in the market itself. There is a profound process that ensures that the socio-cultural tissue is growing ever thicker. Cultural integration moves forward even without much outside help.

But why shouldn't it have outside help? It is culture that can do the most to make Europe one extended homeland, and in fact has done the most already. This is the most affordable and most organic process of unification.

That sense of being related, of the intertwining of Europe, seems to unfold almost of itself, and accepts what it has seen in other countries also as its own. Identities are differentiated in both directions. Links are made both above and below the level of the nation state. The European community has a sense of itself, but so does a tiny village. Every small town has its own artistic subculture, association, group of friends, forum, publication, gathering place, workshop, pub, and habits. Artists come in packs and their associations are imbued with an intimacy all their own. I don't think we need fear the general mixing of these unusual characters in the overall European dough.

Can we say that the European Union is becoming a new kind of nation? Is there a Europe that is a many-headed thinking unit searching for its own image and defining values?

European unification is without doubt a child of the Enlightenment, but experience shows us that as a counterpoint to

universalist tendencies, an anti-integrationist, or even dis-integrationist romanticism must also emerge.

We are all learning to be our modern selves: what does it mean to be a citizen not only of our own states but at the same time of the European community as well? What is there that's new in this situation, compared to how we saw ourselves before?

Since European association unites such disparate elements, it is understandable if it performs a balancing act between force and compassion, efficiency and graciousness, between material and moral values.

Man cannot live without a sense of the transcendental. The European Union can exist only if it is built not only on interests, but on a community of chosen values and lasting sympathies. The question is what to place above all else? What historical and moral achievements can we agree on as fundamental axioms? We elect, invent and create ourselves; the history of our world is a contest of contradictory self-definitions.

Association brings with it growing variety. European integration contributes to the proliferation of cultural identities. Within the progress of the march of similarities, a division into small groups and communities is also taking place; a clash of differences, individuals and communities putting themselves forward, each outdoing the other. It is encouraging that they all say something different. Trouble comes from introverted, homogenized, unitary thinking, from a single centre of power within the European association deciding what we should think.

If we perceive each other as enemies, then there is no individual, and dialogue stops. It is hard to find common ground with someone who wants to conquer us, to humiliate us. It is in Europe's interests to win over other countries, continents, and cultural spaces and tame them. The correct approach is to move through borders and maintain a constant dialogue with the wider world, in the discovery of which our children will get further than us, the generation that preceded them.

It is natural that we should fill the new frameworks that have come into being with mutual interest. To internalize what has so far been external, to make something completely everyday that yesterday was new-fangled, to become empathetic and interested neighbours, to see ourselves often in others — these are the challenges that await us.

Europe is a studious continent, a quality which is epitomized by the studious man. This is the basis of its system of values and the secret of its progress; it is — if you like — Europe's identity itself. Research, learning in action, means the development, correction and critical conservation of everything there is; and every now and then systemic change and revolution.

The studious man is capable of regret and can learn from his mistakes. He respects others and himself as someone possessed of self-control. He gets to know his environment, the lay of the land, feels out the opportunities open to him and wants to achieve more with less effort. He hones and refines his tools and methods.

The opposite of the studious man is the quarrelsome man, who is always in the right himself but who can never accept that others — perhaps a specific group of others — might be. The quarrelsome man is incapable of self-reflection, blames others for his troubles, is embittered, shouts. He likes to get red in the face, lose control and shake his fist — to remind him of his strength.

There was a long period of European history when the ultimate form of quarrelling — making war for spoils — was more profitable than law-abiding work; those who decided to rob stood to make great gain quickly, and this is also true of the wars of the twentieth century just gone. The European Union, I think, has brought an end to this period.

To rob, or to learn? Robbery is forced labour and corruption by another name, while learning is research, entrepreneurship, art and play. Those who would rather argue than learn believe in *fighting.* Holy war in the name of a religion, nation, or the worldwide revolution; the spiritualization of conflict.

There are slow-witted people and cultures who turn away from non-physical competition, and take criticism as malicious nitpicking. Here, the quarrelsome man — and not the studious — is the norm. Where the fashion is for uniforms and the waving of machine guns, learning is not in vogue. Rather than going to school, people prefer to be out waving flags. Even a bad student can make an impressive, skilled and remarkably determined soldier.

These indolent know-nothings do not learn languages, and understand neither others nor themselves. Our common biography is a tale of education. Or rather, self-education. Out of the unreflexive man emerges a man who can think about life and death,

accompanied through life by learning as a quotidian practice, like prayer. We may see God in the faces of others, or we may not, but even if we see nothing more than the face itself, we won't go at it with our fists – that much is certain.

Europe is learning to live together. It could be said that at the centre of modern European progress is the development of the bourgeoisie, that difficult process whereby the elite and the people all become citizens equal before the law, respecting both exchange and contract. The European and North American model is a secular constitutional state instead of the religious one, to ensure that several religions can exist peacefully side-by-side and that religious belief is neither forbidden nor compulsory. In places where religion is the dominant force, a popular franchise can even reproduce the very opposite of a citizen-centric democracy, the sternest of theocracies. The vast majority of Europeans do not think that what people believe is any business of the state's; the religious authorities have neither the right to judge nor to execute judgement.

We can say that a union of secular states is a European phenomenon, as is the taking root of plural, citizen-centric democracies. The twentieth century was still dominated by the challenge and downfall of the ideological state (National Socialism, Communism). The insanity that the ideologically driven regimes of the twentieth century could call forth was there for us all to see.

In their place today, there are more or less liberal democracies in which the freedom and rights of the citizen are the highest values. Europeans were able to embark upon the road of contractual association because the states themselves made room in their inner lives for an environment defined by the respect for contract and the rule of law.

With our status as European citizens comes the responsibility to know and carefully preserve what we have – our values and the beautiful works we inherited from our forefathers. Could we claim that Europe's uniqueness lies in its beauty? The beautiful continent? This flattering epithet would not be too far from the truth. But the others are beautiful, too, each in their own way. In any case, Europe has the highest concentration of manmade constructions and historic remnants per square kilometre, and the history of Europeans has always been accompanied by a desire for the beautiful works of man.

Europe is an articulate continent — we put ourselves into words, write journals, justify and judge ourselves; the things that happen leave written traces. Here, love, food, politics and literature are surrounded by a goodlier number of words, references and analyses than elsewhere. We think about ourselves using the European heritage of texts and images. We live in the mythology bestowed upon us by our authors and artists. We pose ourselves the ancient questions in ever newer forms.

Multilingual Europe has succeeded in developing into — here and there — a cultural tissue thanks to the efforts of translators; literary translators may well be the ideal protégés for European cultural policy. European culture, thanks to its wide-ranging curiosity, is an *accepting* culture. Europe, in no small part, has its inquisitive culture to thank for its power and strength, as well as the fact that Europeans read a relatively large amount and that there still exist among them — though in smaller proportions, it's true — absolutely passionate readers.

At the heart of Europe is its curiosity (which is maybe the most easily pardonable sin and most endearing virtue), the thirst for learning and research that has become a model to the world, the desire to understand, the hedonism of the mind. The vibrant dialogue of innovation and conservation is a European speciality, as is the way books moved out of the monasteries in the wake of the Gutenberg revolution and the appearance of independent intellectual enclaves.

European culture has no limits. It is present throughout the world — in universities, libraries, concert halls — and is more universally diffused than European politics. Europe's uniqueness lies in its great variety of independent, individual stories, original thinkers and achievements. It is precisely this feature that European cultural policy has to reinforce, because it is what is best about Europe: respect for those who create.

It doesn't take much to figure out that this kind of intellectual environment breeds a friendly humility. In opting for the Union, we opted for each other; in the same way that when we choose a partner, we take their relations along with them. Togetherness, whether we like it or not, shapes us all as well.

For me, one of the things that defines Europe is that no one has managed to rule the whole of it for any significant period of time; European individuality is too strong. We have had the chance to learn that Europe can only unite in freedom and all

other calls to unity are false. The need for freedom can be delayed but cannot be buried, except within our very selves.

On top of Europeans' self-awareness and national bodies of culture, another level is being erected — our increasing knowledge of our shared European home. In the wake of the union of our states and the increasing facility of travel, we can increasingly think of each other's cities, great thinkers, and masterpieces as our own.

Our range of differences is almost predetermined for us by our great number of highly developed languages. It would be an impossible illusion to aim for monolingualism. Behind the battles over language lies the indolent selfishness of monolingualism. Europe can do nothing other than make a virtue of necessity and be a multilingual, polyglot place. Most people are capable of learning several languages. We can find common languages; we can overcome the curse of Babel, while pragmatically accepting that English is increasingly the *lingua franca*. But whoever speaks *only* English can, in a European context, be said to be lacking. What makes us European is that we can switch without too much difficulty from one great European language to another out of consideration for the people we're with.

European cultural policy can be said to be succeeding if it helps people and communities get to know one another across national and linguistic boundaries. Europe now has the pleasant task of shuffling the cards. In the nineteenth century, it was writers who defined national cultures. Now we are faced with the challenge of defining a European culture.

European literature already existed when the idea of a European Coal and Steel Community was still completely inconceivable. In fact, European literature in Latin existed first — it was only in the modern period, with the mass production of books that boundaries, tied to the various national languages, appeared. The European Union is not a *sine qua non* of European literature; it did and can get by without it. But since the Union exists, European literature should profit by it.

There are things that work by themselves, things that the market will take care of, for which there is no need to formulate any kind of policy. But there are things that the market will not take care of and which really do require policy intervention, in order to ensure the bold enlargement and dedicated care of Europe's cultural treasury. The most immediate way of

understanding other peoples is through the dissemination of their cultural works. A famously good way of exercising our empathy is reading novels. If you want a union, then you have to want from time to time to get inside the skin of other Europeans, perhaps through the medium of books. Let us recognize our mutual complexity and celebrate it, or laugh at it if we will. But while teaching and research will provide a livelihood for the majority of the intelligentsia, the artistic world has no such strong, securely funded, institutions. If you teach literature, you will make a living. If you write it, you might not.

Europe has learned the consequences of hubris and aggressive, arrogant pride through its own mistakes. The Europeans, too, had their jihad — the Crusades — centuries ago; and perhaps Colonialism was something of the same, but these too have passed, though the latter only recently. This is cause for great humility. Wars of religion need an exaggerated, belligerent phraseology, and the firm conviction that God, our homeland, or historical destiny demands our actions.

The European Union can establish contact with the residents of other parts of the world on the basis of secular humanism, which makes it possible for people of different religions — or no religion at all — to live together peacefully. The key thing is an a-religious state that guarantees freedom of thought: liberal democracy. In Europe, even those countries are liberal democracies where Christian Democratic or Social Democratic governments are in power. A democratic system that guarantees its citizens human rights and political freedoms, a system, in other words, where not only the opinions of the majority, but those of the minority are also taken into account, is a liberal democracy. The constituent states of the European Union are all more or less liberal democracies.

We can even picture Europe as a huge and complex factory of culture, of which our lifestyles, our living arrangements, the use of our time, what we do on our evenings and weekends, our summer and winter holidays, and our manners are all part. If that's the case, then it is doubly paradoxical that so shockingly little of the European budget is spent on the actors and institutions of culture. The people whose job it is probably think that this is a task for national and local institutions. They are wrong. Because just as there are transregional cultural goals and institutions of national importance, there are also transnational goals and

institutions of European importance; or at least there should be. There should be a European sense of self derived from the European cultural narrative.

My optimism does not extend as far as expecting to see a significant improvement in the circumstances of the artistic intelligentsia. There will be subsidies for everything under the sun, but if I am reading the numbers correctly, less than a thousandth part of the European budget will be dedicated to supporting culture. But if we want an answer to the question of what it is that keeps Europe together, I can say with no hesitation whatsoever that it is its symbolic culture, the arts, and literature. Specifically, above all, the European religious and secular literature, which came into being centuries, indeed millenia, before Europe's economic and political union.

It is a political triumph if those in power manage to establish a meaningful dialogue with the thinking public. It is important that the intelligentsia have an appropriate role in the European Union. There is a need for counterweights, for positions of authority that — by law — cannot lead into actual governing. We need outstanding thinkers, scientists, and artists who will, after round-table consultations, take a position on issues in such a way that they will be interesting to public opinion. The convocation of such expert and ethical committees is already a more and more common part of political life. There have to be points of view that are given validity not by the number of their adherents but by their texts themselves and the moral and intellectual standing of those who formulated them.

Advisors are not and do not want to be professional politicians. But they are interested in public matters and have an opinion. They are not elected or appointed, but *invited* to their positions. Politicians speak to their constituencies, have to answer to their party and are necessarily committed to certain things. A round table assembled by invitation, however, has no such commitments. The infrastructure of such a body would cost infinitesimally less than the European Parliament with its 28 official languages. I mention this not to say that it could replace the Parliament, but only to note that there is space for it as well. As well as the *elected* and the *appointed,* the *invited* should be given a significant role on the stage of European decision-making so that public opinion will be able to follow the dialogue between politicians and independent intellectuals with greater engagement.

And if the subject of some other country comes up, let's not forget to see if there is censorship there, or people who are prosecuted for agitating against the state; whether there is demagogic incitement against any particular community, people, religion or group, any ethnic minority or class, and whether the media proclaims that they are the barrier to the majority's happiness. I see nothing admirable in states with the rule of law consorting with demagogic dictatorships.

Europe is sceptical, cautious and most likely liable to go on living politely with things it condemns; or not to condemn in other places what it would never tolerate at home. Only a minority of humankind, about a quarter, live in democratic states with the rule of law. This democratic minority of humanity should stick together and think as openly as possible about its own collective responsibilities and strategies.

The strategy that the West employed with the Eastern European states in the 1980s was workable and could be continued. Here I am referring to that values-based, communicative opening — radio and television programmes, donations of books, visits, invitations, tourism, and normalized trade — that made the iron curtain permeable and weakened the monopoly on news and discourse. It also supported those living in dictatorships in their efforts to ensure that they, too, should not have especially to fear the state.

This opening up, exchange, study, and the creation of individual relationships is expensive, but still costs less than military intervention and the occupations that follow. In this way, efforts are not concentrated on one place, diverting resources from other spots on the globe. This strategy was effective even against the Soviet empire and proved generous. Its success lay in expanding the community of people engaged in dialogue. I consider that the channelling of internal criticism back into a state with strict controls on its media was a step that yielded important results.

In response to ideological globalism came a countermovement, ideological culturalism. This is a determination not to understand one another and the labelling of these fundamental efforts as incompatible. Culturalism considers a people's culture to be a closed, organic whole, as if cultures were isolated sets that never met, with solid boundaries, like the shell of an egg or a walnut. This is a metaphor that makes society vulnerable to potential dictatorship by the nation state.

Those political systems that, by citing their religious or cultural specificities, refuse their responsibility to respect universal human rights, are allowing themselves to use all sorts of terror tactics. Culturalism's view of society works in favour of the secret police. European radical-romantic movements like to acclaim bearded guerrillas with machine guns as heroes. Someone who is a terrorist externally, to a group of people designated as enemies, will also be a terrorist internally, to the people in his own sphere of influence – the very people he's supposedly there to represent and protect.

The West, and specifically European thinkers, have managed to construct a set of humanitarian values that takes as its point of departure the fundamental equality of people, regardless of their beliefs or loyalties.

This system of values did not just fall into our laps, but is the product of hard work; it feeds on experience and not merely reflection. Its prelude is the history of European culture including not only its wise but also its wicked ideas and the historical experiments that grew out of them. It includes not only the triumphs, but also the failures of the human spirit.

There is a palpable sense of defeatism around both the left and the right flanks in Europe in the face of ideological and religious aggression.

Our understanding of legality also reflects the results of the European-American way of thinking.

To depart from this, to attribute validity in law to any system of values based on premises alien to it within a European society, would be a cowardly act of idiocy.

As a child, I rejected National Socialism and as an adult I rejected Communism. I cannot see even the germ of an idea on the horizon that could persuade me to give up European secular humanism, which represents the spirit of tolerant behaviour. I am convinced that this comportment is compatible with any sophisticated reading of the great philosophies and world religions.

No party can arrogate to themselves alone the principle of European freedom. In a constitutional democracy, every party carries within it the consensus of the principles of freedom. Democratic parties are in constant competition with each other and their debates drive European culture.

The European system of values is the result of several thousand years of learning. We cannot give up its fundamental values

through reckless relativism. 'You are in love with life, we are in love with death', wrote one of the 9/11 mass murderers. He was right and there is no reason for us to reverse this preference. There are certain fundamental truths that are not products of caprice, but of bloody experience. Making concessions to the logic of dictatorship on the basis of culturalist arguments is a mistake we cannot afford to make. There is no·cause, no private opinion of any guest, for us to abandon the values of European humanism.

Europe should not be casting ashes upon its head. The learned should not be ashamed when they look the ignorant in the eye.

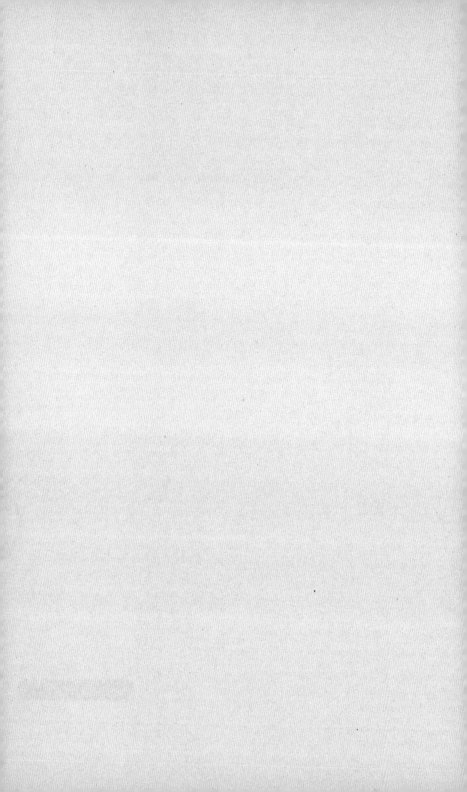

Part 3

Educational Culture

European Culture
Between Rationality and Reason

Barend van Heusden

Introduction

In order to tackle the issue of 'cultural awareness and expression' in Europe, which was designated by the former European Commission as one of the eight key competencies to be acquired in European lifelong education (European Commission, 2007), I will distinguish and systematically relate three levels of meaning of the concept of 'culture'.

On a first level, which can be labelled 'anthropological', the concept of culture relates to the ways in which humans give form and meaning to their life and environment. In view of distinguishing human from animal cultures, it has been argued that the uniqueness of human culture resides in the fact that humans not only are able to learn things — this being an ability shared with quite a few other species — but are also able to interpret the world intentionally. This means that humans are not tied to a single interpretation of reality, but are free to interpret any situation in a variety of ways. Take, for example, the use of different images, words, metaphors, or value qualifications. In order to do so, we must be able to distinguish the reservoir of potential meanings available from the single reality that is interpreted — which comes down to the very familiar, but from an evolutionary point rather unique capacity to distinguish between memory and reality. Reality always eludes our memories of it; it is dynamic, changeable, and potentially unpredictable. This is a defining characteristic of human culture, of our 'condition humaine'. There is nothing specifically European about that.

European Culture

However, the ways in which humans have dealt with this unavoidable difference between memory (what is known) and reality (what is experienced) at the heart of culture have varied enormously throughout human history and can be used to characterize different cultures. And here European culture stands out. It is difficult to tell when and where it originated, but it probably came about in waves — starting in Greek Antiquity, and developing slowly but steadily in Roman and Christian times. With the Enlightenment a European culture was definitely established. Its main tenet is quite simple: ratio rules over beliefs. The European project has been and still is a continuous attempt to tame beliefs and give them a place and function within an overarching rational framework. The advantages of a culture based on rational thinking

are obvious: instead of dealing with the difference that reality continuously generates in terms of metaphysical values, these values are understood, within the rational perspective, as choices deriving from, indeed, values that people or groups of people adhere to for a variety of reasons. Values are not, from a rational point, an aspect of nature; a value is never empirically given. Nature is neutral: it does not care for values. Humans attribute values. One of the important consequences of this Enlightenment perspective was of course that wars between religions and ideologies could now be dealt with in terms of political disputes. Personally I see traffic rules as a nice example of the rationality-over-power perspective which characterizes European culture: In any European country, when the traffic lights are red, I stop – even if my car is ten times bigger than the other car crossing my path. When there are no traffic lights, whoever comes from the right (or from the left in some countries) has the right of way – the power relation between the two drivers is of no consequence. If traffic rules had existed in Greek Antiquity, Oedipus would never have killed his father and no tragedy would have been written about him. We may consider Oedipus as one of the first modern Europeans, and Sophocles as one of its first critics.

In terms of Merlin Donald's theory about the origins of modern culture (Donald, 1991), European culture is basically anti-mythical. It does not consider the universe, or life, as the result of a will and actions but as a fact, determined, in the end, by the laws of nature and logic. European culture is therefore also deeply universalistic, as it is aware of the fact that humanity is not something that pertains or belongs to a particular group or society. European culture cannot but consider itself as global, for the simple reason that it takes a stance on humanity that transcends the particularities of a certain belief or ideology. Our politics, our economics, our education systems are all imbued by this conviction that in order to keep beliefs at bay, a rational framework is necessary: it was a European who wrote that the sleep of reason produces monsters, and how right he was.

The opposition against the dominant rationalist perspective has, in the course of the past centuries, worn different masks but the underlying stance has remained very much the same. Rationalism was criticized from two different sides: that of collective value systems, as represented by religions and ideologies, and that of individual experiences and emotions. Together they were

responsible for the main forms of romanticism — the ideological and the artistic — that are also at the heart of European culture.

Multiculturalism

In recent debates on multiculturalism the relation between reason and belief is again at stake. In order to understand this problem we have to consider a second meaning of the concept of culture, which is precisely that of collective 'beliefs', or 'customs', or 'ways of doing things' ('traditions'). Now unless one accepts an overarching rational, 'value-less' framework, multiculturalism is simply impossible, because without this overarching framework, beliefs again become what they were before the Enlightenment, that is, metaphysical truths. But on a metaphysical level, multiculturalism is impossible, as one true belief necessarily excludes all others. Therefore, multiculturalism requires all 'cultures' to renounce their claim to truth and accept that there is one overarching common culture which is not metaphysical, which is not about values, and which is that of rationalism. This overarching framework reduces each of the participating cultures to a matter of choices. Beliefs are possibilities, options, often guided by very practical interests. And that, unfortunately, is still hard to swallow for many age-old, or putatively age-old belief systems. Christianity went through this process in Europe in the past centuries, but for many a culture coming from outside Europe it is still one step too far.

Cultural Awareness

A third meaning of the concept of culture is that of 'collective self-consciousness'. Culture now includes the arts, religion and ideology, the news, historiography and philosophy. The one umbrella uniting all these domains across their differences is the dimension of reflection, of culture pondering itself through perception, criticism, imagination, interpretation, and analysis (Van Heusden, 2009). This is culture-as-awareness or 'cultural awareness'. In European culture, cultural awareness is, or should be guided by the cultural — rational — tenets of the culture it reflects upon. In European education, however, this is still far from obvious, as many educators firmly stand in a romantic tradition of political and artistic opposition against rationalism.

To my mind, a European cultural awareness is an awareness of the uniqueness of the culture that was originally developed

in Europe, and of the great advantages the dominance of reason brought to society. Education in cultural awareness, that is, education in journalism, the arts, heritage and history, citizenship and philosophy should teach Europeans about the basic structure of their culture, and about the consequences of this structure for all the dimensions of public and private life: politics, economics, education, information and more. The very special political project that Europe is will only advance if Europeans are aware of what is really at stake. In order to achieve this, the perennial problem of the tension between rationality on the one hand and collective and individual values on the other hand must be tackled. It must, because unless the issue is cleared, Europe will always face the danger of falling back into romantic movements that aim at re-establishing some dominant creed – be it national, or religious, or political, or sectarian.

The Return to Reason

One danger that European culture has had to face since its beginnings, and which was very lucidly depicted already by Sophocles in *King Oedipus,* is the danger of the hegemony, not of reason, but of rationality. A rational culture is not the same thing as a culture of reason (Toulmin, 2003). In a culture of reason, which European culture strives to be, rationality is overarching but not all-mighty. In a rational culture, which European culture tends to become, rationality invades all other domains of life as well. The domains of experience and value are either marginalized or colonized; numbers take over in every field, be it care or education, politics or economics. Instead of respecting them as necessary for social and individual life, experiences and values are either considered to be irrelevant, nonsensical and wrong, or they are considered as marketable sources of financial profit.

The strength of the rational perspective, which involves the submission of value-thinking to truth-thinking, is also its weakness. Sophocles saw this danger, which is inherent in a culture based on rational inquiry, very clearly: in a society dominated by rational intelligence, even though this intelligence is capable to solve a great many practical problems (getting rid of sphinxes being only one of them) the community is bound to die, and so are intimate relationships. The pest reigns in Thebe, because Oedipus did not recognize his father, mother and siblings. A good many of the problems Europe is facing today derive from this almost

blind trust in rationalism, in the force of logic and mathematics and scientific research. It seems that the great truth underlying Enlightenment thought from the beginning, namely that value is not 'a matter of fact', has mistakenly been understood as, and perversely turned into: 'values are of no importance', 'values don't count' (pun intended). This is not, however, a correct conclusion, as we are now finding out the hard way. Values may not be matter of fact, but valuing is. It is a dimension of human culture, on an equal footing with perceiving, creating, and knowing.

In order to successfully advance the European project, it seems inevitable to finally make the rational choice for a culture of reason, based on rationality but not solely rational. Only through an immanent, that is: a rational critique, can rationality be kept at bay, and made aware of its own 'regionality' as one of the modes of human existence, cognition, and culture.

In order to be able to live in a culture of reason, one has to learn, first of all, to experience and to attribute values, i.e. to choose. Secondly one has to learn how to argue for and defend one's values in the public space. And, finally, one has to accept that these experiences and values do not and will never coincide with 'reality'. This requires both a strong cultural awareness and the ability to deal with complexity and change.

Arts and Cultural Education

An awareness of European culture is an awareness of what allows Europeans to be so different and yet coexist peacefully. It is an insight, as well as a felt experience, not of multiculturalism, but of the unity of a culture based on reason, in which a changing reality can be experienced and valued in a variety of ways, but will never be identified with either the experiences or the values.

What could this mean for one of the main forms of education in cultural awareness, namely arts education? What distinguishes the arts from other forms of cultural awareness, such as journalism, history, politics, or philosophy is that it is a reflection upon life through *imitation,* representing it in the form of a lived experience. Art mirrors experience, and it does so by giving it a palpable, perceivable form. Thanks to this concrete, experiential form we can live or relive the experience, alone or together with others, we can discuss it, or simply ponder it. Art is reflective imagination. It brings life to life — in movement, sound, artefacts, language and graphics.

Art serves to reflect upon life, to get a hold on it. The latter is particularly important, as it explains why art has been practiced since times immemorial. Art is more than a joke, or a no-strings-attached pastime. It helps us gain insight into ourselves, into others and into humanity in general. It contributes to our awareness and self-awareness and with that to our self-image and identity. When we act, we do so upon the basis of this self-image, and the image we have of others. Not in an abstract, conceptual or theoretical way, but through the imaginative recreation of an experience. As such, art is one of the most important forms of cultural awareness we have, and it is the form that affects us most directly, precisely because it comes with and through an experience. Which is why whoever is in power in a society also wants to control the arts — they mould consciousness.

Insight into the cultural function of the arts will help the public to understand why in contemporary European culture people seldom agree about which works or performances should be considered art. Only a few decades ago, when relatively small elites still decided about what mattered in culture, things were a lot easier. Today, we often live in more than one culture only (culture in the second sense discussed above!), and we have different kinds of experiences, which is one reason why we do not appreciate the same art works most of the time. And whenever this is the case — i.e. when we do appreciate the same artworks or performances — it might be because we share an experience, or because we have a similar history, live similar lives, share personality traits. More often, however, we disagree, and disputes about art are always a sensitive matter, precisely because our self-awareness, our self-image and our identity are at stake. The realization that people can have a very different cultural consciousness and a different view of life is of vital importance to democracy and to a true European culture. And this is an important argument in favour of art education as education in cultural awareness. Not only do students learn that life can be and has been reflected upon through imagination, and not only do they learn that this allows one to come to grips with it, but it is just as important that they also learn that one sometimes does not understand, that one cannot always understand, and that it is not always necessary to understand. And that this doesn't detract in the least from the right one has to one's own imagination — there is no final truth to imagination, only to imagining. To acknowledge that one does not

always understand someone or something, and to learn that this isn't a cause for panic is one of the main goals of art and cultural education, and fundamental to an open society.

Bibliography

- Donald, M. (1993) *Origins of the Modern Mind: Three stages in the evolution of culture and cognition,* Cambridge MA: Harvard University Press.
- European Commission (2007) *Key Competences for Lifelong Learning: A European Framework.* Annex to a Recommendation of the European Parliament and of the Council of 18 December 2006 on key competences for lifelong learning that was published in: *Official Journal of the European Union* on 30 December 2006, Luxemburg: Office for Official Publications of the European Communities.
- Heusden, B. van (2009) 'Semiotic cognition and the logic of culture', in: *Pragmatics & Cognition,* 17 (3), 611-627.
- Heusden, B. van (2014) 'Was wir von Kunst- und Kulturerziehung lernen', in: K. Westphal, U. Stadler-Altmann, S. Schittler, & W. Lohfeld (eds.), *Räume Kultureller Bildung: Nationale und transnationale Perspektiven,* (Räume der Pedagogik), Weinheim: Beltz, 58-75.
- Toulmin, S. (2003) *Return to Reason,* Cambridge MA: Harvard University Press.

Lessons of/for Europe
Reclaiming the School and the University

Jan Masschelein &
Maarten Simons

Homework, Assignments

In November 2013 we went to Athens with 28 Master students, in the context of a course on the design of educational spaces. The city derives its name from the goddess Athena. She was the protective goddess of the city, but also the goddess of wisdom and the arts and more generally of the practitioners of science. Ancient Athens, as we know, had (and still has) a large influence on the formation of Europe, not only through its art and ideas, but also because of its material inventions that are still traceable in the present: the agora, the democracy, the theatre, the school and the academy (to name just a few). Today we associate Athens with lots of other issues and especially with the crisis in and of Europe. In today's Athens, all our students individually walked a marathon: 21 kilometres from a point on the outskirts of Athens to the Acropolis and 21 kilometres back. During these walks, the students made observations and registered all kinds of parameters (informal settlements, benches, abandoned buildings, graffiti, et cetera), they talked to people, captured smells and sounds and shared moods. Every night they translated their observations into common maps, which covered about 1200 km of Athens' streets. They extensively discussed their observations and conversations. For example: the distance that the Trojka covers when they land in Greece to dictate the EU policy is about 40 kilometres, not by foot of course, but by car. The walks really impressed everyone involved in this educational exercise. Thousands and thousands and thousands of vacant shops and abandoned buildings (including huge Olympic stadiums, complete factories, large shopping malls), closed universities, closed hospitals, the extreme duality of society, the very precarious situation of migrants who were scared to death, walls and streets trying to speak (massive graffiti, demonstrations), occupations (of national broadcasting stations, public spaces), huge numbers of empty billboards, violent attacks, the guile of the mobilization (the auto-mobility in every sense as an anaesthetic and incantation), more than half of all young people unemployed (and not because they were 'incompetent'!!). And of course the students visited the Acropolis. But the Acropolis could not arrest their attention or move them. In fact, they literally and figuratively turned their back at the Parthenon and despised the bubble of happy tourist consumption in the immediate surroundings of the Acropolis. It was too different from the reality that confronted them during their walks and it had become vacant of

meaning itself, empty. Which did not only confront them (us) in a very existential way with what a crisis means, but also made them (us) think in an equally *existential* way about Europe itself. Athens as a magnifying glass for Europe's general condition? What about Europe, indeed?[1]

In May 2014, with over 70 students, we were involved in a collective research on mapping Europe as part of a course on educational policy. The aim of the mapping was to formulate an opinion on Europe and education. An opinion is not a personal thing. Or rather, when personal ideas are made public, and hence, considered to be worth making public, they turn into opinions. An opinion is a personal viewpoint that is shared. We thought Europe was in need of such opinions, that is, it was worth exploring how Europe could be turned into a matter of public concern. For that purpose, we did a simple exercise. Each student was given one European policy document or report, and was asked to make two things: a network visualization of all actors and agencies related to the document and a word cloud that gave an overview of the relative importance of words in the document. Without wanting to make major claims, everything was put together, resulting in a network with several hundreds of nodes and a word cloud based on more than a million words.[2] We pictured Europe as a network and as a vocabulary. These visualizations attempted to turn Europe into something to think about. The network images showed, for instance, the complexity of multi-layered governing, and more importantly, the visibility of soft governance, and the absence of politics. Is this what made European policy actually hard and influential? The alliance with the OECD became manifest. Something we already knew: we turn the OECD – think about PISA – into an 'obligatory passage point' (Callon, 1986) through our will to know about our performances. Representation is spread all over Europe, but not as a central node. The central nodes – the European Commission, European Parliament, Directorate General for Education and Culture – have an enormous hinterland of small actors and agencies. Is that hinterland showing how important the central nodes are? Or, perhaps, is that hinterland Europe's power, and hence is it indicating that European power is actually dispersed. Not a hierarchy but a netarchy. Europe, for sure, is the name for a powerful infrastructure, for empty symbols waiting to be filled and for fast communication circuits. Europe is discourse, and discourse is powerful. The

word cloud showed that learning and education were part of the European vocabulary. That was no surprise. But these words were immediately surrounded by the words qualification, training, quality, mobility and level. Europe, thus, is the name for that which loves to speak about managing education, about mobilization, about the recognition of learning results. Education refers to learning, and learning, for Europe, is too important not to be managed and valorized. The words 'European' and 'national' are also omnipresent. Europe clearly is in need of those words; Europe wants or has to talk about itself when it comes to education and learning, but always in relation to the national level. As if there is no European education (yet) and no national education (any more), and all other words just fill that gap. We made maps of the most visible actors and agencies, and we constructed clouds of words used in European documents. These visualizations and articulations helped us to regard Europe as something to think about, but also to listen to what only murmurs in Europe's presence. It allowed us to actually formulate our opinions about all those things and issues that are present in their absence, still looking for words and opinions to become public. European issues?

Lesson Planning
The American philosopher Susan Neiman, who is actually living in Berlin for many years now, recently gave the so-called Socrates-lecture on the future of Europe (2014). She stated that whereas many arguments to support the further formation of Europe (and the European union/project) often either appeal to fear (the fear of war, of threatening economic and political irrelevance), or point to personal or collective benefits and advantages that Europe would offer, it is important to stress that Europe is more than an organization and an infrastructure to satisfy (individual and collective) needs or interests (related to trade, mobility, etc.) Europe is actually also the name and materialization of some ideals and the question is, she says – reminding us of the famous words of JF Kennedy: 'Do not ask what your country can do for you; ask what you can do for your country' – what are we willing to do for this continent named Europe, not just as geographical entity, but as continent of ideals that are still worthy to maintain? We agree with Susan Neiman that today it is absolutely necessary to talk about Europe while not only appealing to fear or possible profit, but pointing to the ideals and believes it names. But whereas

Neiman mainly refers to the ideals of the Enlightenment, we wish to recall an older belief. We wish to recall the at once maybe familiar but also unique and radical belief that human beings are all equal *and* that they have no natural destination. Precisely therefore they can educate themselves. This is the belief that is materialized in the European invention of schools and universities as particular ways to deal with the new generations and to take care of the world that is disclosed for them. If *education* is the response of a society to the arrival of newcomers, as Hannah Arendt (2006/1958) formulates it, and if schools and universities are particular ways of doing this, ways that are different from initiation and socialization, ways that offer the new generations the possibility for *renewal* and the opportunity of making its own future, i.e. a future that is not imposed or defined (destined) by the older one, ways that imply to accept to be slowed down (in order to find, or even, make a destiny), ways that accept that education is about the common world (and not individual resources), then the question arises whether there is still a will in/of Europe to support schools and universities and to elaborate an *educational* policy that allows them to exist? Whether schools and universities are in themselves still a public European concern? It should be possible to address this question and concern in seven short lessons.

Lesson 1: European Education Policy is a Learning Policy
Twenty years ago the 'White Paper on Education and Training' of the European Commission already clearly stated that education is all about employment and competitiveness (White Paper, 1995: 1). However, it still started by indicating as a first approach to this challenge one that was 'focusing on a broad knowledge base' that should allow 'grasping the meaning of things', 'comprehension and creativity' and developing 'powers of judgement and decision making' (pp. 9-11). 'Developing everyone's employability and capacity for economic life' (p. 12), being the second response. Things have developed since then. The recent document of the European Commission on 'Rethinking Education' (EC-document 2012) does not hesitate to put the emphasis right from the start on 'delivering the right skills for employment' and on 'increasing the efficiency and inclusiveness of our education and training institutions' (p. 1), the starting point being that education is about 'boost[ing] growth and competitiveness' (p. 1). The Erasmus+ program, which started in 2014 and is the main

concrete EU-programme regarding education and teaching, states first of all that it 'aims to boost skills and employability' (Erasmus+, 2014). The conclusion being that 'Europe will only resume growth through higher productivity and the supply of highly skilled workers, and it is the reform of education and training systems which is essential to achieving this' (p.13).

There is also no doubt about what this reform entails. It is about 'stimulating open and flexible learning' and 'improving learning outcomes, assessment and recognition', indeed 'achievement should be driven by learning outcomes'. The argument is as follows: 'Education and training can only contribute to growth and job creation if learning is focused on the knowledge, skills and competences to be acquired by students (learning outcomes) through the learning process, rather than on completing a specific stage or on time spent in school.' There are very concrete frameworks set up that have the 'learning outcomes approach' as their basis: the 'European Qualifications Framework', and the (new or adapted) national qualification frameworks are based on it. However, the document complains that 'this fundamental shift towards learning outcomes has not yet fully percolated through to teaching and assessment. Institutions at all levels of education and training still need to adapt in order to increase the relevance and quality of their educational input to students and the labour market'. In order to do so 'the power of assessment needs to be better harnessed' since 'what is assessed can often determine what is valued and what is taught. While many Member States have reformed curricula, it remains a challenge to modernise assessment to support learning... the power of assessment has to be harnessed by defining competences in terms of learning outcomes and broadening the scope of tests and exams to cover these.... In this context, the potential of new technologies to help find ways of assessing key competences needs to be fully explored' (ibid. p. 5).[3]

It is difficult to state it more clearly than the document itself does. 'Rethinking Education' means to conceive of education as the production of learning outcomes. This 'fundamental shift', as the document rightly states, implies that educational policy is essentially about 'stimulating open and flexible learning' and 'improving learning outcomes', i.e. increasing the performance of 'learning environments' (including the performance of institutions, teachers, students) which can be assessed through benchmarking

(i.e. performance indicators). The overall aim being a more efficient and effective production process, employability (i.e. competences that are learning outcomes) being the product. And this implies even explicitly questioning the meaning of 'time spent in school' (p. 5). Indeed, it seems that schools are 'over' as reads the title of a 2008 report of the European Commission Joint Research Centre with the Institute for Prospective Technological Studies: 'School's Over: Learning Spaces in Europe in 2020: An Imagining Exercise on the Future of Learning'. It is a report that welcomes 'the marginalization of institutionalized learning' (2008, p. vii) and echoes with the increasing number of publications that want to unschool or deschool (Bentley, 2000; Griffith, 2010).

The European Commission is of course not alone in formulating its educational policy in terms of producing learning outcomes and in questioning the meaning of school. This 'fundamental shift' lines up with the policy of most nations worldwide and with the policy framework that is established by the OECD. It is therefore no surprise that it is increasingly providing 'frameworks' to influence 'learning' which address 'educational effectiveness' (analysing 'whether specific resource inputs have positive effects on outputs'), 'educational efficiency' (referring to achieving 'better outputs for a given set of resources' or 'comparable outputs using fewer resources') and 'educational sufficiency' (considering 'necessary conditions for providing the affordances most likely to impact on student learning'). It summarized as follows: 'The idea behind these concepts is that resource inputs... are used in educational activities so that they produce desired outputs for the individual, school and community' (Blackmore et al., 2013: 4).

Lesson 2: Learning Means to Accelerate and Mobilize
As we have seen, the actual European policy with regard to education is taking 'learning' and especially learning for increased employability as its core concern: 'the nexus is learning' and we develop into a 'learning-intensive society' (School's Over, 2008: ii; Miller, 2007). In this context, there is a tendency to maximize learning gains and optimize well-being and pleasure in fast and personalized learning for each and all. Behind these calls lurks a strategy that reduces schools and universities to service-providing institutions for advanced learning, for satisfying individual learning needs and optimizing individual learning outcomes. The

focus on learning, which today seems so obvious to us, is actually implicated in the call to conceive of our individual and collective lives as an enterprise focused on the optimal and maximal satisfaction of needs and even more explicitly requires an extreme flexibility (Simons & Masschelein, 2008, see also further). In this context, learning appears as one of the most valuable forces of production, one that allows for the constant production of new competences and operates as the engine for the accumulation of human capital. Time as time for learning is equated here with *productive time.* The issue of offering good education now becomes the issue of the efficient and effective production of *employable outcomes,* with learning actually being an investment that can be measured in terms of rates-on-return. Or, more precisely, learning becomes a matter of constant calculation keeping one eye on future income or return and the other eye on useful resources to produce learning outcomes. In fact, this is remarkably close to what Nietzsche (1872/1910: 37) already observed: 'The purpose of education, according to this scheme, would be to rear the most "current" men possible — "current" being used here in the sense in which it is applied to the coins of the realm.' Learning becomes a personal business, a matter of productive and investment time, something that is open to endless acceleration, and wants to produce just-in-time.

Therefore the space of a learning environment seems to be the perfect mirror of our hyperactive, *accelerating* society. Our schools and universities — when developing towards effective learning environments — become places for 'fast learning', or, at least, trying to increase the learning input-output ratio. Or as Nietzsche (ibid.) clarified very strongly: '... what is required above all is 'rapid education', so that a money-earning creature may be produced with all speed...' As a consequence, learning environments do not constitute the materialization of free or public time, without defined or private destiny, or of time of delay. Instead, this time becomes one of investment and production. The school and the university are no longer places where society puts itself at a distance from itself, or where someone is allowed to be slowed down by anything that provokes thinking. As far as still useful, schools and universities become a public service provided to individuals and to society, the community or the economy itself in order to reproduce itself, to strengthen, grow or expand. The 'learning environments' articulate the dictates of continuous

self-improvement, proactive self-adaptation and permanent self-mobilization. They mobilize everyone (teachers, students, institutions) as mobile learners. At the level of the experience of these learners this translates into the experience of having no time. Of course there is still 'vacant time', but if it is not altogether consumption time (fuelling the economy), than it is recovery time (to reload the batteries, and hence, refuel the economy). In Arendt's phrase it is 'left-over time' and not strictly speaking free time, free time being 'time, that is, in which we are... free *for* the world and its culture ...' (Arendt, 2006/1960: 202).

Reading these policy documents, it is clear that all of us are called upon to deploy our talents and competences for an economic war that, as these documents proclaim, must be permanently waged to ensure a prosperous society, to provide opportunity for all and to make Europe the world's highest performing knowledge economy. 'Europe can only succeed in this endeavour if it maximizes and employs the talents and capacities of all its citizens and fully engages in lifelong learning as well as in widening participation in higher education' (Leuven/Louvain-la-Neuve Communiqué 2009: 1). Governments have to engage in this permanent struggle and remind everyone of their duty to mobilize their competences and talents to contribute to the effort and, above all, to ensure that our competences and talents are *de*ployable and *em*ployable. We are being mobilized and called to duty: we must apply ourselves totally and always. In all of this European policy there seems to be a biblical combination of logics that makes it compelling, but at the same time destructive; on the one hand, a kind of humanistic logic of equal opportunities claiming that every talent, and hence, everyone of us, counts, and on the other hand, a kind of economic logic of exploitation that claims that we have to mobilize all available talents and turn them into competences in order to remain competitive. Also, this is again very similar to the 'two seemingly antagonistic tendencies, equally deleterious in their action' that Nietzsche (1872/1910: 37) observed in the nineteenth century: '... the first-named would... spread learning among the greatest number of people; the second would compel education to renounce its highest, noblest and sublimest claims in order to subordinate itself to some other department of life – such as the service of the State.' The combination of both tendencies actually leads to a situation where the main reference point of education is minimizing input and accelerating the

learning process in order to maximize output. Fast learning for a fast society in which there is no time to lose. The message is: time is not something you receive, and it is not something you give; it is a *resource* that can and must be *managed*. In this sense, there can *be* no 'free time', and we *have* no time — we can only set priorities for how to use always-already occupied time. This condition is aptly articulated in the now well-trafficked terms 'permanent' and 'permanence'. Being a learner means being permanently busy and being a learner is a permanent condition in order to remain, as Nietzsche called it, a 'current' man.

Lesson 3: Culture turned into a
Resource for the Professional Learner

Mobilization (maximum exploitation of resources — human, physical, social, cultural) and personalization are seen as adequate responses to challenges that are understood in terms of productivity (i.e. increasing added value). If you don't want to sink into the swamp of waste of talent and loss of production time, you should resist the temptation to be overly concerned with the common everyday world in which we live. The mobilization of students and, more particularly, of the resources or talents that they embody is one of the most important strategies to increase Europe's competitiveness, but also that of member states, universities, research centres and teaching programmes. Part of this strategy is to address the students as *professional* learners who invest in their human capital (and therefore have to be entrepreneurs who manage their private businesses), produce competences to increase their employability. Precisely in order to enable and optimize this production process, education and educational programmes must become totally transparent in terms of output (learning outcomes, competences) and means. This transparency is a logical and necessary request from the viewpoint of professional learners who are always in a hurry. For them learning is a stressful affair: looking for study trajectories or credits with market value (added value), niches, opportunities to invest, choices with high returns, creative accumulation of competences and credits to accredit themselves. They have to manage and accumulate these credits, ECTS-points and count the hours of study and learning.

It is no surprise that the educational relationship becomes a contractual relationship (in the first place a legal agreement concerning the service between a provider and a customer — a

customer who can be motivated only by the return, or in today's parlance 'incentives'). Nor that education is organized as a collection of individual learning trajectories to guarantee optimal learning gains (improvement), nor that professors are also asked to become professional teaching staff – not in the service of truth, but in that of the learning outcomes of individual learners – and that they are asked to think of their teaching as production of learning outcomes with the learners. Such a professional attitude (aimed at performativity and efficiency in terms of learning) is not experimental, but implies submission and obedience to a permanent economic tribunal, combined with the fear to lose time and to not be productive. It turns professors and students into individual learners who make private use of their powers of reason, are not relating to a commons but to resources, following individualized trajectories, and who have no time, or better, know only productive time.

Lesson 4: Learning as Investment
and the Risk of Speculation

The learning policy as a policy founded on the capitalization of learning in terms of competences is increasingly creating 'credit bubbles' that are not so different from the ones being produced in the financial world. Following Marx' theory of the 'tendency of the rate of profit to fall' within capitalism, David Blacker convincingly argues that we can now witness a 'falling rate of learning' (Blacker, 2013) – learning being the new labour force to produce added value. Indeed, apart from the fact that less and less 'workers' (and 'a fortiori educated ones', p. 79) are needed, there is the inherent tendency that the added value of competences (the learning outcomes) decreases and that therefore there is a need for ever more learning, ever more competences (the ultimate competence being the one to learn to learn everything) in order to produce added value and to keep the rate of profit high enough (both at the level of the individual workers and the companies that 'employ' them). There is the increasingly empty and endless acquiring of competences that return the curriculum 'to its etymological roots and revolves back into a race. The word curriculum is a Latin derivative from the verb *currere*, which means 'to run' and 'to move quickly'... this race is in 'perpetual motion'... [and] is always left open as the ultimate flexibility' (Storme, 2014: 291). Maximizing flexibility or producing one's own 'empty'

productivity — without content or world — is becoming the aim of the fanatic learner who is the ideal worker that, for instance, Google is looking for. In a brief article on 'How to get a Job at Google' in the NYT, Thomas Friedman quotes Laszlo Bock, 'the senior vice president of people operations for Google — i.e., the guy in charge of hiring for one of the world's most successful companies' saying that '... for every job, though, the No. 1 thing we look for is general cognitive ability, and it's not IQ. It's learning ability.' (NYT, Feb 22, 2014)

As Blacker (2013: 3-4) further indicates for the neoliberal world in general, but is certainly also true for Europe, the imperative to engage in this race to acquire ever more competences and being ever more flexible is so effective because we are so well-prepared by the tradition of our religious narratives, which encourage us to look for guilt within our 'sinful selves'; the guilt of not yet being the most competent and competitive learner or the most competitive knowledge economy. The actual narratives that sustain the learning policies strongly suggest that if we could make ourselves stronger, smarter, i.e. learn more, better, faster, then 'our bright futures would once again be assured' (p. 3). We have only to blame ourselves: burdened forever by 'the new original sin, of which we are perpetually guilty: our all-too human failure to keep pace with the exponentially increasing drumbeat of production'. But 'fortunately', as the many discourses that surround and support the learning policies assure: '... we can become ... plastic 'lifelong learners', in other words, infinitely malleable human material' (p. 4) that can be used to keep the economy running and produce growth. Growth and well-being, so the story goes, are all in our own hands, and the cardinal sin is not to acknowledge that.

Moreover, one should consider whether another great illusion is being created and perpetuated here, based on the highly questionable premise that it is actually possible to realize an effective link between acquiring certain knowledge and skills on the one hand and the labour market and society on the other. The objective of employability (and hence, no longer employment), combined with a focus on competences, is actually based on that premise. It often echoes the dream of learning and education that is finally useful, that is finally connecting with the real world, and hence, the often announced but now welcomed realistic turn in education and learning: 'professional learning (preparing) for life'. But actually, it is based on a very speculative mode of rea-

soning. If competences are the goals of education and these competences are assumed to be underlying certain activities, education and learning – when focusing on competences – is actually oriented towards assumptions. One may wonder whether we are confronted here with a gigantic 'speculative' or 'transcendental' operation that consists of trying to 'presuppose' what unique sets of knowledge, skills and attitudes are needed to 'perform' certain activities. Ironically, the engineers of fast learning seem to subscribe to a grand and old metaphysical tradition that actually tried to recover or reveal and carefully articulate the presuppositions of our knowing and speech activities. One almost needs (again) a training in metaphysics if one wants to make sense of those long, amazingly detailed and carefully constructed competences lists.

Lesson 5: A Crisis in Education is a Crisis in Culture

If we take as our starting point Hannah Arendt's suggestion that culture refers to 'the mode of intercourse of man with the things of the world' (2006/ 1960: 210) and more specifically to *'[taking] care of the things of the [common] world'* (p. 211, our italics), then we can state that pedagogic forms – and especially the school and the university – are among the most important ways in which this intercourse and 'loving care' (p. 208) take place. This is so because they deal in a particular way with the new generations which constitute always *both* a 'threat' to the common world (which 'needs protection to keep it from being overrun and destroyed by the onslaught of the new that bursts upon it with each new generation' (Arendt, 2006/1958: 182)), and a promise of its continuance *and renewal* ('our hope always hangs on the new which every generation brings' (p. 189)). Schools and universities deal with the new generations in a particular way, in that they do not want the old generations to control or dictate how the new might or will look (i.e. they represent the world by putting something on the table, but in that act, also setting it free) *and* in a way that they form the new to be fit to take care of the common world (i.e. they promote the *cultura animi*, (p. 211)). Schools and universities do this to the extent that they offer 'free time' or 'leisure time' (*scholè* in Greek), which is not simply vacant time ('left-over time', see above) but 'time to be devoted to culture'. (Arendt, 2006/1960: 195) From this perspective, culture is not just simply referring to works of art, or habits or systems of signs. It always also includes ways of taking care of (the things of) the

common world, that is, very specific practices and technologies that allow shaping oneself in relation to the world.

When using the terms 'school' and 'university' in referring to specific pedagogic forms, we are actually referring to the rich practices and technologies (of lecturing, of researching, of rehearsing, of looking,... all making study, exercise and thinking possible) that, on the one hand, allow for people to experience themselves as being able to take care of things, and, at the same time and on the other hand, to be exposed to something outside of themselves (the common world). It is a very specific combination of taking distance and (allowing for) re-attachment. As a consequence, the terms 'school' and 'university' are not used (as is very often the case) for so-called normalizing institutions or machineries of reproduction in the hands of the cultural or economic elites. There is reproduction and normalizing, of course, but then the school or university does not (or does no longer) function as a pedagogic form. There is an important element of slowness in these pedagogic forms, exactly because immediate political, social or economic requests and claims are, for a while, put at a distance or suspended (hence, not ignored or destroyed). Or more precisely, when being engaged with the world, and hence, when taking care of things, there is no point in meeting economic, social, cultural and political requirements and expectations that accelerate because from these outside perspectives and within their rationale there is no time to be lost (especially not at school).

Focusing on the existence of schools and universities as particular pedagogic forms along these lines, also means to be ready to put society at a distance from oneself. In other words, a society that accepts schools and universities always runs the risk that reproduction or the cycle of fast learning in view of permanent employability is broken down. Actually, in order to allow the coming generation to be a new generation, a society that accepts schools and universities must give and make (free) time, must prevent that the claims from society overrule the claims made on society by the new generation, must put something on the table and set things of the world free, and as a consequence, allow these things to slow down. This also means that such a society is forced to engage in a discussion about what kinds of 'grammars' one wants to offer to the new generation so that it can take its future into its own hands. Competences may, although this is highly speculative, guarantee

employability, but there is no possibility, that is, no grammar, to create distance. The basic grammar of society slows down, but it also allows to begin, to relate, to give shape to oneself.

Education, thus, is not in the first place about needs and functions, not even about values. As Arendt states, 'values' — even 'cultural values' — are 'what values always have been, exchange values, and in passing from hand to hand they [are] worn down like old coins' (p. 201). Education is a whole of practices to keep the things of the world out of the circles of consumption and the business of use and exchange value. It is about 'common things' that have 'the faculty of arresting our attention and moving us' (Arendt, 2006/1960: 201) and therefore it is cultural. In this sense, we can consider 'schools' and 'universities' to belong to the most elementary part of Europe's 'cultural heritage', that is, they belong to the heritage that allows us to take care of the common world. And precisely because Arendt also states that this heritage is today offered to us without testament (p. 3), it seems that it is in need of our explicit support when the common world is transformed into a pool of available resources for fast learning and producing predefined outcomes. Or to put it differently: the actual European educational policies that focus on learning and learning outcomes, and that equate 'slow time' with 'lost time', imply a direct attack on the taking care of a common world and, thus, on European culture. A crisis in education is then a crisis in culture.

Lesson 6: Reclaim the School and the University

There are modes of learning outside the school and the university, and there are also practices of initiation, apprentice-master relationships and on-the-job training. It is not our intention to disqualify these other forms of learning. But schools and universities are different. They organize collective and public forms of learning, and they impose a different responsibility on society as well. A responsibility to decide on basic grammars, and hence, to gather people around these grammars (and creating a public in that sense), and as such it is about creating relations between generations, about relating to a common world, about making knowledge and practices public, and about allowing for renewal. The university and school offer time that is freed from the needs and urgencies of the world, and to use that time to contribute to things in common. It is time to reclaim the school and the university.

To reclaim the school and the university means first of all to take them from the hands of those who do not acknowledge that the coming generation is a new generation. Not only from the hands of the political and cultural conservatives, but also from the hands of those who in the name of progress turn schools into learning environments and implicitly or explicitly favour fast learning. To reclaim the school is not about restoring classic or old techniques and practices, but about actually trying to develop or experiment with old and new techniques and practices in view of designing a pedagogic form that works, that is, that actually slows down, and puts society at a distance from itself. In these attempts, we wish to stress two issues that may be taken into account.

First, the school and university as pedagogic forms include a very specific idea of equality. In line with Rancière (1991), one could argue that pedagogic action starts from the assumption of equality, that is, the assumption that everyone should be able to know, understand, speak.... Equality in pedagogic terms is not a fact, but a kind of assumption that is verified in pedagogic action. This equality is closely related to the assumption that human beings have no natural (or culturally or socially imposed) destiny, and hence, they can and have to find and shape their own destiny. This assumption is not making education impossible. On the contrary, there being no destiny, natural or otherwise, makes education – in terms of shaping oneself – possible and gives it meaning. It is important at this point to stress that a pedagogic perspective is different from and not to be reduced to a political, ethical or cultural perspective. We cannot elaborate upon this in detail here, but one could think of the pedagogic perspective as referring to the assumption of equality and freedom in terms of 'being able to...', whereas the ethical perspective often includes a point of departure in terms of 'having to' or 'being unable not to'. Furthermore, both politics and pedagogics are concerned with change, but collective change through reform is different from renewal initiated by a new generation. Yet, it is clear that politics often uses schools and universities for reform, and hence exploits the coming generation as a resource for solving problems in the current society. Perhaps the school and university should not be politicized, but we should acknowledge that allowing schools and universities to exist – as sites of pedagogic renewal – is in itself a political act. Finally, schools and universities should not be

mistaken for forms of initiation into a culture, or into norms and values of a society. In a sense, at schools and universities culture is always already put at a distance, that is, it becomes a common thing that allows for study, exercise and thus renewal. But spokespersons of 'the culture' often claim the school and university as sites of initiation. In our view, this does not do justice to schools and universities, but equally, it reduces cultural work to school work. This is not to say that schools and universities are not cultural, or have nothing to do with culture. As far as the world and shared, common things take central stage, they actually 'make' culture and prepare the new generation for culture.

Second, it may be interesting to distinguish between different 'levels' within pedagogic forms. In the previous sections, we have not distinguished clearly between the meaning of the school and that of the university. Suggesting distinctions probably reaffirms that education is cultural in the sense of 'putting the world' first, and therefore it is worth formulating some theses about what could be called the 'finality' of the different levels of education. Each level is somehow involved in putting the world at a distance, but at the same time making care or attachment possible. Perhaps, the kindergarten is about 'playing'. In kindergarten, something is brought into play, and that thing becomes something to focus on. Learning through playing is then not just an artificial activity, but the play allows children to be engaged in something because it temporarily keeps parts of the world (that is, requests and utility) outside. Primary education could be about offering the basic grammars, and hence, allowing young people to acquire a basic shape. These grammars are needed in order to be able to relate to what (in the world) is influencing us. The grammars do not impose a destiny on each and all, but allow each and all to find a destiny. In this vein, one could think of secondary education as the place and time of the formation of 'interest' (fascination, curiosity about something). It is about making possible that something outside of your life-world and common horizon touches you, and slows you down in your orientation to study, exercise and think. Finally, one could argue that higher education is about the formation of the faculty of judgment and taste. This means that basic grammars and cherished interests can always be questioned. In higher education, it is always about a kind of learning through research, in the broad sense of transgressing the limits of what is of interest or what the basic grammar is, and hence allowing for a distance

and care that makes judgment and taste possible. These distinctions need elaboration, but they can serve as touchstones in order to develop and experiment with pedagogic forms within Europe, at least if Europe allows for schools and universities to exist.

Lesson 7. The Price for Europe to have a Future

A European *educational* policy that does not put 'learning' and 'resources', but the renewal of society, the care of the common world and especially the possible future of new generations at the centre, should allow for schools and universities to remain. Or, in stronger words, it should focus on the support and reinvention of these pedagogic forms. Therefore, such a policy must not offer benchmarks but touchstones, i.e. no measures of performance but measures of authenticity, in order to investigate whether new forms of gathering people and things can be considered as being truly a school or a university. Such a policy would include the awareness that the existence of schools and universities requires the European community to deliberate democratically on the grammars that it wishes to offer to the new generation. Or, put differently: the will to have schools and universities confronts Europe with the responsibility to articulate what is common and therefore urges Europe to engage in a public debate on what is common. By contrast, a policy that is focusing on learning needs, learning resources and learning outcomes reduces 'European frameworks' and 'European spaces of (higher) education' to an infrastructure to promote private interests instead of allowing it to be a space of exposure to common things, a space to take care of the common world and become fit to take care of that common world. These frameworks and spaces are not operating in the name of a common world, but in the name of private interests, choices, preferences and concerns and in name of their own survival. They just enable or facilitate an ongoing capitalization of learning, a permanent mobilization and acceleration and an increasing speculation.

To us, what Arendt writes at the end of her famous text on 'The crisis in education' is now more valid and right then ever: 'Education is the point at which we decide whether we love the world enough to assume responsibility for it and by the same token save it from that ruin which, except for renewal, except for the coming of the new and young, would be inevitable. And education, too, is where we decide whether we love our children

enough not to expel ... from their hands their chance of under-taking something new, something unforeseen by us, but to pre-pare them in advance for the task of renewing a common world' (Arendt, 2006/ 1958: 193). Relating this back to her recollection of Cicero's *cultura animi* as a training and cultivation of men in order to be 'fit to take care of the things of the world', we could maybe state that 'education', this particular way of dealing with the new generation which is materialized in schools and univer-sities, is one of the most essential cultural heritages of Europe. Moreover, one that would support that other heritage which we call democracy, since it forces it to have a debate on what it wants to put on the table in relation to the new generation. It is clear that a society does not put itself at a distance of itself spontane-ously, and certainly not at the moment that it is dominated — as Stiegler (2010) discusses in great detail — by all kinds of media powers that are used 'to form opinions' and 'capture attention'. Gaston Bachelard (1967/1934) once spoke about 'une société faite pour l'école' (that means a society that fits the school, not a school that fits a society). He asked whether society is ready to recognize the school as such, as having its own 'public' role and to provide it with the means to 'work', a society which does not ask of the school what it cannot do but provides it with the means to be a school: to provide 'free time' and transform knowledge and skills into 'common goods', and therefore has the *potential* to give everyone, regardless of background, natural talent or apti-tude, the time and space to leave their known environment, rise above themselves and renew the world and thus change it in un-predictable ways. The price such a society has to pay is to accept that it is *slowed down* (because there could be something more im-portant), that it gives its future out of its hands (and reconfirms that there is no destination, fundamentally accepting its finitude) and is ready to trust people enough to free them of requirements of productivity in order to enable them to make school happen. The price for Europe to have a future therefore is focusing its educational policies on the support and reinvention of schools and universities.

Questions?

Is a learning policy actually an adequate response to what Athens reveals of the European condition? Is it not just one more step in the acceleration and speculation which, confronted with the

falling rate of learning as the new resource to capitalize, now is going towards the total exploitation of time?

Is the 'fundamental shift' towards learning outcomes and lifelong learning as the permanent production and valorization of the learning ability in itself not related to 'a generalized inscription of human life into duration without breaks, defined by a principle of continuous functioning ... a time that no longer passes, beyond clock time' (Crary, 2014: 8)? Is it part of the creation of a '24/7 universe', as Crary calls it, which implies the 'mobilization and habituation of the individual to an open-ended set of tasks and routines' (p. 83) and is 'continuous with a generalized condition of worldlessness' (p. 18)? Is there still a world for the fast learner since 'world' refers to something that is not a resource to be used, and hence, something that asks too much and slows down?

Does Europe still want a future beyond what is anticipated in the logic of investment and innovation? Can it accept to be slowed down? Can it accept 'un-productive time'? That is, school-time, university-time? Does it still allow these words to be used? Is it still listening to the murmurings of what is not connected, what is not waiting to be connected or prefers not to be connected in the power networks? Can it leave behind the words 'European' and 'national', or at least bracket their pressing operations, in order to allow for schools and universities to look for meanings and futures? Perhaps Europe is in need of another liberalism, a kind of pedagogic liberalism, and hence, an assumption of trust in schools and universities, since we have to find our own destiny.

Notes

1 The findings (including maps, photographs, texts) were discussed at a four day public workshop 'Educolabo' in May 2014. See: https://ppw.kuleuven. be/ecs/onderwijs/labo/toelichten/labo
2 For more information, see: https://ppw. kuleuven.be/ecs/les/mediapaginas/ meningsvorming-publiek-debat (in Dutch).
3 As the document further states 'A number of European instruments such as the European Qualifications Framework (EQF), Europass, European credit transfer systems (ECTS and ECVET), the multilingual classification of European Skills/ Competences, Qualifications and Occupations (ESCO) and quality assurance frameworks have been implemented in the last decade to support the mobility of learners and workers.' (p. 5) These instruments 'will contribute to real European mobility where a person's knowledge, skills and competences can be clearly understood and quickly recognized'. It is accompanied by the 'creation of a European Area of Skills and Qualifications' (p. 5) and finds also an articulation in the 'European Civil Society Platform on Lifelong Learning'.

Bibliography

— Arendt, H. (2006) 'Preface: The Gap Between Past and Future', in: *Between Past and Future,* New York: Penguin, 2-15 [1961].
— Arendt, H. (2006) 'The Crisis in Culture: its Social and its Political Significance', in: *Between Past and Future,* New York: Penguin, 194-222 [1960].
— Arendt, H. (2006) 'The Crisis in Education', in: *Between Past and Future,* New York: Penguin, 170-193 [1958].
— Bachelard, G. (1967) *La formation de l'esprit scientifique: Contribution à une psychanalyse de la connaissance objective,* Paris: Vrin [1934].
— Bentley, T. (2000) 'Learning beyond the classroom', in: *Educational Management & Administration* 28 (3) 353-364.
— Blacker, D.J. (2013) *The Falling Rate of Learning and the Neoliberal Endgame,* Winchester and Washington: Zero Books.
— Blackmore, J., Manninen, J., Creswell, J., Fisher, K. & Von Ahlefeld, H. (2013) *Effectiveness, Efficiency and Sufficiency: An OECD Framework for a Physical Learning Environments* Module retrieved on 6/11/2014 from: www. oecd.org/edu/innovation-education/ centreforeffectivelearning- environmentscele/LEEPFramework- forWEB.docx
— Callon, M. (1986) 'Some Elements of a Sociology of Translation: Domestication of the Scallops and the Fishermen of St Brieuc bay', in: Law, J. (ed.), *Power, Action and Belief: A New Sociology of Knowledge?,* London: Routledge and Kegan Paul.
— Communication from the commission to the European Parliament, the Council, the European Economic and Social Committee and the Committee of the Regions (2012). Education: Investing in skills for better socio- economic outcomes. COM/2012/0669 final. Retrieved on 6/11 from: http:// eur-lex.europa.eu/legal-content/EN/ ALL/?uri=CELEX:52012DC0669.
— Crary, J. (2014) 24/7: *Late Capitalism and the Ends of Sleep,* London: Verso Books.
— Griffith, M. (2010 – 2nd ed.) *The Unschooling Handbook: How to Use the Whole World As Your Child's Classroom,* New York: Prima

Publishing (Random House).

— Miller, R. (2007) *Towards a Learning Intensive Society,* retrieved on 6/11/2014 from: http://www.urenio.org/futurreg/files/making_futures_work/Towards-a-Learning-Intensive-Society_The-Role-of-Futures-Literacy.pdf.

— Nietzsche, F. (1910) 'The Future of Our Educational Institutions', in Levy, O. (ed.): *The Complete Works of Friedrich Nietzsche,* retrieved on 26/11/2014 from: www.gutenberg.org/files/28146/28146-h/28146-h.htm [1872].

— Neiman, S. (2014) 'De toekomst van Europa', in: *De Groene Amsterdammer,* 138 (10) 30-35.

— Rancière, J. (1991) *The Ignorant Schoolmaster: Five lessons in Intellectual Emancipation,* Stanford CA: Stanford University Press.

— Simons, M. and Masschelein, J. (2008) 'The governmentalization of learning and the assemblage of a learning apparatus', in: *Educational Theory,* 58 (4), 391-415.

— Simons, M. and Masschelein, J. (2008) 'From schools to learning environments: the dark side of being exceptional', in: *Journal of Philosophy of Education,* 42 (3-4), 687-704.

— Stiegler, B. (2010) *Taking Care of Youth and the Generations,* Stanford CA: Stanford University Press.

— Weil, S. (1948) *La pesanteur et la grace,* Paris: Plon.

— Storme, T. (2014) *Education and the Articulation of Life: Essays on children, animals, humans and machines,* unpublished doctoral dissertation KU Leuven.

Part 4

Political Culture

No High Culture,
No Europe

Naema Tahir &
Andreas Kinneging

Introduction

The present time is a time of uncertainty. Not so long ago, the mood was very different. The Berlin Wall and Communism had collapsed, democracy and the rule of law were on the rise everywhere in the world, and European unification made giant strides forward. Now, about twenty years later, optimism has given way to pessimism. Globally, democracy and the rule of law are on the defence. Neither is all well with European unification, for nationalism is on the rise everywhere in Europe. And there is of course the uncertainty related to the Islamic part of the world. It is hardly an exaggeration to speak of a prevailing sense of crisis.

In this paper the authors try to outline a philosophical analysis of our present situation, within Europe and outside, and give some suggestions on how to adjust in order to improve. The state seems a crucial variable, and therefore we begin with an analysis of the state. Culture seems a crucial variable as well, but rather than defining it as 'a shared frame of reference' or 'something that gives meaning to people's lives', as is mostly done today, in this paper we emphasize the significance of culture in the traditional sense of the world, i.e. High Culture.

I.

Of all organizations, the state is the most problematical. Not surprisingly. Mankind has known for a very long time that freedom, in the basic sense of freedom from oppression by others, presupposes an equality of power as well as checks and balances.[1] The state, however, usually is much more powerful than everyone else in society, and hence no one is capable of providing real checks and balances against it. The darker side of human nature — *pleonexia, libido dominandi,* etc. — virtually guarantees that such power will be misused. Hence, the frequency of tyrannies of various stamps in the history of the state.

The state nevertheless has a notable tenacity. All uprisings against a tyranny end in the establishment of a new state, or of new wielders of power within the same state. It never results in the abolishment of the state, as anarchists would like. Perhaps because the new wielders of power need the state as much as the old ones for their purposes, or perhaps because real anarchy looks different from what the anarchists imagine it to be like. Real anarchy, it is often said, is war, *bellum omnium contra omnes,* so to speak, in which everyone is a potential mortal enemy, and life is

hence 'nasty, poor, brutish and short'.[2] In other words, the state is exceedingly problematical, but the absence of the state is even more problematical.

If, as it seems, abolishing the state is no viable option, the question is: how do we minimize the chances of a state degenerating into a tyranny of some kind? A partial answer to this question is to be found in the intellectual tradition of constitutional theory and law, the most fundamental recipe of which is building checks and balances *into* the organization of the state. (Not to be confused which the checks and balances mentioned above, which are concerned with power relations *vis-à-vis* the state.) But there is another side to this issue, i.e. the question of the size of the state. Taken in the sense of number of political offices and civil servants, that topic too is a matter extensively discussed by constitutional theory and law. But no so, when size of the state is taken as size of 'the country'. There are large countries and small countries. What, if any, size of a country, is more prone to tyranny? Moreover, what world is more prone to tyranny? A world of small countries, or a world of large countries, and ultimately one country?

There is a strong tendency, especially among international law enthusiasts, to believe that one world state should be the ultimate goal. There are strong reasons, however, to believe that large countries are likelier to degenerate into tyranny than small ones.[3] In this respect the state is no different from any other organization. The larger it gets, the more power will have to be centralized. This has aptly been called the iron law of oligarchy.[4] Only very small organizations can be really democratic. Contemporary large-scale states that call themselves democracies, are at best democracies only a few seconds every four years or so.[5] In between they too are oligarchies. Now, an oligarchy can easily turn into a tyranny. Every time the oligarchs rule in their own interest instead of the common interest of the whole people, tyranny is established. From servants of the people they have changed into their masters, who use the people for their own designs. Given the darker side of human nature, already referred to, the chance that this will occur is substantial. And the history of states provides ample evidence of it.[6]

Large states are also more warlike than small ones. Large states bring about big egos in their rulers. Big egos easily become tyrants. They consider themselves much better than anyone else

and uniquely capable of ruling. Such people are also likely to wage war. Everyone has to be shown who is strongest! And because their state is so large, and hence their armies as well, they often succeed in their aggression. As a result of which their country or its sphere of influence becomes even larger, and so do their egos. The upshot of this analysis is evident: a world of small states is the best world. Long live *Kleinstaaterei*!

II.

Let us now turn to Europe and the attempt at European unification that is called the European Union. What's the point of it all? Superficial minds think that it is all about free trade and everyone getting richer. And in a superficial sense, it really is all about that. But there is a deeper and darker underlying issue here, or rather two issues.

First, there is the issue of the giant Germany, a country much larger and stronger than any other European country, France and Britain included. Humbled by guilt and shame for the role their country played in the Second World War, the present generation of Germans consists of perhaps the most civilized and unassuming people of Europe, and Germany poses no danger. But what will happen to the German ego, two or three generations further down the road? Large countries give birth to big egos, small oligarchies, tyrannies, and a lust for war, as we argued before. Chances are that today's Germany is a temporary phenomenon, and the future will bring a return to the 'normalcy' of a large country that will try to dominate in the world, near and far. From the very beginning, the European unification was intended to prevent this from happening, by integrating Germany as far as possible into the greater European whole.

In view of the danger of large states, would it not have been preferable to cut Germany into pieces after the war, and bring it back to pre-Bismarckian times? Yes, of course it would have, but that was impossible. Even the division into an eastern and a western part was artificial and could not last. Moreover, the founders of European unification had a second aim, which conflicted with such *Kleinstaaterei*. They aspired to make Europe an equal to Russia and especially the United States, which after WWII had taken over world dominance from Britain, France, and Germany. One of the founders, Adenauer, explicitly spoke of European unification as 'Europe's revenge upon America'. Europe had to

become as large and influential a country and state as the USA. And this is still – usually unsaid – its goal.

It is safe to say that a world without large countries would be much safer. A world in which the North-American continent would consist of dozens of small countries instead of one giant. (And a small country, with a small-country mind-set, on a huge, icy, empty piece of land.) A world without China, Russia, India, and Brazil. A world without quasi-states such as the European Union and large organizations such as NATO, which wield state-like power in their field. A collapse of all this largeness is not impossible. After all, it would not be the first time in history for empires to implode and fall apart. Think of the Roman Empire, the Carolingian Empire, the Mogul Empire, the British Empire. And there are many other cases.[7]

However, there is no indication that this will happen in the foreseeable future. For the moment we are stuck in a world of large countries, or, to be more precise, a world in which the few large countries dominate over the many small countries. From this perspective, the idea of European unification is not a bad idea at all, both for Europeans and for the world at large.[8] For Europeans, this means that they will be part of a really large state, which gives status, power, and security. For the world, it means that there is one more large state. And more large states is better than fewer large states. For the more large states there are, the less each one of them will be able to impose its will upon the world.

But let us not fool ourselves into believing that European unification is something idealistic and unproblematic. That Europe will be a 'soft power'. A large state, as we said before, implies a small ruling oligarchy that easily becomes oppressive and tyrannical. It is full of overly big egos, and too fond of warfare. Many Europeans are quite aware of all these problems and dangers, when reflecting on China, the USA, Russia, and other large countries. But they are blissfully unaware of the fact that European unification poses exactly the same threats.

III.

Knowledge of the problematical nature of the state, and the large state in particular, is anything but new. It was first put forward in the works of the philosophers of ancient Greece. And, in contrast to their cosmological views, which are by and large superseded, the Greek ideas on these matters are anything but outdated.

Indeed, never again was that reflective level reached again in later days.[9] In this literature, we not only find extremely astute analyses of the problematical nature of the state, but it is also full of perceptive and judicious insights on how to deal with it as best as possible. One finds, for instance, elaborate theories about building checks and balances into the organization of the state.[10]

Even more prominent than such theories of checks and balances, however, are theories of education (Greek: *paideia*). One of the basic ideas of Greek political thought is that a good state is impossible without a good education of the people in general and the ruling elite in particular.[11] Now, this idea of *paideia* is closely related to our conception of culture. This latter nation is Latin in origin, and is derived from the verb *colere*, which means 'to grow', 'to cultivate'. It primarily referred to agriculture, in Latin *agri cultura*. But, thanks to Cicero, that great translator from the Greek, it also came to be applied to the human soul. In his *Tusculan Disputations* we read: 'Just as a field, however good the ground, cannot bear fruit without cultivation, so souls cannot bear fruit without teaching (doctrina)'.[12] In sum, culture is a product of education. A cultured person is an educated person. The culture of a country depends on the education of its people.

What the Greek philosophers were searching for, was an education resulting in a culture that could handle, among other things, the problems inherent in the nature of the state. If the argument in section I above is correct, i.e. that these problems only increase with the size of the state, the world we live in today, and the process of European unification in particular, make this search even more pertinent for us today, than it was to the ancient Greeks.

What does such an education look like? It is in essence an education of the human soul. Since the problematic nature of the state is in the last resort a consequence of the problematic nature of the human soul. After all, it is human beings who make up the state, who are subjects, voters, and rulers. When the state degenerates into an oppressive tyranny, it is human beings who do it, human beings who collaborate, and human beings who accept it. The basic idea of this education of the human soul is controlling the darker side of human nature and reinforcing the brighter side. From this perspective, education — true education — is not merely transferring knowledge or skills, but improving characters, making better persons. Education is moral education.

Hence, culture, the product of education, is equal to civilization and virtuousness, as opposed to barbarism and viciousness. A cultured person is a good person. He is no longer the person he once naturally was, but has acquired a second nature, a better nature. Culture is thus the improvement of human nature. Culture, in this sense, is important for every human being, but it is supremely important for those who rule over other human beings, since due to their august position in society they are much more capable of doing evil than the average man.[13]

IV.

What should such a cultural education look like? This is one of the basic themes of Greek thought, and both the question and the answers that were given by the Greeks, have exerted an unparalleled influence over European thinking concerning these issues for two millennia, both directly and as mediated by the Romans. It is only in the last fifty years or so that this influence has declined. Hence, European ideas on education and culture have always been decisively shaped by the ancients.

This cultural education was an education focused on and structured by what was called the art of living (*techne tou biou, ars vivendi*). Living a good life, i.e. a happy life was seen as an art. That is to say, it was considered to be difficult, and had to be learned. It was argued that many misunderstandings come natural to man, for instance the belief that fame, power, and money make happy. To be happy, such misunderstandings have to be overcome. The best life, it was maintained by all, is a virtuous life. But many writers added that some luck was also necessary. And the idea of the golden mean returns time upon time: too poor is bad, as well as too rich. Too ugly is bad, as well as too beautiful. Too small as well as too big. Too much, as well as too little.[14]

Much more could be said about this. But for now this suffices. Because what interests us here, just as much as the goal of the educational enterprise, are its means and methods. How did one think knowledge of and skill in the art of living could best be conveyed? The general answer can be short: by the study of the human being and his life: *studia humanitatis*.[15] But here, as everywhere, the devil is in the detail. What exactly is meant by *studia humanitatis* and how did one picture the help it could provide in informing us about the art of living? Two essential clarifications need to be made, before we can continue.

First, a contemporary, post-romantic or 'post-modern' person might ask how the study of other human beings could help him or her to lead a good and happy life, since all humans differ fundamentally from each other.[16] The point is, however, that precisely this last supposition is denied by the traditional view of education. The idea is rather that all human beings are fundamentally alike, and the differences between them are superficial. Or to be more precise, all human beings are considered to be different from each other, sometimes very different, but the differences are like the differences in the numerical values of the *same* variables. Hence, there is no deep unicity, which would make human beings incomparable; that would presuppose *different* variables. Now, if it is true that human beings are, in this sense, fundamentally alike, the study of other people does help in the pursuing the art of living, since being comparable, we can learn from each other's lives.

Secondly, the *studia humanitatis* are clearly not equivalent to contemporary social science's approach to the study of human beings. The latter is wholly geared to the idea that it should be value-free.[17] No description should contain any prescription. In the *studia humanitatis,* on the other hand, the descriptive and the prescriptive, the 'is' and the 'ought' are completely intertwined. The point of understanding the human being here is precisely to help him lead a good and happy life, by studying examples of such lives, as well as of lives that turned out unhappy. This does not imply the logical mistake of deriving an 'ought' from an 'is'. The *studia humanitatis* start from an 'ought' and study which lives in fact ('is') approach it more, and which less. From a logical point of view, that is perfectly viable.

How does one study the human being? Practical experience in dealing with others was considered to be very important. But theory was also seen as indispensable. We will here focus on the latter. Where does one find the theory concerning the human being and his life? Again, the general answer can be short: in the *fine arts,* i.e. in literature, painting, sculpture, music, dance, etc. The arts are the medium per excellence in which the theory of the human being and his life is to be found.[18]

An important caveat should be made here. The fact that the fine arts have this function in the traditional view, does not mean that this was seen as their only or even their main function. Indeed, throughout history this never was the case. The highest function of the fine arts was always considered to be the expression

of truth, not about humanity, but about the divine and the cosmos, which were conceived as intimately related. That does not stand in the way, however, of the fine arts also being the prime vehicle of the *studia humanitatis.*

From this point of view, good fine art is art that says or shows something of deep truth about the world. And when it is not so much about the divine or cosmic aspects of the world, but about the human aspect, good art is art that says something of deep truth about human beings and their lives. This is essentially what beauty consists of. So beauty is intimately connected to the true. But the true is also intimately connected to the good. Because without truth, we cannot find the (true) good. And whoever does not see the true as good, will not want to know the truth. Moreover, it follows that (true) beauty is also intimately connected to (true) goodness. Bad fine art, on the other hand, is bad in essence because it is mistaken or deceitful about the world and humanity. It can still be beautiful, but its beauty is at most superficial and merely external. At its inner core, it is ugly. And because it is erroneous or a lie, it does not help us achieve the good.

What about so-called 'abstract', i.e. non-figurative fine art? How does this appear from the traditional point of view? Presumably, since it does not say anything about the world and the human being, it is in the traditional view not so much bad art, as no art at all, rather a type of decoration, which in itself can be superficially beautiful, much like bad art, but not beautiful in the full sense of the word.[19]

Now, if the traditional view of fine art is correct, fine art, or rather good, great fine art, contrary to what is often thought today, is not an accessory matter, a side issue, a way of spending one's free time with dignity, but a thing of the utmost importance, since it is one of our main tools in acquiring the art of living. And that includes the art of establishing and maintaining a good state, and the art of not letting it degenerate into a warlike tyranny. What could be more important in the world today? In Europe today?

V.

A few remarks on fine arts need to be added, especially with regard to the notion of 'literature'. For it is quite obvious what the other elements of the fine arts, such as 'painting', 'sculpture', 'music' and the rest, stand for. But the concept of 'literature' as we use it nowadays, is much narrower than its etymological predecessor

litterae. And it is the latter, not the former, that is meant in the traditional view of the fine arts.

'Literature' as we use the term now, refers to what is usually called 'fiction', i.e. novels and short stories, in which things are narrated that did not really occur, and persons that do not really exist play a role. As fiction, literature is contrasted to 'non-fiction', which supposedly deals with real persons and events.

From the traditional perspective this dichotomy is superficial and misleading. *Litterae* i.e. literature in the true sense of the word, is everything written that contains some deep truth on the world, the human being and his life. It therefore includes 'non-fiction', such as historiography, philosophy, letters, diaries, etc. But it also includes 'fictional' novels, poetry, and plays. The relevant distinction is not between 'fiction' and 'non-fiction', it is the distinction between good and bad *litterae*, good *litterae* being writings that contains deep truths about the world and mankind, and bad *litterae* being writings in which little or nothing of that kind can be found. All good *litterae*, also fictional literature, is in the true sense of the word non-fiction, since it is in a deep sense true, all bad litterae, also non-fiction, is really fiction, since it is essentially unrealistic. There is more and deeper truth in Tolstoy's *War and Peace* than in most if not all history books on the Napoleontic Russian campaign. There is more and deeper truth in Paul Celan's poem *Todesfuge* than in many 'non-fiction' descriptions of the Third Reich. And so on.

VI.

It is time to finish with a fitting conclusion. So what follows from what has been said? First of all, that if the effort at European unification implodes, that will not be the end of the world. Such a development would even have positive consequences, in view of the fact that smaller states are less problematic than large states. However, now that we live in a world dominated by large states, it is probably better if European unification goes ahead, since *Kleinstaaterei* in a world of big states is a recipe for trouble.

A unified Europe should not be seen as an automatic force for the good. To do so, as many Europeans do, betrays naivité. Like any other large state, a unified Europe could easily turn into an oppressive and tyrannical entity, and warlike on top of that. These tendencies are inherent in states, particularly in large states.

What can we do about this? More than anything else, a moral education of the people and their leaders is needed, to secure that these tendencies will not get the better of Europe. For the problematic nature of states is in the end a product of the problematic nature of the human being.

This is a very old insight, going back to the ancient Greeks. According to it, such a moral education must be built on a thorough study of humanity — *studia humanitatis.* If well done, i.e. not in a modern 'scientistic' way that consciously expels all judgments of value, but in the older 'humanistic' way, in which the 'is' and the 'ought' are intertwined, this will bring about the moral education that we need.

Central to the *studia humanitatis* in this traditional sense is the study of the fine arts. That is to say, the best of the fine arts, truly great art. The art that used to be called High Culture. If this view is correct, as the authors believe, it implies that High Culture is not merely a nice pastime of a cultural elite, but a *sine qua non* for a civilized Europe, and ultimately, of a civilized world.

Notes

1 About equality of power, see Thucydides' Melian Dialogue, in his *Peloponnesian War,* 2.34-2.46. About checks and balances see Aristotle, *Politics,* IV.9; V.11; VI.4. The believe that these ideas are discoveries of the Enlightenment is historically and philosophically myopic.

2 These famous words come from Hobbes' *Leviathan,* of course. But he is far from the only one asserting that theory about a stateless society. Many contemporary anthropologists and archaeologists tend to agree with him, on the basis of their empirical research on the pre-statal society of Paleolithic man. See e.g. Lawrence Keeley, *War before Civilization: The Myth of the Peaceful Savage,* Oxford University Press 1997; Jean Guilaine and Jean Zammit, *The Origins of War: Violence in Prehistory,* Wiley-Blackwell 2004; Keith Otterbein, *How War Began,* Texas A&M University Press 2004.

3 Montesquieu, *Esprit des Lois,* VIII.19, even maintains that large countries *'presuppose* despotic authority in the one who governs.' Emphasis added. That seems somewhat exaggerated.

4 This 'Iron Law of Oligarchy' was first set out by Robert Michels in his 1911 book *Zur Soziologie des Parteiwesens in der modernen Demokratie.*

5 J.J. Rousseau, *The Social Contract,* 3.15.

6 Waller Newell, *Tyranny, a New Interpretation,* Cambridge University Press 2013.

7 Toynbee, *A Study of History,* abridged by D.C. Somervell, Oxford University Press 1960.

8 The nationalist movements we see growing in many parts of Europe are psychologically understandable, but in the context of a world dominated by big states ill-conceived.

9 This is not so much a personal conviction, as a *communis opinio* among political philosophers of all later ages. It is the reason why all serious political philosophy returns to and is a comment upon a footnote to ancient political philosophy, especially Plato and Aristotle.

10 Aristotle, *Politics,* passim; Polybius, *Histories,* VI.

11 A brilliant general overview is provided by Werner Jäger, *Paideia,* 3 Vols., Walter de Gruyter 1933-1947.

12 Cicero, *Tusculan Disputations,* II.13. Ut ager quamvis fertilis sine cultura fructuosus esse non potest, sic sine doctrina animi.

13 On the matter discussed in this whole paragraph, see primarily Plato, *Politeia, passim.*

14 Good overviews of this moral philosophy are e.g. Terence Irwin, *Plato's Ethics,* Oxford University Press 1995; Julia Annas, *The Morality of Happiness,* Oxford University Press 1993.

15 Still the best introduction to the original idea is Henri Marrou, *Histoire de l'Education dans l'Antiquité,* Le Seuil, 1948; brilliant and too little known is C.J. de Vogel, *Het Humanisme en zijn Historische Achtergrond,* Assen: Van Gorcum 1968.

16 The 'difference-principle' that is at the heart of romantic and post-modern thinking, goes back to Heraclitus and Cratylus. The first famously said that no man could step in the same river twice. Cratylus' not so famous comment on this opinion was that no man could step in the same river once.

17 An ideal authoritatively expressed by e.g. Max Weber and Karl Popper. Of course, it never lacked critics, as for instance Jürgen Habermas and Peter Winch.

18 This is a very different idea of the fine arts than the one expressed in the adage 'l'art pour l'art'. In the former idea, art has a function external to itself. But it is a higher function than the function of the applied arts. These are serviceable to the body, whereas the fine arts are serviceable to the soul.

19 An interesting contemporary example of such criticism of non-figurative art is found in Lennaart Allan e.a., *Niet Alles is Kunst,* Amersfoort: Aspect 2013.

An Untimely Present in Europe

Isabell Lorey

Understanding time as linear is characteristic of European modernity, because with this understanding of time it became a measure for everything else in the world. Politically, European modernity is rooted in revolution, from which freedom and equality emerged as the highest values of political community. Beginning in the late eighteenth century, an incomplete and reductionist narrative of progress and civilization formed in the course of the Enlightenment, which conjoined with a teleological historiography.[1] Since the French Revolution and the Enlightenment, in Europe, politics cannot be separated from the narrative of continuous time becoming history: a history of the victors.

For decades, post-structuralist and de- and post-colonial theory have been pointing out how closely the form and status of European democracy and historiography are interwoven. Democracy did not crystallize independently from capitalist expansion and domination, and modernity and colonialism are not to be separated from one another in the dialectic of the Enlightenment. Europe has styled itself as the normative model for everything that is non-European, the future of which is shown solely in the European present. The presence of non-European societies, on the other hand, remains fixed in the past, inhibited by tradition and religion. In the linear order of past, present and future written into the history of development, Europe and the 'West' are the telos for progress and democracy. This historism represents one of the technologies with which Europe and the 'West' have been able to style themselves as the model of a universal development and solidify their predominance. Colonialism appears in this as a project that first made historical development possible for those colonized.

Post-colonial approaches deconstruct this hierarchical division of history by shifting attention to a multiple 'divided/shared history'.[2] 'Cultures' are no longer, in the tradition of Herder, equated with a homogeneous people and a nation-state territory, but instead there is an emphasis on relationality and exchange within and among purportedly definable and homogeneous 'cultures' and nations. With the focus on global historical processes of change, on contacts, intertwinements and relations, European modernity is no longer a telos of contemporary history, for we live in a 'common modernity'[3], in connected histories. Emphasizing colonial relationships makes it just as impossible to tell a separate history of single nation-states as it is difficult to speak

of 'Europe' or the 'West' without problematizing the global exchange and domination relations tied to these identities. Divided/shared colonial history marks political, economic, social and legal practices in the post-colonial 'centres' up to the present in the way they deal with those constructed as 'other'; colonialism continues to determine, even long after the end of political relationships, several aspects of culture, the patterns of racism and social authoritarianism, and even the predominant visions of international relationships.[4] Looking at the 'connectedness of the world' by no means implies the absence of inequality, domination and violence.[5] It is by looking at relations that it is possible to appropriately analyse not only relations of power and domination, but also differences. In post-colonial discourse, the intertwinements and exchange relationships are understood as 'entangled histories'.[6] This discourse does not seek to create a new universal and totalizing perspective of history, but rather to reveal connections in the concrete entanglements of ideas, institutions and practices.

Entangled history is a history that oscillates between the connotations of the terms *shared* and *divided*, between a common and a separate history. An entangled history shows that an increase in interaction repeatedly goes hand in hand with a striving for demarcation, not least of all within Europe.

In the post-colonial perspective on time and history, the experiences, dimensions and historicities omitted from European historiography are brought out of their positioning in a frozen and closed past.[7] As divided and shared histories they become the genealogy of a different understanding of present, which breaks with the limited geopolitical paradigm of historism. It is an *untimely present,* which does not fit into the continuity between past and future, but instead takes place discontinuously and not historistically.

This untimely present becomes minoritarian[8], but not simply through the representation of the histories of previously 'overlooked' minorities, thus contributing to an increasing democratization also according to the understanding of general history. That would mean that this present merely persists in the logic of liberal representative democracy, in which it is no longer historical superiority that is foregrounded, but still the struggle over inclusion and representation in an expanded liberal-democratic image of history. Instead, untimely present resists a liberal-democratic historicization in the logic of an expanded representation or

inclusion and seeks to break through it. Instead of a representative democratization, it contributes to becoming democratic in a new way, because in the untimely present the many act without becoming one, without becoming an autonomous and superior subject of the Enlightenment.

When Dipesh Chakrabarty speaks of the 'untimely present', he emphasizes that it is not constituted separately from other ways of being that are hierarchized according to time, but rather that it is composed of simultaneously existing heterogeneous forms of living. 'This now is... what fundamentally rends the seriality of historical time and makes any particular moment of historical present out of joint with itself.'[9] According to Chakrabarty, a 'radical critique' of European historiography must always contain a critique of liberalism and representative democracy, including their normative rhetoric of 'freedom and equality'.[10] Europe can only then be 'provincialized', if democracy is newly conceived beyond nation-state constitution and previous forms of representation – in 'nonstatist forms of democracy that we cannot yet either understand or envisage completely',[11] according to Chakrabarty's diagnosis at the beginning of the 2000s.

Over a decade later, these kinds of democratic practices are unfolding in the midst of Europe, and are currently concatenating into a constituent process that gives an impetus from below to a becoming-democratic in Europe. This is happening now in a political-economic crisis, in which the structural adaptation and debt policies of the IMF and others imposed on the countries of the south are being applied to an extreme degree for the first time within Europe. The austerity policies for southern Europe are only one of many examples showing that the former colonies and the global south do not at all abide in the European past, but actually conversely function as laboratories of this specific modernism and draw the image of the future of Europe up to the present.

The Actuality of Presentist Democracy
The representation- and identity-critical movements of occupying squares since 2011 have been inventing new forms of democracy, especially in Spain and Greece, for which I have proposed the term 'presentist'. Presentist democracy does not mean simply the negation or the other side of political representation. The presentist is not in a dichotomous relation to re-presentation, but rather

it emerges through a break with identitarian confrontations be-tween 'us' and 'them', through an exodus from dualisms between refusal and engagement or consensus and conflict.[12] In the midst of the presentist, such an exodus opens up a breach for transversal constituent processes.[13]

In the limited context of the discourses of liberal democracy we encounter the perpetually same decision: *either* political representation and organization *or* unpolitical presence as aesthetic and social immediacy, as the spontaneism of the movement resistant to sustainable organization. Exodus from this old way of thinking means two breaks in the dramaturgy of time, which also structure political action in Europe: first the break with chrono-political stages of development, which channel political action in the direction of traditional political representation. For this chrono-politics, following the tradition of Hegel, has little regard for the present, in order to maintain the promise of the coming democracy; secondly, the break with linear and continuing narratives of time (as called for by post-colonial theories), in order to practice an untimely and unpostponed non-Eurocentric becoming of democracy in the now-time. This becoming of new forms of democracy unfolds in a constituent process, which is directed less to a concrete goal within a foreseeable period of time, but rather far more fundamentally to the emergence of new political subjectivations, in order to invent a different Europe. The central question is: How can we fundamentally change the existing political, social, and economic conditions, and at the same time try out forms of democratic self-government that were previously unimaginable?

The Perpetual Promise of a Coming Democracy

The current crises of representative democracy are part of the tradition of the bourgeois form of democracy and the aporias constituting it. One of these aporias arises from the constitutive separation between the state on one side and (civil) society on the other. Representative democracy is not to be separated from statehood and is regarded in this sense as 'political democracy', which is severed from society, from *all* who are supposed to be represented – which Marx already criticized Hegel for.[14] From the separation between the political and the social, which is considered a necessary political division of labour in bourgeois liberal democracy, the indispensable fact of political representation arises. Bourgeois

democracy is thus trapped in a further aporia: representation is always exclusive, the aspiration to equality cannot be reached with this instrument, inequality is constitutive. Comprehensive participation is only to be understood as a future telos, as a principally endless expansion of participation rights that have to be fought for. The unfulfillable promise of coming democracy, of democratization endlessly postponed until the future, is the basis for this political democracy separated from the social.

The reverse side of this conception of the political, which is marked as unpolitical, applies to the particular, situated presence that, reduced to authenticism and immediacy, is shifted into the realm of the social and the aesthetic and is frozen in the present. In this kind of understanding of immediacy and presence as a negation of (political) representation, Hegel's handwriting is clearly evident, as he had decidedly little regard for the present. For him it is a moment that cannot be captured in our thinking, feeling, and acting, that is fleeting and ultimately without history.[15]

Having little regard for the present is the foundation of a 'western' understanding of democracy, according to which the creative self-government of the indeterminate and heterogeneous *demos* must be warded off.[16] For Marx, the actuality of the Paris Commune breaks with this logic, as it pursues no ideals oriented to the future. The self-government of the Commune releases elements of the new society in the present, elements that had already developed in the crisis of bourgeois domination. It is the social revolution that develops out of the bourgeois teleology of history and breaks with it, leaves it behind.[17]

The Now-Time of Struggles
In his text 'On the Concept of History' Walter Benjamin describes bourgeois historiography as a historiography of the victors,[18] which must be interrupted in its linear narrative of time that secures domination. The idea of history as a continuum primarily serves to reproduce domination relations, for which the precondition is that the present does not count. It is in revolutionary movements starting from the present that the break in this continuum first emerges – which Benjamin called a 'tiger's leap'.[19] This tiger's leap is evident in the (class) struggles over material things as well as in the 'fine and spiritual things'[20], such as courage, humour, and cunning, which emerge at the same time. These affects and affections continually call the victories of the rulers, the temporal

continuity of historism into question and 'brush history against the grain'.[21]

The struggles take place in the 'now-time' ('Jetztzeit')[22], but that does not mean they are untouched by the past. The now-time is specifically not a temporality that remains self-identical in itself, as an immediate presence, as an authenticity of body and affect, or as a pure emotional state. It is constructive temporality, in which the slivers of history are newly composed, in which history persistently emerges. The now-time is the creative midpoint, not a transition of the past into the future. In the previously described sense, it is untimely present.

The Benjaminian now-time flees from humanist and idealistic notions of progress that draw from the idea of a civilizational development and colonizing temporality. This kind of projection into the future does not adhere to reality and, in Benjamin's view, weakens the present revolutionary strength. Rather than being fixed on progress, the now-time of struggles actualizes halted constellations of emancipation and does not continue on the paved roads of oppression and violence: the present becomes political. A tiger's leap has the capacity to scent what is actual in a part of the past. It breaks with the continuity of history through a present leap into the past that tracks down what is actual there. If it is revolutionary, then it is a leap that starts under the conditions of the ruling class, breaks with its command, and goes beyond it.

A Constituent Process for Europe

Against this background of theories of democracy and the philosophy of history, the presentist in the context of current democracy movements signifies an exodus from the historism of liberal democracy as well as from chrono-political development paradigms, in which political institutionalization always represents only a necessary *next* step for a movement. The new democratic practices emerge in the midst of a recurrent and climactic crisis of representative democracy that has turned itself into a neoliberal governing through precarisation and indebtedness. For the precarious, the connection with the past has been broken off in manifold ways, and the future cannot be planned. In the midst of this temporality broken open, there emerges a break with the notion that political action must be tied to representation, and at the same time a revolutionary desire for a new form of democracy that does not offer an empty promise of a permanently

postponed future, but one that is already being experimented with in the now-time.[23]

From the perspective of a theory of presentist democracy, the current representation-critical democracy movements develop untimely transversal constellations. They pose no demands to governments for a further democratization, but instead practice a new form of democracy in the now-time of struggles. The identity- and representation-critical attitude of the movements of the precarious is not a passing mood, not a misunderstanding, not politically naïve. The heterogeneous precarious cannot be unified or organized according to the logic of identity. Because of the heterogeneity of the socio-economic modes of existence, negotiation processes and decision-making structures are needed that channel the multiplicity of positions, but do not bring them to a standstill in the dual logic of inclusion and exclusion. The point is not so much to assemble '*all* individually', but rather that the many mutually inter-related singularities partake specifically not as separated individuals.[24]

Affective relatedness and practices of solidarity – the fine and spiritual things that Benjamin speaks of – have constituted the democracy movements since the occupations of squares in 2011. From the beginning, social reproduction was newly organized, which plays an increasingly important role in the solidarity networks developing from the occupations in the fields of health, education, and housing. Feminist considerations on a reorganization of the division of labour and reproduction take on a new actuality here, for instance those of the Madrid collective Precarias a la deriva on *cuidadanía*, a sociality based on care.[25]

Unlike the bourgeois-capitalist tradition in Europe, being connected with others is not devalued here. More and more social fields are arranged through open assemblies, through modes of participation as egalitarian as possible, and through radical inclusion. With these instruments, shared concerns in the communes or in educational and health institutions are self-organized and privatizations – also of common goods like water – are prevented. Solidarity networks form through and with those who are dropped from health insurance in the course of austerity policies, such as the social clinics in Greece[26] or the network *Yo Sí, Sanidad Universal*[27] in Spain, which supports migrants. The successful and influential Spanish platform for those harmed by mortgages (PAH) and all the initiatives that collect food for the indigent do not see

themselves simply as social aid services for those in need either, but rather as political practices for developing a new democratic way of living together.

New forms of political action, in the desire for a completely different democracy, are poised for a leap, for a tiger's leap, and they open up a breach for the concatenation of failed, halted, and successful revolutionary practices from the past: the procedure of drawing lots from ancient Greek democracy, in which equality is not regarded as a postponed normative aspiration, but rather as the actualization of the equality of those who take part; the councils of the Paris Commune of 1871; the strategies of the Zapatistas from the 1990s; the instrument of horizontality from the Argentinian Revolution of 2001; identity critique from the (queer) feminist movements; the occupations of squares in Tunis and Cairo.

All these components of the presentist becoming of democracy unfold in a constituent process. Through the exodus out of chrono-political and historical patterns of thinking, the democratic constituent process is no longer simply opposed to the established constituted power; it constitutes itself not simply as a counter-power, but rather as a new composition of space and time. Thus the instrument of horizontality does not signify the affirmation of the other side of vertical, hierarchical structures. Instead, horizontality presents itself, for instance in the complexity of the Argentinian revolutionary practice, as a starting point for experimenting with the transversal concatenation with representation-critical practices, dependent mandates and delegations all the way to new political parties that are committed to horizontal assemblies. It is a matter of a heterogeneous and broad experimentation with simultaneously occurring different constellations from new and past practices, which are constantly changing and composed anew, in order to impel the constituent process in the untimely present.

This constituent process does not emerge solely in the composition of heterogeneous practices and discontinuous rhythms of time, however. Presentist democracy is not primarily a question of participatory procedures. It depends to a crucial degree on how it newly unfolds as an attitude in the subjectivation — as a critical attitude of singularities that have always already been relational and social. In this attitude, being different is no longer a reason for anxiety and devaluation, but rather a guarantee for

transversal relationships and new democratic forms of subjectivation and self-government.

These kind of constituent processes can be observed in all the countries where the democracy movements have spread out with their solidarity networks into the respective societies. They will hopefully increasingly infect the areas of Europe that are not threatened by austerity policies to the same degree as southern Europe, but which must take a stand for a different Europe in the constituent process of a presentist democracy. In this process a first draft of a 'Charter for Europe' has already been developed, which is being discussed since summer 2014 throughout Europe in various places in different groups.[28] The ideas of a different Europe that can be read in the Charter form an untimely present. The draft of the preamble begins: '1. We live in different parts of Europe with different historical, cultural and political backgrounds. We all continuously arrive in Europe. We share experiences of social movements and struggles, as well as experiences of creative political work among our collectivities, on municipal, national and transnational levels. We have witnessed and participated in the rise of multitudes across the world since 2011. In fact, the European "we", we are talking about here, is unfinished, it is in the making, it is a performative process of coming together.'

Notes

1. Enrique Dussel (1998) 'Beyond Eurocentrism. The World-System and the Limits of Modernity,' in: Frederic Jameson, Masao Miyoshi (eds.), *The Cultures of Globalization,* Durham and London: Duke University Press, 3-31.

2. Shalini Randeria (2000) 'Geteilte Geschichte und verwobene Moderne,' in: Jörn Rüsen, Hanna Leitgeb, Norbert Jegelka (eds.), *Zukunftsentwürfe: Ideen für eine Kultur der Veränderung,* Frankfurt am Main and New York: Campus, 87-95, here p. 87.

3. Achille Mbembe (2008) 'What is postcolonial thinking?' An Interview with *Esprit* 12/2006, transl. by John Fletcher, *Eurozine* (2008), www.eurozine.com/articles/2008-01-09-mbembe-en.html.

4. Boaventura de Sousa Santos (2010) 'From the Postmodern to the Postcolonial — and Beyond Both', in: Encarnación Gutiérrez Rodríguez, Manuela Boatca, Sérgio Costa (eds.), *Decolonizing European Sociology: Transdisciplinary Approaches,* Farnham: Ashgate, 225-242, online pdf: www.boaventuradesousasantos.pt/media/From%20the%20Postmodern%20to%20the%20Postcolonial_2010.pdf.

5. Frantz Fanon (2001) *Black Skin, White Masks,* transl. by Richard Philcox, revised edition, New York: Grove Press); Paul Gilroy, *Against Race: Imagining Political Culture Beyond the Color Line,* Cambridge MA: Harvard University Press.

6. Shalini Randeiria (2002) 'Entangled Histories of Uneven Modernities. Civil Society, Caste Solidarities and the Post-Colonial State in India,' in: Yehuda Elkana et al (eds.), *Unraveling Ties,* Frankfurt am Main and New York: Campus and St. Martin's Press.

7. Steven Feierman (1993) 'African Histories and the Dissolution of World History,' in: Robert H. Bates, V.Y. Mudimbe and Jean O. Bart (eds.), *Africa and the Disciplines,* Chicago: University of Chicago Press.

8. The concept of becoming-minoritarian in Gilles Deleuze and Félix Guattari (1987) *A Thousand Plateaus: Capitalism and Schizophrenia,* transl. by Brian Massumi, Minneapolis and London: University of Minnesota Press, 291 ff.

9. Dipesh Chakrabarty (2008) *Provincializing Europe: Postcolonial Thought and Historical Difference,* Princeton NJ and Oxford: Princeton University Press, 113. For Chakrabarty's notion of 'now', see p. 249 ff.

10. And thus a critique of the bourgeois construction of citizenship, the modern state, and the bourgeois private sphere (Chakrabarty, *Provincializing Europe,* 42).

11. Ibid., 107.

12. Also counter to Chantal Mouffe's reading, when she interprets my thoughts on the new democracy movements in my essay (2013) 'On Democracy and Occupation. Horizontality and the Need for New Forms of Verticality', transl. by Aileen Derieg, in: Pascal Gielen (ed.) *Institutional Attitudes: Instituting Art in a Flat World,* Amsterdam: Valiz, 77-99, in this dualist logic (see Chantal Mouffe (2013) *Agonistics,* London and New York: Verso Books, 106-127).

13. For my understanding of exodus and constituting, see Isabell Lorey (2011) *Figuren des Immunen: Elemente einer politischen Theorie,* Zürich and Berlin: Diaphanes; Isabell Lorey (2015) *State of Insecurity: Government of the Precarious,* transl. by Aileen Derieg, London and New York: Verso Books. On the concept of constituent processes, see Michael Hardt and Antonio Negri (2012) *Declaration* (distributed by the authors).

14. Karl Marx (1976) 'Zur Kritik der Hegelschen Rechtsphilosophie: Kritik des Hegelschen Staatsrechts' [1843-1844], in: MEW, vol. 1, Berlin: Dietz, 203-333 (Engl.: Marx, 'Notes for a Critique of Hegel's Philosophy of Right: www.marxists.org/archive/marx/works/1843/critique-hpr/ch03.htm#023).

15. G.W.F.Hegel (1970) *Phänomenologie des Geistes, Werke in zwanzig Bänden,* vol. 3, Frankfurt am Main: Suhrkamp, 86-88 (Engl.: Hegel, *Phenomenology of the Mind:* www.marxists.org/reference/archive/hegel/works/ph/phprefac.htm).

16. Isabell Lorey 'On Democracy and Occupation', op.cit.

17. Karl Marx (1973) 'Der Bürgerkrieg in Frankreich' [1871], in: *MEW,* vol. 17, Berlin: Dietz, 313-365, here 340-344 (Engl.: 'Civil War in France': www.marxists.org/archive/marx/works/1871/civil-war-france/).

18. Walter Benjamin (2003) 'On the Concept of History' [1938-1940], in:

ibid. *Selected Writings,* Vol. 4, 1938–1940, edited by Howard Eiland and Michael Jennings, transl. by. Edmund Jephcott et al, Cambridge MA: Belknapp Press, http://cscs.res.in/dataarchive/textfiles/textfile.2010-11-02.7672177498/file.

19 Ibid., thesis XIV.
20 Ibid., thesis IV.
21 Ibid., thesis VII.
22 Ibid., thesis XIV.
23 Isabell Lorey (2013) 'Das Regime der Prekarisierung: Europas Politik mit Schuld und Schulden,' in: *Blätter für deutsche und internationale Politik,* 2013(6), 91-101; Lorey, *State of Insecurity,* op.cit.
24 Isabell Lorey 'On Democracy and Occupation', op.cit.
25 Precarias a la deriva, *'Was ist dein Streik?' Militante Streifzüge durch die Kreisläufe der Prekarität,* 2014, http://transversal.at/books/precarias-de.
26 For the networks in Greece, see: www.solidarity4all.gr/about-solidarity-initiative.
27 yosisanidaduniversal.net.
28 A publication of the first draft of the 'Charter for Europe' can be found under: http://transversal.at/blog/charter-for-europe.

Afterwords

Katherine Watson
Paul Dujardin

Afterword by European Cultural Foundation

'The European project can only gain more meaning and support if it allows citizens to really assign meaning to it', write Gielen and Lijster in the lead article of this publication. Later they add that 'there is no individual freedom without collective structures of solidarity, institutions and constitutions to fall back on.'

These thoughts resonate well with the European Cultural Foundation's values and beliefs, and even more with our current thematic focus on *Connecting Culture, Communities and Democracy.* Understanding the significance of creating and nourishing a space to shape ideas and negotiate meaning, individually and collectively, is at the heart of our work. It is not about creating commodities, but about creating a space for reflection, action and meaning; not about sustaining the cultural sector but about creating the conditions for it to thrive and sustain itself.

ECF does not stand for culture for the sake of culture, or Europe for the sake of Europe. For us, culture is the foundation of our societies. Through culture, we express values and beliefs, highlight differences and commonalities, give meaning to our lives. The well-being of the individual is very much interrelated with the well-being of the collective – be this collective a local initiative or the project Europe (or anything in between). For this to happen, we need frameworks, encounters with others, the possibility to disagree, as well as the possibility to unite in a common vision.

The European Cultural Foundation contributes to the development and strengthening of such frameworks through grantmaking, programmes and advocacy. It is vital to connect this work to academic reflection and we are proud to have partnered in this exceptional, comprehensive and compelling collection of essays.

Katherine Watson
Director European Cultural Foundation

Afterword by BOZAR

'In its role as the oldest and greatest centre of arts in Belgium, the Centre for Fine Arts strives to be a model 21st-century European cultural centre', the as first sentence of our cultural mission statement underlines. It is an ambitious and an enduring story, which includes showing and telling, debate and research.

In our view, a cultural project is a social project, a community project. Culture is an essential pillar of social cohesion. A cultural institution, especially in a multicultural metropolis such as Brussels, contributes to the context in which citizens and decision makers experience diversity. Increased knowledge of cultural differences and affinities changes one's 'view of others'. In exhibitions, concerts and multidisciplinary festivals BOZAR presents the enriching - and also conflicting - power of the relationships between cultures throughout the centuries. The 'unity in diversity' of European culture is the result of age-old exchanges, individual contacts and migration flows. Contemporary artists are inclined to cross borders, mentally and physically. This all becomes apparent in our concert hall, exhibitions spaces, and multidisciplinary rooms.

As a cultural project, BOZAR not only wants to show but also 'tell' by stimulating the contribution of artists in the societal debates with scientists, decision makers and the economic field. How can artistic ideas and socio-scientific speculations contribute to the idea of Europe, not only as an economic and political entity but also as a cultural, community building project? Therefore BOZAR is investing time and efforts in cross-sectorial debates, research and artistic output on the European cultural commons.

No Culture, No Europe strikes the right tone.

Paul Dujardin
CEO & Artistic Director Centre for Fine Arts, Brussels

Contributors

Rosi Braidotti (B.A. Hons. Australian National University, 1978; PhD, Université de Paris, Panthéon-Sorbonne, 1981; Honorary Degrees Helsinki, 2007 and Linkoping, 2013; Fellow of the Australian Academy of the Humanities *(FAHA)*, 2009; Member of the Academia Europaea (MAE), 2014) is Distinguished University Professor and founding Director of the Centre for the Humanities at Utrecht University, the Netherlands. Her latest books are: *The Posthuman,* Cambridge: Polity Press, 2013; *Nomadic Subjects,* New York: Columbia Univ. Press, 2011a and *Nomadic Theory: The Portable Rosi Braidotti.* Columbia University Press, 2011b.
www.rosibraidotti.com

Kurt De Boodt (1969) is artistic advisor in the policy team of the Centre for Fine Arts, Brussels, Belgium. As an independent curator he made exhibitions on the Belgian sculptor Rik Wouters (2011) and the modernist painter Prosper De Troyer (2013). He has published six volumes of poetry, including the epic poem *Minnezang* (2011) and *Ghostwriter* (2015), 'a generous collection in a time of economic cuts and excessive profits'.

Pascal Gielen (1970) is director of the research centre Arts in Society at the Groningen University, the Netherlands, where he is Professor of Sociology of Art. Gielen is editor-in-chief of the book series 'Arts in Society' (Fontys School of Fine and Performing Arts, Tilburg & Groningen University). He has written essays and co-edited several books on contemporary art, cultural heritage and cultural politics: *Being an Artist in Post-Fordist Times,* Rotterdam: NAi Publishers, 2009; *The Murmuring of the Artistic Multitude: Global Art, Memory and Post-Fordism,* Amsterdam: Valiz, 2009, 2010, 2015; *Teaching Art in the Neoliberal Realm: Realism versus Cynicism,* Amsterdam: Valiz, 2013; *Creativity and other Fundamentalisms,* Amsterdam: Mondriaan Fund, 2013; *Institutional Attitudes: Instituting Art in a Flat World,* Amsterdam: Valiz, 2013; *The Ethics of Art,* Amsterdam: Valiz, 2014; and *Aesthetic Justice,* Amsterdam: Valiz, 2015. Gielen's research focuses on cultural politics and the institutional contexts of the arts. Books by Gielen have been translated into English, Korean, Russian, Spanish and Turkish. www.rug.nl/staff/p.j.d.gielen/cv

Barend van Heusden holds the chair of Culture and Cognition, with special reference to the Arts, in the Department of Arts, Culture and Media Studies at the University of Groningen, in the Netherlands. He has published articles and books in the fields of literary and culture theory, semiotics and cognition, as well as arts and culture education. Since 2009, he supervises the national project 'Culture in the Mirror: toward a curriculum for culture education'. In this project, culture education is approached from a cognitive-semiotic perspective. A framework is developed that allows schools and teachers to design a culture curriculum tailored to the students' development and culture. Personal homepage: www.rug.nl/staff/b.p.van.heusden/index; homepage of the 'Culture in the Mirror'-project: www.cultuurindespiegel.nl

Andreas Kinneging is professor in the philosophy of law at the Faculty of Law of the University of Leiden, the Netherlands. He is the author of hundreds of articles and several books, two of which are in English. *Aristocracy, Antiquity, and History: An Essay on Classicism*

in Political Thought, New Brunswick: Transaction, 1997; *Geography of Good and Evil,* Wilmington: ISI Press 2009. He is co-translator of the first complete Dutch translation of Tocqueville's magnum opus, *De la Démocratie en Amerique,* Rotterdam: Lemniscaat, 2011.

György Konrád is an Hungarian writer who is well known for books such as *A Guest in My Own Country* and *A Feast in the Garden.* Konrád is the recipient of numerous prizes and awards, including the Herder Prize (1984), the Charles Veillon Prize (1990), the Manes-Sperber Prize (1990), the Friedenspreis des Deutschen Buchhandels (1991), the Goethe Medal (2000), and the National Jewish Book Award in the memoir category (2008). He has received the highest state distinctions awarded by France, Hungary, and Germany: Officier de l'Ordre national de la Légion d'Honneur (1996); The Hungarian Republic Legion of Honor Middle Cross with Star (2003); and Das Grosse Verdienstkreuz des Bundesrepublik Deutschland (2003). A more exhaustive biography can be found at www.konradgyorgy.hu

Thijs Lijster studied philosophy at the University of Groningen and the New School for Social Research in New York. In 2012 he received his PhD in philosophy (*cum laude*) at the University of Groningen, for a dissertation on Walter Benjamin's and Theodor W. Adorno's concepts of art criticism. Currently he is a researcher and coordinator of the research centre Arts in Society at the same university. He lectured on philosophy of art and culture at the Faculties of Philosophy and Arts of the University of Groningen, and the Faculty of Humanities of the University of Amsterdam. In 2009 he received the ABG/VN Essay prize and in 2010 the Dutch/Flemish Prize for Young Art Criticism.

Isabell Lorey is a political theorist at the eipcp, based in Berlin, and an editor of transversal texts. She teaches social science, cultural and gender studies at several universities in Europe. Her most recent book: *State of Insecurity: Government of the Precarious,* London and New York: Verso Books 2015. For more see: transversal.at/bio/lorey

Jan Masschelein is Professor of Philosophy of Education and Director of the Laboratory for Education and Society at the University of Leuven, Belgium. Masschelein's primary areas of scholarship are educational theory, critical theory, and social philosophy. His current research concentrates on the public role and meaning of education and on 'mapping' and 'walking' as critical research practices. He is involved with architects/artists in the development of experimental educational practices and is the co-author (with Maarten Simons) of: *Globale Immunität: Ein kleine Kartographie des Europaischen Bildungsraum*, Berlin and Zürich: Diaphanes, 2005; *Jenseits der Exzellenz: Eine kleine Morphologie der Welt-Universität*, Berlin and Zürich: Diaphanes, 2010; and *In Defence of the School: A Public Issue*, Leuven, 2013; free downloadable: http://ppw.kuleuven.be/ecs/les.

Anoek Nuyens is a writer, theatre maker and dramaturgist. She works and has worked in Kinshasa, Brussels, Berlin, Amsterdam and other places. She is the founder of Transitiebureau, a group of theatre makers and theorists who initiate projects at the borderline of arts and society. For the Dutch online news medium

De Correspondent she writes about now released state secrets. She received the 2013 Marie Kleine-Gartman Pen Award in recognition of her writing. She will give her first solo performance at Frascati, Amsterdam, in 2015.

Maarten Simons is Professor of Educational Policy and Theory at the Laboratory for Education and Society of the University of Leuven (Belgium). Simons' principal interests are in educational policy, new mechanisms of power, and new global and European regimes of governing education and life-long learning. His research focuses explicitly on the challenges posed to education, with a major interest in (re-)thinking the public role of schools and universities. He is co-editor (with Jan Masschelein) of *The Learning Society from the Perspective of Governmentality*, Oxford: Blackwell, 2007; *Rancière: Public Education and the Taming of Democracy*, Oxford: Blackwell, 2007; and of *Re-reading educational policies*, Rotterdam: Sense Publishers, 2009, with Mark Olssen & Michael Peters.

Naema Tahir (1970, Slough, England) is a British-Dutch writer and human rights lawyer, of Pakistani origin. Tahir read International Law at Leiden University, the Netherlands. She worked as a lawyer for the Dutch Government for a decade, for the UNHCR in Nigeria and for the Council of Europe in France. In 2006 she left the legal practice because of her love of writing. Her first book, *A Muslim Woman* Reveals (Een moslima ontsluiert, 2005) dealt with the effect of migration on identity and became an instant bestseller in the Netherlands and Belgium. A year later she authored *Prized Possession,* a novel on the lives of three women living partly in Pakistan, partly in the West and this also became a major Dutch bestseller. Tahir further authored *Lonesome Today* (Eenzaam heden) on the immigration experience of a child, *Little Green Riding Hood* (Groenkapje), a book of fairy tales in today's Europe, and *The Bride* (De Bruid), on forced marriages amongst immigrant women. Tahir is currently working on a collection of essays on Muslim women and feminism. Naema Tahir is seen as a leading opinion maker and writer on issues regarding Europe's multicultural societies, with a special focus on women and human rights.

Arts in Society Series

No Culture, No Europe: On the Foundation of Politics is the 16th publication in a series of books that map the interaction between changes in society and cultural practices. Inspired by art and critical theory, the series *Arts in Society* studies the possibilities of a repositioning of the arts and culture in society. The series is open for publishing proposals in the form of essays, theoretical explanations, practice-oriented research in the arts, and research studies.

Editor-in-chief
Pascal Gielen
p.j.d.gielen@rug.nl

Index

Colophon

Colophon

No Culture, No Europe
On the Foundation of Politics

Editor
Pascal Gielen

Contributors
Rosi Braidotti
Kurt De Boodt
Pascal Gielen
Barend van Heusden
Andreas Kinneging
György Konrád
Thijs Lijster
Isabell Lorey
Jan Masschelein
Anoek Nuyens
Maarten Simons
Naema Tahir

Antennae Series n°15
by Valiz, Amsterdam

Part of the Series
'Arts in Society"

Translation
Leo Reijnen & Jane Bemont (text
Pascal Gielen); Marc Baczoni (text
György Konrád); Aileen Derieg (text
Isabell Lorey)

Copy editing
Leo Reijnen

Literature, index and proof check
Elke Stevens

Production
Pia Pol

Design
Metahaven

Paper inside
Munken Print 100 gr 1.5,

Paper cover
Bioset 240 gr

Printing and binding
Ten Brink, Meppel

Publisher
Valiz, Amsterdam, 2015
www.valiz.nl

ISBN 978-94-92095-03-9

This publication was made possible
through the generous support of

Fontys School of Fine and Performing
Arts, Tilburg

European Cultural Foundation,
Amsterdam

BO
ZAR

BOZAR, Brussels

The authors and the publisher have made every effort to secure permission to reproduce the listed material, illustrations and photographs. We apologise for any inadvert errors or omissions. Parties who nevertheless believe they can claim specific legal rights are invited to contact the publisher.

Distribution:
USA /CAN/LA: D.A.P.,
www.artbook.com
GB/IE: Anagram Books,
www.anagrambooks.com
NL/BE/LU: Coen Sligting,
www.coensligtingbookimport.nl
Europe/Asia/Australia: Idea Books,
www.ideabooks.nl

ISBN 978-94-92095-03-9

Printed and bound in the Netherlands

Antennae

Antennae Series

Antennae N° 1
The Fall of the Studio
Artists at Work
edited by Wouter Davidts
& Kim Paice
Amsterdam: Valiz, 2009
(2nd ed.: 2010),
ISBN 978-90-78088-29-5

Antennae N° 2
Take Place
Photography and Place
from Multiple Perspectives
edited by Helen Westgeest
Amsterdam: Valiz, 2009,
ISBN 978-90-78088-35-6

Antennae N° 3
The Murmuring of the
Artistic Multitude
Global Art, Memory and
Post-Fordism
Pascal Gielen (author)
Arts *in* Society
Amsterdam: Valiz, 2009
(2nd ed.: 2011),
ISBN 978-90-78088-34-9

Antennae N° 4
Locating the Producers
Durational Approaches to Public Art
edited by Paul O'Neill
& Claire Doherty
Amsterdam: Valiz, 2011,
ISBN 978-90-78088-51-6

Antennae N° 5
Community Art
The Politics of Trespassing
edited by Paul De Bruyne &
Pascal Gielen
Arts *in* Society
Amsterdam:
Valiz, 2011 (2nd ed.: 2013),
ISBN 978-90-78088-50-9

Antennae N° 6
See it Again, Say it Again
The Artist as Researcher
edited by Janneke Wesseling
Amsterdam: Valiz, 2011,
ISBN 978-90-78088-53-0

Antennae N° 7
Teaching Art in the Neoliberal Realm
Realism versus Cynicism
edited by Pascal Gielen &
Paul De Bruyne
Arts *in* Society
Amsterdam: Valiz, 2012
(2nd ed.: 2013),
ISBN 978-90-78088-57-8

Antennae N° 8
Institutional Attitudes
Instituting Art in a Flat World
edited by Pascal Gielen
Arts *in* Society
Amsterdam: Valiz, 2013,
ISBN 978-90-78088-68-4

Antennae N° 9
Dread
The Dizziness of Freedom
edited by Juha van 't Zelfde
Amsterdam: Valiz, 2013,
ISBN 978-90-78088-81-3

Antennae N° 10
Participation Is Risky
Approaches to Joint
Creative Processes
edited by Liesbeth Huybrechts
Amsterdam: Valiz, 2014,
ISBN 978-90-78088-77-6

Antennae N° 11
The Ethics of Art
Ecological Turns in the
Performing Arts
edited by Guy Cools & Pascal Gielen
Arts *in* Society
Amsterdam: Valiz, 2014,
ISBN 978-90-78088-87-5

Antennae N° 12
Alternative Mainstream
Making Choices in Pop Music
Gert Keunen (author)
Arts *in* Society
Amsterdam: Valiz, 2014,
ISBN 978-90-78088-95-0

Antennae N° 13
The Murmuring of the Artistic
Multitude
Global Art, Politics and Post-Fordism
Pascal Gielen (author)
Completely revised and enlarged
edition of Antennae N° 3
Arts *in* Society
Amsterdam: Valiz, 2015,
ISBN 978-94-92095-04-6

Antennae N° 14
Aesthetic Justice
*Intersecting Artistic and Moral
Perspectives*
edited by Pascal Gielen &
Niels Van Tomme
Arts *in* Society
Amsterdam: Valiz, 2015,
ISBN 978-90-78088-86-8

223

No Culture, No Europe

224